CRITICAL ACCLAIM FOR WINGS

"Different times, different places, different muses, but *toujours France*. In *Wings*, while offering a feast of discoveries, tastes, feelings and surprises, Erin Byrne shares with us her fascination with a country that rewards those who love its idiosyncrasies as much as its delights. To join Erin Byrne on her travels is to see France through the eyes of an ever-curious and affectionate friend."

—Alan Riding, author of *And the Show Went On: Cultural Life in Nazi-Occupied Paris*

"I found myself re-reading this book with growing delight. As a writer, Erin Byrne has a graceful touch and a knack for telling captivating stories. As a traveler, she is sometimes obsessed, confused or a bit distraught. All the better for us. Byrne doesn't just see, she feels and that makes all the difference."

—Tim Cahill, author of *Jaguars Ripped My Flesh* and *Hold the Enlightenment*

"With lush prose, remarkable honesty and passion that crackles off the page, Erin Byrne's beautifully-observed stories reveal the many ways—both subtle and profound—that France has transformed her over a decade of travels there. What is perhaps most inspiring is how she peeks behind the obvious and finds connection, meaning and most of all beauty everywhere on her journey—in a taxi in Arles, on a staircase in the Louvre, in the simplest glass of Bordeaux, in a Normandy village steeped in history. Byrne urges us all to find our stories, but these are hers, and they are dazzling."

—Marcia DeSanctis, author of *100 Places in France Every Woman Should Go*

"Erin Byrne's essays about France's grand treasures, from her museums to her old bakeries, creaky bookstores, wine shops, sun-spangled cafes, the red windmills of Montmartre, and even the harrowing bullet holes left behind from past wars remind me of discovering long-lost wonders in the *bouquinistes* along the Seine. Read on, for this is a reverie-inducing glimpse of past and present France."

—Phil Cousineau, author of *The Book of Roads: A Life Made of Travel* and *The Art of Pilgrimage*

"Reflective and poetic, *Wings* is a magic mirror held up to French art, culture and history. It's also a window into Byrne's life, with its share of shadows. But while *Wings* is often profound, many stories are frank and funny—I'll never think of Balzac the same way again."

—Jeff Greenwald, author of *Snake Lake* and *Shopping for Buddhas*

"Reading these beautifully crafted essays is like traveling with your best friend. Erin Byrne not only experiences France with her senses, she experiences it with her heart, rendering her impressions of the country, its art, and its people with both grace and warmth."

—Janis Cooke Newman, author of *A Master Plan for Rescue*

"Erin Byrne's deep appreciation for France—and for the unique power of travel to transform us—is infectious. Here, she writes with heart and tenderness about the country's greatest art and artists, its shattering role in World War II, and the pleasures of family travel. In fact, as I read about her experiences traveling in Paris with her sons, I couldn't help but reflect on my own travels with my daughter. I defy you to read these stories and not want to hop on the next flight to Charles de Gaulle."

—Jim Benning, co-founder of World Hum

"For anyone who fell for France long ago, like me, *Wings* rekindles the love anew while posing the inevitable question we all ask ourselves: What is it about a place that pulls us back? Erin weaves together the answers through deeply observed and reflective stories about the people, places, and ghosts, familiar and foreign, that swirl in our memories and hearts long after we return home."

—Kimberley Lovato, author of *Walnut Wine & Truffle Groves*

"*Wings* is an amazing book and a delightful and compelling read. This book will be cherished by all who seek true connection and meaning in their travels."

—James Bonnet, author *Stealing Fire from the Gods*

"*Wings* is a smart and delicious memoir. I felt as if *I* were the one traveling near the Seine and dipping a little bread in my glass of scarlet wine, as Erin Byrne's essays fully capture the intimate details of France. She writes, "Often we have a hunger for something, but know not what," and these beautiful, inviting essays become what feeds us. Engaging, poignant, and honest, *Wings* will nourish your inner traveler and take you into the enchantments of France. This book is truly a must-read to satisfy the wanderlust in each of us."

—Kelli Russell Agodon, editor of Two Sylvias Press
and author of *Hourglass Museum* and *The Daily Poet:
Day-By-Day Prompts for Your Writing Life*

WINGS

GIFTS OF ART, LIFE, AND
TRAVEL IN FRANCE

Travelers' Tales Books

Country and Regional Guides
30 Days in Italy, 30 Days in the South Pacific, America, Antarctica, Australia, Brazil, Central America, China, Cuba, France, Greece, India, Ireland, Italy, Japan, Mexico, Nepal, Spain, Thailand, Tibet, Turkey; Alaska, American Southwest, Grand Canyon, Hawai'i, Hong Kong, Middle East, Paris, Prague, Provence, San Francisco, South Pacific, Tuscany

Women's Travel
100 Places Every Woman Should Go, 100 Places in France Every Woman Should Go, 100 Places in Greece Every Woman Should Go, 100 Places in Italy Every Woman Should Go, 100 Places in the USA Every Woman Should Go, 50 Places in Rome, Florence, & Venice Every Woman Should Go, Best Women's Travel Writing, Family Travel, Gutsy Mamas, Gutsy Women, Mother's World, Safety and Security for Women Who Travel, Wild with Child, Woman's Asia, Woman's Europe, Woman's Passion for Travel, Woman's Path, Woman's World, Woman's World Again, Women in the Wild

Body & Soul
Adventure of Food, Food, How to Eat Around the World, Love & Romance, Mile in Her Boots, Pilgrimage, Road Within, Spiritual Gifts of Travel, Stories to Live By, Ultimate Journey

Special Interest
365 Travel, Adventures in Wine, Danger!, Fearless Shopper, Gift of Birds, Gift of Rivers, Gift of Travel, Guidebook Experiment, How to Shit Around the World, Hyenas Laughed at Me, It's a Dog's World, Leave the Lipstick, Take the Iguana, Make Your Travel Dollars Worth a Fortune, More Sand in My Bra, Mousejunkies!, Not So Funny When It Happened, Penny Pincher's Passport to Luxury Travel, Sand in My Bra, Soul of Place, Testosterone Planet, There's No Toilet Paper on the Road Less Traveled, Thong Also Rises, What Color is your Jockstrap?, Whose Panties Are These?, World is a Kitchen, Writing Away

Travel Literature
The Best Travel Writing, Deer Hunting in Paris, Ghost Dance in Berlin, Shopping for Buddhas, Kin to the Wind, Coast to Coast, Fire Never Dies, Kite Strings of the Southern Cross, Last Trout in Venice, One Year Off, Rivers Ran East, Royal Road to Romance, A Sense of Place, Storm, Sword of Heaven, Take Me With You, Trader Horn, Way of the Wanderer, The Way of Wanderlust, Unbeaten Tracks in Japan

WINGS

GIFTS OF ART, LIFE, AND TRAVEL IN FRANCE

ERIN BYRNE

TRAVELERS' TALES,
AN IMPRINT OF SOLAS HOUSE, INC.
PALO ALTO

Travelers' Tales and Solas House are trademarks of Solas House, Inc.
2320 Bowdoin Street, Palo Alto, California 94306. www.travelerstales.com

Art Direction: Kimberley Nelson Coombs
Cover Image: Winged Victory of Samothrace © Fotolia
Author Photograph: Lone Mørch
Illustrations: Anna Elkins
Page Layout: Howie Severson, using fonts Centaur and California Titling
Production Director: Susan Brady

Library of Congress Cataloging-in-Publication Data

Names: Byrne, Erin, 1959-
Title: Wings : gifts of art, life, and travel in France / by Erin Byrne.
Description: First edition. | Palo Alto : Travelers' Tales, an imprint of
 Solas House, Inc., 2016.
Identifiers: LCCN 2015041533 (print) | LCCN 2015047606 (ebook) |
ISBN 9781609521134 (paperback) | ISBN 9781609521141 (ebook)
Subjects: LCSH: France--Description and travel. | Byrne, Erin,
 1959---Travel--France. | France--Social life and customs. | Art,
 French--Psychological aspects. | Travel--Psychological aspects. |
 Self-actualization (Psychology) | BISAC: TRAVEL / Essays & Travelogues.
Classification: LCC DC29.3 .B97 2016 (print) | LCC DC29.3 (ebook) |
DDC
 914.404/8412--dc23
LC record available at http://lccn.loc.gov/2015041533

First Edition
10 9 8 7 6 5 4 3 2 1
Printed in the United States of America

*In memory of my sister, Allison
who flutters her angel's wings.
Listen.*

If what you are following, however, is your own true adventure, if it is something appropriate to your deep spiritual need or readiness, then magical guides will appear to help you. If you say, 'Everyone's going on this trip this year, and I'm going too,' then no guides will appear.

Your adventure has to be coming right out of your own interior. If you are ready for it, then doors will open where there were no doors before, and where there would not be doors for anyone else. And you must have courage. It's the call to adventure, which means there is no security, no rules.

—Joseph Campbell, *A Joseph Campbell Companion: Reflections on the Art of Living*

Everybody knows that when it is noon in the United States the sun is setting over France. If you could fly to France in one minute, you could go straight into the sunset, right from noon. Unfortunately, France is too far away for that. But on your tiny planet, my little prince, all you need do is move your chair a few steps. You can see the day end and the twilight falling whenever you like . . .

—Antoine de Saint-Exupéry, *The Little Prince*

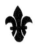

Table of Contents

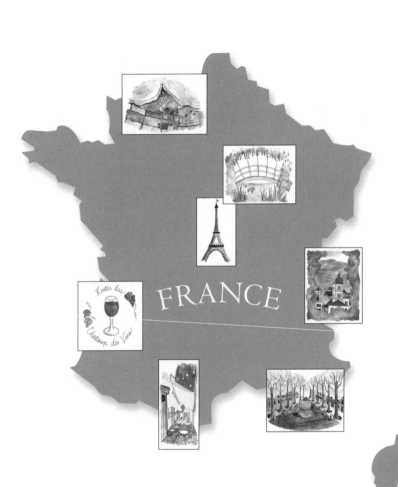

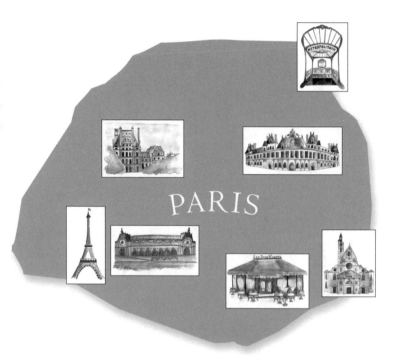

PARIS

KEY
clockwise from upper left

❖ Musée du Louvre
❖ Montmartre
❖ Hôtel de Ville
❖ Saint Étienne du Mont
❖ Les Deux Magots
❖ Musée d'Orsay
❖ Tour Eiffel

Introduction

*Challenging the meaning of life is the truest
expression of the state of being human.*

—Viktor Frankl

IT IS EARLY MORNING INSIDE A CAFÉ on rue des Canettes, a tiny side street on the left bank of Paris near the cathedral of Saint Sulpice. From the kitchen comes the sounds of the place being coaxed to wakefulness: the hollow clatter of spoon on saucer, the solid clump of cup on counter, a knife plunging through a crusty baguette then cracking down on a wooden block.

You are alone in the room, ensconced in a golden brown embrace. The scent of coffee nudges your blood to thrum, and you sense that something in this place is here just for you. Drowsy sunlight yawns through lace-curtained windows and gleams a soft honey onto one of the tables.

Upon the table is a box wrapped in glossy fuchsia paper with a raised spiral design that catches the light, and a shiny white ribbon gathered from all sides that meets in a scalloped bow in the middle. The box is full but not bulging, its edges folded tight enough to tempt.

The stories in this book—written over the past decade as I have traveled to France several times a year for stays of three to ten weeks—are not meant to amuse or entertain, but to call forth responses. This is how literature has worked its magic with me: I read Julian Green's essay about the tiny church of Saint Julien le Pauvre, and when I stepped inside the ancient church, Green's image of Dante kneeling on straw listening to his lessons swirled with my own misty mood. Lines from the poem "Autumn" by Charles Baudelaire, read on a leaf-spangled day in the Luxembourg gardens, reminded me that my own *summer's stunning afternoons will be gone*, plunging me *into cold shadows. It was summer yesterday; now it's autumn*, I knew, and echoes of departures from my own life—my sons going off to college, my sister dying—resounded in the air.

I share with you the hungers I felt inside a Parisian café, so that perhaps you may feel pangs of your own. I pass along secrets told to me by the late French photographer Henri Cartier-Bresson, Vincent van Gogh, and the patron saint of Paris, Geneviève, wondering what they have to say to you. I write about images and scenes that caused me to feel the sensation described by the French word *chantepleure*—to sing and cry at the same time—in the hope that you will recognize a singing sob rising from your own depths.

I hope to inspire you to ask yourself questions about your own travels to the Andes or the Appalachians, the Alps or the Atlas Mountains.

These are stories of the gifts I've received from France, music from the métro stations and the streets, compassion from a

woman in Normandy, wisdom from my friends Jean-Bernard and Michèle, and wings from the statue Victory[1] in Musée du Louvre.

I was drawn to this country and returned again and again, beckoned by unlikely guides who escorted me back in time through revolutions, wars, reigns, and riots; down medieval staircases; deep into wild forests; up onto parapets with panoramic views; and around and around in concentric circles, coming closer and closer to the X on the map. I'm no expert traveler, just a person who set out thinking she had it all together, only to find pieces of her fragmented self scattered all over France. The surprise was that each time I returned home, I felt reconfigured. This is the adventure of travel: We see, we feel, we perceive. Receptors reach out from our depths toward what we need, and we have the potential to integrate into ourselves the transformative treasures of the world.

Just as Julian Green and Charles Baudelaire's meanings merged into my own, so, I hope, will a morsel of Franche-Compté cheese or a sip of Côtes du Rhone taste different to you than it did to me. My view of Notre Dame at midnight invites your unique response. The story of a young boy in occupied Paris about which I helped create a film may spark new sentiments in you. My experiences differ from yours, as you smell the smoke of faraway fires and hear words of foreign tongues roll off your own, but we connect in our search for meaning.

The café hums into action. You hear shoes slap the wooden floor, a waterfall of conversation and laughter, *"Bonjour! Ça va bien?"* and the clinking of glasses and dishes. Your arm is brushed by a rush of warm air, bumped by another arm, caressed by a shiver of anticipation.

[1] Winged Victory has always been more to me than a work of art, thus her name is not italicized.

Look closer. On top of the sparkling fuchsia paper is a cream-colored tag with your name written in swirling black calligraphy. Inside the glittering box on the table are the stories of *your* life, images and scenes and people from your travels and times that these stories can somehow mingle with. I hope they resonate with you, call up echoes of your own tales, tempt you to travel, and tap into your dreams.

Grasp a corner of the smooth white ribbon.

Les Deux Garçons

Nothing can be compared to the new life that the discovery of another country provides for a thoughtful person. Although I am still the same I believe to have changed to the bones.

—JOHANN WOLFGANG VON GOETHE

AT THE TIME OF THESE STORIES, my son Brendan and his friend Corbin were seventeen years old and visiting France for the first time.

Prior to the trip, I did some research on traveling with teens. *The New York Times* offered "Options for Taking the Sullen Set Along," as if the two were somehow disabled. As a mom of two teenage boys, I had noticed that awkwardness led to grouchiness faster in teens than it did for the rest of us, but my boys usually didn't remain sullen for long.

On the other end of the spectrum, Travelforteens.com's claim that "Teens have a wonderful window for growth and transformation into citizens of the world" struck a chord with me, but seemed to overlook the times they slip-race around a corner and mud splatters the window, obstructing the view. One must be ready to hand them a cloth at such moments.

The Travel Channel reminded me that if the teens are happy, everybody is happy, but I feared if we handed Brendan and Corbin the reins to our moods, we'd be glum half the time and giddy the other.

I knew in Europe teens traveled regularly, both alone and with their families, without anyone bending over backwards to avoid "attitude with an A, silence, and mono-syllabic conversations." I felt the boys could handle a more challenging trip than family camp or a dude ranch, so we went to Paris and Normandy.

In order to ensure that the two boys could ride the rapids we all face when we travel, I decided to think of them as travelers first and teens second. My friend, writer Marcia DeSanctis, author of *100 Places in France Every Woman Should Go* and mother of two teens, narrowed it down to four tips: "Feed them well. Keep them moving. Get them to bed early. Let them explore on their own a bit. Teenage boys are great companions on the road and the truth is, they keep you laughing. They help you take it in."

The story "Two Boys in a Bistro" shows Brendan and Corbin hitting a few travel-bumps ramming some rocks, and finding their own way to right their rafts.

Once they acclimated, I wished only to whisk the blindfold off so they could see the magic. When we travel to a place we love with people we love, we want to show them, to introduce them, to usher them along, but it doesn't always work out as we imagine. Part of the reason I loved France so much was that I had discovered my own little lanes and hidden parks, sought out my own alcoves and corners and niches, and found my own adored works of art. Brendan and Corbin were not patrons of the arts, but a painting inside Musée d'Orsay caused them to develop their powers of perception in the story, "Day Dreamer."

Then we traveled to Normandy, a place where history refuses to stay stopped up in a bottle. Like a genie, it taps us on the shoulder and shouts that the Second World War existed in brutal, bleeding reality—on the beaches, in the countryside, in the villages. This very moment, upon the grass in the American Cemetery there, the white carpet of almost 10,000 crosses screams in silence.

"Coasting Beyond Boyhood" shows the two travelers-who-happened-to-be-teenagers coming to a pivotal point, where, at Pointe du Hoc, a plain high above the Normandy beaches, Corbin and Brendan were changed to the bones.

Two Boys in a Bistro

Little by little, one travels far.

—J.R.R. Tolkien

TWO LANKY SEVENTEEN-YEAR-OLD BOYS unfolded out of the taxi, stood, stretched, and looked around, blinking in the sun, wearing the dizzy gaze that comes only after spinning day into night back into day, crammed in a claustrophobic seat high above land and sea. Their eyes shone with identical glints, as though the taxi had just fulfilled every terrifying car chase fantasy they'd ever had, zooming down boulevards and darting under the Arc.

Brendan and Corbin stared at the creamy stone buildings with balconies spilling red geraniums, as people clicked past them on the sidewalk. They grappled with the tangled straps of their bags and shuffled their feet. I could tell in an instant, from my vantage point above, that they were off-kilter.

That old equilibrium-destroyer, travel, does it every time.

Image: Bistrot d'Henri, 16 rue Princesse

The teen boy, as a rule, controls his demeanor with a tenacious grip. He takes pains to avoid any situation that makes him feel stupid or awkward. Nonchalance is his aim, cool his game. Only his eyes reveal his inner state.

From my perch on our balcony, I saw lightning bolt eyebrows above wary eyes.

An apartment on rue Berryer was our home for the week. My husband, John, and I had arrived several days earlier; Brendan and Cory had journeyed on their own. When they heard my familiar voice (Brendan's mom, *c'est moi*) and looked up, relief flashed across their faces.

They clamored up the stairs and swooped in with their duffle bags bouncing on their broad shoulders, juggling good-natured comments like brightly colored balls.

How swiftly equilibrium was restored at first.

"*Bonjour, Bonjour, Bienvenue à Paris!*" I circled my hand to indicate I expected a response *en Français*. We'd rehearsed this; I waited.

"*Bonjour,*" they droned together, shifting uncomfortably on this shaky linguistic ground.

Requests for naps denied, we set off toward the Champs Élysées in the early summer evening. Smooth, rolling French, sharpish German, staccato Italian, and dozens of other indecipherable tongues tinged the air. We had traveled to other international cities where English had always been an undercurrent, and here it was not.

"These people sound crazy," Brendan growled. "I'm on the lookout for fellow Americans."

Corbin bobbed along behind, his mouth a straight line, his eyes never leaving Brendan's back.

This wasn't the way I'd envisioned them embracing the new.

After a few moments of crowd-jostling vertigo, their head swiveled. *Les filles sont très jolies.* The *bonjours* that had choked them minutes

ago were now boldly accompanied by a little eyebrow wiggle, for lost balance can be recovered with a little surge of testosterone.

We scooted up to a tiny table at a sidewalk café, and I reminded them to order in French, say *s'il vous plaît* and *merci*, articulate clearly, and pay in euros.

The waiter greeted us smoothly and called them *Messieurs*. This stunning show of deference caused Brendan's jaw to drop, and Corbin gaped. No one had ever called either of them Sir. They sat up straighter, caught each other's eye, and exchanged chin lifts. The waiter waited, his pen poised. As I ordered, I saw out of the corner of my eye that they were both slumped behind their menus, balking at the prospect of ordering.

After I tapped Corbin's arm, he blushed and puckered as if he'd been squirted with vinegar: a look that would become all too familiar in days to come.

"Boof Boor-gayn-yone, See voo play, Mon-sher?"

"Good job on the *S'il vous plaît*, Corbin," I whispered.

Brendan glowered and with his mouth barely moving uttered one word: "Steak." He was willing to risk my wrath to hold onto his bravado. French cuisine, however worked its magic, and later, after only a minute of prodding, replenished by red meat (and red wine), he haltingly said *merci* (gurgling a rolled 'r') and offered to sift through the euros.

I could see I would need to expend an effort to keep them afloat; it would be like dealing with a couple of toddlers.

The next day they climbed the Eiffel Tower on foot (*à pied*). Brendan, stricken with vertigo at the slightly swaying top, aban-

doned Corbin to scramble down the metal stairs. After wandering through Musée d'Orsay admiring the art and the girls, they topped off lunch with three *pâtisseries* each, which steadied their moods. They traipsed through

Les Invalides war museum, where they caressed cannons in fascination, but frowned at the placards. I handed Brendan the French dictionary. We meandered through dozens of narrow alleys where Corbin lurched and tripped on the cobblestones. Both of them were dumbfounded at time told by the twenty-four hour clock: "Nineteen o'clock—what the…?" In the Luxembourg gardens they spread out the map in confusion, turning it this way and that, disoriented.

At another sidewalk café, Brendan tried to order Dr Pepper and engaged in a duel with a waiter:

"*Coca Cola?*"

"Dr Pepper."

"*Quel médicin? Le docteur?*"

Brendan's eyes flashed menacingly. On our way back across the city to rue Berryer, at the métro station, Corbin fumbled in his pocket and sent his ticket flying over the barrier. Today, nap requests were granted, for we would be dining late at a bistro.

At twenty-one o'clock, again we crossed Pont Alexandre, the bridge facing the gold dome of the Invalides, recalling new words we'd learned earlier that day— *guerre, Résistance, engagées*—Charles de Gaulle's heroism, and the size of Napoleon's tomb. A bistro, I informed my *garçons*, was a small restaurant, often owned by a family and patronized by regulars. Small bar, small tables, simple food—Parisian to the core. I kept to myself the detail that English would likely be absent.

We ambled down rue Guisarde, a tiny street lined with bistros, their windows glowing golden, and turned on rue Princesse. The dark, rich smell of butter, herbs, and roasting meat, *la cuisine grand-mère*, reached out and pulled us into Bistrot d'Henri.

Inside, all three of us inhaled; our nostrils blossomed and ribs expanded. To our left was a rack of coats which softly brushed against us as we ventured in. The walls were red and covered with posters, mirrors, and paintings; against one leaned an antique carousal horse, black with shiny copper trim, whose open mouth made him appear to be joining the conversations which buzzed pleasantly at each table. Burnished woodwork had the look of the Velveteen Rabbit, used and loved.

We could tell at once we were the only people from outside the neighborhood (and the country) by the way everyone paused for a split second, noted us out of the corners of their eyes, then continued talking. Six small tables lining the wall were each separated by a five-inch space. Brendan and Corbin, usually agile on a basketball court, attracted the attention of *tout le monde* in their embarrassed effort to squeeze into the corner. The tables wobbled and clonked as Corbin's thighs wedged between them. He sat down with a thud, leaned his head against the wall, closed his eyes, and assumed his vinegar mouth grimace. Brendan eyed the chalkboard of unreadable French words with a vicious sneer.

The waiter arrived and I drew in a deep breath, preparing myself to provide the counter-balance. Then I heard a voice in my ear.

"*Je voudrais un verre de vin rouge, s'il vous plaît, Monsieur,*" Brendan said. Corbin smiled at the waiter. "*Bonsoir, Monsieur. Comment allez-vous?*"

The prospect of comfort food, it seemed, transcended language.

No longer flailing to stay afloat, they drifted along with the current and were able to enjoy the ride. We listened to the regulars launch into long discussions with the waiter, translating enough to know they were analyzing the preparation of each dish: Had the scallops been sautéed in butter and garlic? When

had the asparagus been picked? What was the origin of the name of the dessert *Paris Brest*?

When plates arrived at the tables, a jaunty lilt could be clearly heard, for the bistro is a place where food lifts all moods, and our corner table was caught up in the intimacy.

Brendan and Corbin's composure lasted late into the night. Later when they offended a taxi driver by getting into his *voiture* with ice cream cones, Brendan immediately apologized, "*Pardon, Monsieur!*" Corbin waggled his brows and agreed, "*Oui, oui, Monsieur. Pardon.*" The driver laughed. They climbed out of the backseat, tossed the cones into the nearest *garbage*, and hopped back in.

After this, whenever they tripped, stumbled, and fell face first, they knew they'd be able to pick themselves up off the cobblestones. In this way, a traveler is tried and seasoned: It is not that we develop grace or do not flounder, but that we expect the ride to be rough.

Corbin still fumbled at the métro, but his fellow traveler had an extra ticket ready. They attempted such pronunciations as *bateaux* and *Bastille*. Brendan forgot about his search for Americans and began guessing where people came from by their clothes or language. They ordered *canard* (duck) and *huîtres* (oysters) with ease, asked and answered each other the time of day, and did not even miss *Docteur* Pepper.

～

Day Dreamer

*Those who dream by night in the dusty recesses of their
minds wake in the day to find that it was vanity: but
the dreamers of the day are dangerous men, for they may
act their dream with open eyes, to make it possible.*

—T.E. Lawrence, *Seven Pillars of Wisdom*

CORBIN LOOKED AS THOUGH HE HAD left his head in the clouds
as he stumped down the stairs of the Eiffel Tower. From the
Champs des Mars below, I kept my eye on his blond head, bob-
bing above the others in his fast-growing teenage body.

"You should never have left him up there, Brendan, how will
we find him in this mob?" I hissed. "I don't care if you got ver-
tigo. Get up there and grab him before he's completely lost!"

We were already an hour late to meet my friend at Musée
d'Orsay, where she and I would visit Georges Seurat's Pointillist
paintings—in peace, I hoped. By the time we retrieved Corbin,
walked along the Seine, rode on the métro, waited in line and
arrived inside the museum, my lofty aim to turn these two into
art aficionados had shrunk to a disappearing dot.

"Here." I scribbled a list, remembering how they'd always loved treasure hunts. "Find these in the museum. I'll meet you here in the lobby in one hour." They were getting hungry; that was all the time I'd have.

The List:

1. Statue of woman's head, cut off at the neck

2. Painting of guys playing cards

3. Statue of girl in tutu with real tulle, hair, ballet slippers

4. Painting of empty church, blue inside

5. Find the Louvre across the river (*surely they could?*)

6. Painting of people dancing outside

7. Black-and-white photograph by Degas

8. Painting of snow

9. Opéra Garnier model

10. Big clock

"What if we can't find all this stuff?"
"One hour."
"What's a tutu?"

The artist was obsessed with the weather. In 1885, he was chasing clouds in Étretat, France, engulfed by a surging desire to capture the sea on canvas. One day, he was on the beach at his easel, and as mist rose off cresting waves in droplets of white foam and caught the sunlight, he painted in a fevered froth. When the moment passed, he saw that he had done it: He had caught the sea. But, he noted with despair, he now needed the matching sky, and dusk was falling. He returned the next day and, absorbed, did not hear the increasing thunder of the waves.

I didn't see a huge wave coming, it threw me against the cliff and I was tossed about in its wake along with all my materials! My immediate thought was that I was done for, as the water dragged me down, but in the end I managed to clamber out on all fours, but Lord, what a state I was in!

Oscar was soaked. His palette had splattered his beard with blue, yellow, and green. His painting was *torn to shreds by the sea, that 'old hag'* . . .

He needed identical conditions to appear and remain long enough to complete the painting. If only he could suspend time so that a shadow lingered before skittering off, the light brightened a fraction and held, and the clouds stopped.

Oscar cursed, slashed his paintings, and became *terrified of light.*

I'm very unhappy, really miserable and I haven't the heart to do anything, the painter in me is dead, a sick mind is all that remains of me. . .

Before our trip, in my quest to interest these two teens in art, I'd left heavy tomes, *Art Through the Ages, Treasures of the Louvre, Musée d'Orsay* lying on top of *Sports Illustrateds* around the house, but they served as mere paperweights. I wished just once someone would pick one up and thumb through it.

During our week in Paris, I'd dropped tidbits about the Impressionists.

"Cézanne was the grouchiest, kind of like you, Brendan, last night when you were trying to pronounce *boeuf bourguignon*. He was from a place called Aix."

"Van Gogh slashed his own ear. Could have been too much absinthe, or epilepsy. No one knows for sure."

Image: Honoré de Balzac statue, Avenue de Friedland

"This statue by Rodin is of a famous writer—Balzac."

They both emitted choking hacks.

"What's so funny?"

"Balls - sack?"

I shared my wisdom: This artist was wealthy, that one went by his middle name for years, another strapped paintbrushes to his arthritic hands. Brendan and Corbin's eyes became hooded, they puffed out their cheeks, stifling yawns.

Still, I stopped them at Rodin's statues, smiling at their snickers, pointed out artists' studios, and planned a trip to Giverny. I knew they'd like that pond.

After our trip to Musée d'Orsay, we had lunch in a café.

"What did you like?" I asked, flushed with hope. Perhaps they'd spotted *Impression, Sunrise*, the painting that had defined the movement.

"Nothin'."

"Back in the day, the critics didn't like those works either, they rejected them for the big Paris art salon, so the artists got together and had their own and called it '*Salon des Refusés.*'"

"There was this one painting," said Corbin. "It was of a fence in the snow, and there was something really cool about the air."

"Yeah," said Brendan, and I could tell this was the first time they'd discussed this. "That was wild, like I felt the air."

In the early years, the artist's obsession had been survival. He and his wife and son had moved from place to place, creditors in pursuit, and often went hungry. He penned a constant stream of letters:

Please, I beg of you, send me a bigger sum tomorrow without fail.

I am utterly without hope, and see everything at its blackest and worst.

For a month now I have been unable to paint because I lack colors, but that is not important. Right now it is the sight of my wife's life in jeopardy that terrifies me . . .

His wife had another baby, their desperation continued, and she died.

We lingered over dessert.
"What else did you see?"
Brendan and Corbin smiled at each other and nodded.
"I was gonna talk to her, but she looked Czechoslovakian."
"Like Maria Sharapova with green eyes."
Their goal was to exchange sightings and *Bonjours* with girls from as many countries as possible, a bevy of gesturing Italians, willowy French girls, tall Swedish beauties.
Perhaps it had been vanity for me to think I could lure them into appreciating art.

The artist's lasting obsession seemed impossible. His work began to sell, and he married a woman with six children. They lived in the country, where he could finally paint in peace, *en plein air*, out of doors, with a lasting paint supply.
He squinted at red poppies and let their round edges ravish his canvas as they had his eye. In quest of *the luminous envelope surrounding the model,* he placed one of his stepdaughters at the top of a hill holding a parasol. Every whoosh and wafting breeze appeared in her white dress as clouds spun past. He caught the golden Thames flashing at sunset, gondolas shimmering in Venice, a small red house in Norway.

It's only now I see what needs to be done and how.

His dream was far-reaching. He'd articulated it once and knew people thought him a bit mad.

He was driven, regardless.

Then his eyesight began to go.

Six months later, I remembered the single painting that had attracted Corbin and Brendan.

"Yeah, I remember, the painting of the snow, that one that showed the air."

Corbin drew a picture: a fence with a ladder on the left and a bird on top, a house on the right with trees in front.

Brendan's drawing was identical.

"Yep, the painting of the air." He caught Corbin's eye. "But it wasn't the most beautiful thing we saw that day, was it? Green eyes."

I blew the dust off my *Musée d'Orsay* book, finding Sisley and Pissarro, Impressionists who had often painted snowy scenes. I interrupted the boys' viewing of a college basketball game on TV.

"Is it this one?"

"No."

The halftime buzzer rang.

"This?"

"No."

"Let's find it," said Corbin. He grabbed the book and Brendan hauled himself out of the recliner to flop onto the couch. Heads together, they lingered on images of ships sailing on green-blue squiggly seas, apples leaning against blue china pitchers, pillowy nudes in patches of sun.

"Here it is!"

The Magpie. A rare painting of snow, completed the year his rejection at the Salon had caused him to conclude, *I can no longer claim to cope.*

I knew that the artist had achieved his goal.

WINGS

I am chasing a dream, I want the unattainable. Other artists paint a bridge, a house, a boat, and that's the end. They've finished. I want to paint the air which surrounds the bridge, the house, the boat: the beauty of the air in which these objects are located, and that is nothing short of impossible.

—Claude Oscar Monet

Coasting Beyond Boyhood

We need in love to practice only this: letting each other go.
For holding on comes easily—we do not need to learn it.

—Rainer Maria Rilke

YEARS AGO, BRENDAN'S FIVE-YEAR-OLD BODY sat poised upon a
bicycle seat, with my hand on the leather curve of the back of
it. The scenario had been repeated many times over past weeks:
Ready, slow push, bike and boy waver on the soft, uneven grass,
tip, thud. Begin again. The day Brendan rolled with ease across
little dips in the green, he was steady and it was I who felt wobbly.
He had coasted beyond my reach.

When we take our children out into the world, there is a risk
that forces may be unleashed. Forces of history, mankind, and
the world can cause something to shift inside a child, and they
drift in unforeseen directions.

When Brendan was eleven years old, inside the dungeon of
Warwick castle in England, cold crept across his shoulders as he

Image: Musée de l'Armée, Invalides, 129 rue de Grenelle

heard details of how The Rack worked on the human body. Feet fastened to one roller, wrists chained to the other, after a few cranks, cartilage, ligaments and bones snapped, then popped, and limbs were permanently separated from body. The real Rack inspired in Brendan kinder treatment of his friends and his brother—though he still gave them the occasional smack, he never again yanked their arms or legs in that horrifying way boys do. He was also much gentler with our old black Labrador, Checkers.

Brendan visited the hallowed ground of Saint Andrew's Golf Course in Scotland and acquired a meticulous observation of the rules and courtesies of the game. After that trip, anyone who dragged a golf bag across the green faced his wrath. He fly-fished on the River Nore in the land of his Irish ancestors. When he returned home, he looked in the mirror with new admiration for his own fair skin and reddish-blond hair. He dedicated himself to perfecting his inborn flair for fly-casting, and flew the Irish flag proudly. In Paris, he swaggered down the Champs Élysées with a new sense of *savoir-faire*, which he later flaunted for girls at summer camp.

Before he visited Pointe du Hoc, a desolate plain high above the northern coast of France, Brendan had soaked up what life had to offer with little thought of what he would give back to the world. After this trip, his concept of sacrifice included himself: He pulled his truck over to the side of the road whenever he saw anyone standing helpless, volunteered to help counsel middle school kids, and made plans to become a firefighter in nearby mountains.

Childhood is the kingdom where nobody dies.

—Edna St. Vincent Millay

Brendan and Corbin, two hot-blooded, flag flyin' Americans, were prepared for this trip to Normandy. For years, Corbin's grandfather had told stories of his landing at Utah Beach. Brendan had aced U.S. History his sophomore year, immersing himself in the story of D-Day. I decided to follow these two and observe—a new, more detached role for me.

The week before going to Normandy, we visited the World War II Rooms at Les Invalides Musée de l'Armée in Paris. Brendan and Corbin's spirits were lighthearted as they meandered through displays of uniforms, scoured strategic maps, and stared at photos of Hitler swinging his arms under the Eiffel Tower. They posed pointing toward the camera next to the Uncle Sam poster, and pretended to fire weapons; the sound "*ch-ch-ch-ch*" automatically flew out of their mouths, evoking boyhood war games conducted high up in a tree.

These two comrades had fought many an imaginary war side-by-side. When they were kids in our woodsy backyard, main headquarters had been their handmade tree fort. Getting up without using the ladder was the first challenge: they hoisted, heave-hoed, hollered, and hung on by their fingertips.

"Hurry, hurry!" they would shout, looking over their bony little shoulders at pretend soldiers falling into the chasm below. They'd toss down ropes, under heavy fire from snipers the whole time. Once up, they'd be trapped for boy-hours (weeks, years, decades).

Reinforcements always came to the rescue just in time. Brendan and Corbin were the good guys, and the enemy was a murky, faceless threat. Sweet is war to those who have never experienced it, as the Latin proverb says.

Once, I climbed the ladder for a safety check. Rusty nails, boards dangling by threads, and an exposed edge high enough for an arm-breaking fall caused me to rush back down. That fort was no place for a mom, so I watched from the kitchen window as I removed emergency rations from the cookie sheet.

Some risks are better left unconsidered.

After their moment of nostalgia for the tree fort wars, Brendan and Cory sauntered through Musée de l'Armée. When one would pause and squint, frowning at some display, the other would poke him in the ribs, and the mood would bounce back up like a cork in the water. Such is the buoyancy of teenage boys.

In a dark alcove of the museum, silent scenes flashed upon the wall—the scene of the D-Day Normandy landings flickered jerkily in black and white. Boats in shaky shades of gray spilled over with boys not much older than Brendan and Corbin, their bodies tense and alert, eyes scanning the beach. Soldiers staggered, crawled and clawed through wet sand; some collapsed, twitching, after only a few steps. Several men ran across the chaos and began climbing directly up the side of a cliff. A steady stream of images: soldiers running up on dry land, barbed wire, guns, camouflage, helmets, faces of naked fear.

Brendan and Cory sat fixated, their mouths tightly closed. I stood apart, feeling distant. As I looked at them sitting speechless on the bench, I saw an image of one hoisting the other up into the tree fort just in the nick of time. The images of young soldiers doing this on the Normandy beach gave me a stab of dread at the prospect of taking Brendan and Corbin to the place where it had all happened. I knew it would stun them.

Courage is fear holding on a minute longer.

—General George S. Patton

Two days later on our way from Paris to Normandy, the boys nudged each other in the back seat of the car, traded iPods, bent their heads together viewing the many photos they'd taken of themselves, and guffawed at each other's jokes.

Brendan said in a solemn voice, "We'd all be speaking German now if it wasn't for the Allies, and our American boys." The next moment he gibberished in fake German. Cory alluded, with furrowed brow, to his grandfather's tales of heroism,

but a second later doubled his chin comically, imitating his grandpa.

Brendan arrived at Pointe du Hoc unknowingly ready for the history of the place to move him. He'd been in the same state that day he had pedaled ahead on the grass. As he had rolled ahead, bobbing up and down, I had looked at my skinny son in a baggy black t-shirt and jeans, his blond hair sticking out underneath his bike helmet, catching the sun and glistening, and felt I was really *seeing* him. As he glided away towards independence, he looked different to me.

Soon, his bike was an appendage of his body, handled with ease. Brendan and Cory would speed across the grass on their bikes, squeal to a stop, drop to their stomachs and crawl into a hideout carved out of blackberry bushes. The best thing about the 'stickly fort' was its ability to keep out the enemy and/or parents: No adult could squeeze into the four-by-four foot warren. Often blood was shed getting in and out on hands and knees, with sharp-thorned branches smacking at little boy bodies, so I, the medic, kept a ready stock of Band-Aids.

Yes, Brendan and Cory had hunkered down in many a foxhole right in their own backyard, and their bodies still had the scars to prove it.

Pointe du Hoc is a plain high above Omaha and Utah beaches. Back in 1944, the D-Day mission for the U.S. 2nd Ranger Battalion was to land at the foot of the cliffs, scale the 40-meter-high

vertical face using ropes, ladders, and grapples under enemy fire, then surprise the Germans at the top in order to capture the battery and wipe out the big guns at Pointe du Hoc.

The Rangers landed off-target forty minutes late, and ran down the beach to the cliff.

The Germans (who had already moved the weapons) had time to recover from heavy Allied air bombardments, climb out of their dugouts, and man their positions. The Rangers began to climb, but only one of the ladders that they tossed up had made it, and the ropes were soggy.

The Germans cut the ropes, rolled hand grenades off the cliff edge, and leaned over and fired down on the Americans.

Those who made it to the top fought, and crawled across the plain. Private Robert Fruling later said he spent two and a half days at Pointe du Hoc, all of it crawling on his stomach. He returned on the twenty-fifth anniversary of D-Day, "to see what the place looked like standing up."

On the Normandy plain that day in June of 1944, headquarters were hastily set up on a concrete battery overlooking the beach where wave upon wave of men were essentially being massacred.

Sgt. Frank South, a nineteen-year-old medic, remembered, "The wounded [were] coming in at a rapid rate, we could only keep them on litters stacked up pretty closely. It was just an endless, endless process. Periodically I would go out and bring in a wounded man from the field, leading one back and ducking through the various shell craters. At one time, I went out to get someone and was carrying him back on my shoulders when he was hit by several other bullets and killed."

Under machine gun fire from all sides, with dwindling ammunition and no rations, the 2nd Battalion waited for reinforcements: Company A of the 116th Regiment.

Company A of the 116th Regiment had been wiped out at the beach.

The Rangers lost 135 men out of 225. The remaining 90 ventured inland, then found and destroyed well-camouflaged guns hidden nearby, ready to fire in the direction of Utah beach, with piles of ammunition around them and Germans in an open field 100 meters off. After accomplishing their mission, the soldiers held out two days longer, hiding in the bunkers.

When we arrived at Pointe du Hoc, Brendan and Corbin stood for a moment on the concrete battery looking over the beaches. Brendan's squinted and his mouth clamped shut, pushing his profile up into a grimace, his cheekbones high and angled. I was snapping photos, and through the camera lens it appeared as if he heard every sniper's footsteps, saw in his mind's eye the bullets puncturing the skin of falling soldiers. His expression seemed to contain every particle of fear that had been there on June 6, 1944.

I remembered the green plastic army guys I used to find scattered around our house, 1½ inches high, halted in a variety of poses: leaning forward with arms out, firing a gun, hand by the mouth hollering to comrades, crouching, crawling on their stiff green stomachs. I would find them after they had climbed the cliff (wall), sometimes hanging from ropes (shoelaces) and finally reached the battlefield (windowsill). Up on this Normandy plain I imagined I saw them come alive, crawling, crouching, shouting, firing. When one of them ran past me, the face underneath the helmet had narrowed eyes and sharp cheekbones.

I imagined the 135 mothers of the boys who had died there. I wondered if, when one had received word of her son's death, her mind had flashed back to the days when her boy had played at war. I wondered if any of those mothers had *known*, even before she was officially informed, that her son had coasted away from her forever. I envisioned a mother coming here afterward, staggering around on the grassy knolls or venturing down into a bunker.

Pointe du Hoc has been left undisturbed, except for fencing and footpaths, which Corbin and Brendan naturally did not keep to. They chased each other up and down over craters created by bombs, past blast marks of grenades and bullet-scarred chunks of concrete.

They lumbered down a path buried in overgrown grass, ducked their six-foot high frames under a low entrance and clamored down into the bunker. I followed. The three of us stood, frozen, our eyes adjusting to the dimness.

Down in the cramped space more than six decades after D-Day, the air was eerily silent, as if the spirits of the American boys who fought there still remained. "That's the hole where the gun pointed out," Brendan murmured, as sunlight without warmth shone in from above. "What's that on the wall—is that blood?" Corbin whispered. "They must have . . ." There was indeed a rust-colored stain on the wall, of course it couldn't have remained from that day, but it was odd.

At once, I knew this was not the place for me; I rushed out and up the stairs.

It seemed to me that Brendan had spent his boyhood preparing for this moment, inside a gray rectangle far from his own backyard, years away from a time when his mind had first played with the notions of war, sacrifice, or the possibility of his own death. History collided with his childhood imaginings and shifted him.

As Brendan ducked under the entrance and emerged, blinking, from the bunker, I *saw* him: a young man with his head held high above a solid body, chin set in firm lines, and eyes adjusting to the light.

As sun lit upon his blond head, Brendan's shadow fell upon the grass.

PART TWO

Characters

You see, you feel, and the surprised eye responds.

—HENRI CARTIER-BRESSON,
PARISIAN PHOTOGRAPHER, 1908–2004

There are moments in far off places when we meet a person or visit a historic site, and time and distance morph, bringing characters of place and past close enough to look us in the eye and touch us with fingers that pulse with life.

Sometimes the touch reverberates through our psyches and spins them into something new.

Writer and sketch artist Candace Rose Rardon once told me about a group of Moken sea gypsies she met while traveling through Thailand.

"They showed me how to live," she said.

The Moken were traditionally nomadic, moving from island to island, but in the years since the 2004 tsunami, the Thai and Burmese governments have required them to settle. Candace stayed with a Moken village at a time when she was looking for ways to integrate her traveling lifestyle with a more conventional life back in the U.S.

"What I found in the way the Moken adapted—continuing to forage for shells along the shore, sleeping in their boats at night—gave me the courage to settle down without settling, to let my love for presence and forward motion guide me through my own evolution."

The characters in this chapter showed me how to live, each in a different way. When you meet a person you somehow feel has always known you, seems able to read you like a book, who senses your sorrows and shares your joys, a bond forms.

What if the person is long dead? Lived in a place you never visited?

People of the past can be present in our lives in unexpected ways. Nearly all religions share the concept of saints or deities, who communicate, assist and intercede. Every day, seekers flock to places like the Buddhist stupa Boudhanath near Kathmandu, or Mecca, or Lourdes to experience this.

Père Lachaise cemetery offers tutoring sessions with Pierre Abelard, piano lessons from Frédéric Chopin or jam sessions with Jim Morrison. Artists can slap paint on a canvas with Ingres, Delacroix, or if they feel particularly bold, dabble in Surrealism with Max Ernst. Writers can trade metaphors with Proust, Wilde and Wright.

There is no predicting which characters of the present or past will intrigue us.

The first time I searched for the legendary Shakespeare and Company Bookstore in Paris, I found rue de la Bûcherie, but saw no towering sign, no second story windows running a block long, which was what I had envisioned. A friend had said, "Go meet George Whitman, he'll invite you for tea." I circled the block; surely this place that had attracted all the most famous writers of the day—where Henry Miller and Allen Ginsberg gathered the beat poets, and modern-day authors like Salman Rushdie read— was spacious and sparkling, with perhaps a modern neon sign. I knew it was near Notre Dame, but saw no sign of it and gave up.

On my next visit, I tried again and finally, my last evening in Paris, was astonished to stumble upon a tiny old façade of green and yellow with Christmas lights haphazardly strung outside. I pushed open the door, a bell tinkled, and I walked into a place that ultimately encompassed my past, present and future in an unexpected way.

George Whitman was sitting in a back alcove clutching a paperback, *The Audacity of Hope*. He indeed invited me to tea and to stay. But more than that, he showed what it looked like to dedicate one's life to doing that which makes us happy, and gave me hope that this was possible.

Normandy is perhaps the region of France that, for Americans, houses the greatest collection of ghosts. After visiting Normandy, my memory persistently pulled me back to

Sainte Mère Église, the village where Simone Renaud, wife of the mayor, lived during World War II. I had written a profile of her and a colleague had asked me why I'd wanted to write about this woman, who'd tended the graves of fallen Americans. I pointed out several reasons that had nothing at all to do with me. He persisted with questions—why, why, why.

"Dear Madame Renaud" is my response.

Why indeed. We are magnetically pulled toward what—or who—we need.

Henri Cartier-Bresson was a name I'd heard often without knowing the slightest detail about his life, until I heard it spoken into my ear at the strangest possible time.

The late French photographer Henri Cartier-Bresson reminded me, perhaps in a way no living person could, how to follow the inviting urge, to meander in concentric circles near Jardin du Luxembourg, to take a startling encounter with the Greek statue, Winged Victory of Samothrace seriously enough to write a book about it, to be attuned to signs and premonitions, to slow down long enough to hear the healing call of an oboe. Every story in this book reflects Henri's influence on me.

Recently, I visited an exhibit of his photographs at Centre du Pompidou. In the brochure, in the characteristically all-en-compassing manner of the French, his work was explained this way:

Henri Cartier-Bresson's photographic work began in the Twenties. It arose from a combination of factors: an artistic predisposition, unre-mitting study, personal ambition, a little spirit of the times, personal aspirations and a great many encounters.

My many encounters with Henri helped me welcome *un peu d'esprit du temps* into my life.

This book is crowded with characters: people of chanced meetings, friends, artists, even statues and a set of ceiling beams. These three, George Whitman, Simone Renaud, and Henri Cartier-Bresson, changed me utterly, leading me to believe that there are no chance meetings, only Decisive Moments when characters both alive and long vanished from the earth reach inside of us.

We feel them, and the surprised soul responds.

The Rarest of Editions

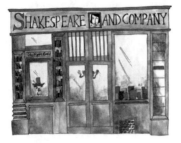

*There is something gorgeous about him, some heightened
sensitivity to the promises of life.*

—F. Scott Fitzgerald, *The Great Gatsby*

IF BOOKS ARE HUMANITY IN PRINT, he's the king of the world.

The old man sits holding his worn paperback. His gnarled
fingers, veins raised under papery skin, caress the cover as if it
were an archaeological treasure he has just unearthed in the des-
erts of Egypt. His thin plaid-flannel-shirted frame hunches on a
low stool, knobby knees sticking up at awkward angles. He sits
majestically in his small but stately palace.

His rheumy eyes rise to contemplate his kingdom: a tiny set
of rooms lit by dusty chandeliers, crammed floor to ceiling with
books. He observes his subjects: an assortment of characters
whose eyes glaze over with the wonder of being among thou-
sands of new, old and rare editions. He savors the sounds of
his domain: pages shuffling, pure-pleasure sighs, the murmur of

Image: Shakespeare and Company Bookstore, 32 rue de la Bûcherie

voices, the clattery squeak of the door as it opens, and the nearby bells of Notre Dame.

He lifts his head with its long strands of silky white hair and inhales the comforting scent of that magical combination of books and people: leather, paper, ink and interest. The promising perfume of historical, imaginary and fantastical lives. The smell that makes one instantly settle in for a good read.

A girl with short dark hair and berry lips sinks down cross-legged against the Poetry shelf. Her black eyes race across the page as she whispers. A graying professor grabs *Ulysses* and curls up to it while standing. A bleary-eyed traveler breathes in the limb-loosening smell of home and dives into *The World Atlas* to plan the next leg of his journey.

The old man smiles, releasing a wreath of leatherish wrinkles and thinks: *A stranger walking the streets of Paris can believe he is entering just another of the bookstores along the left bank of the Seine, but if he finds his way through a labyrinth of alcoves and cubbyholes and climbs a stairway leading to my private residence then he can linger there and enjoy reading the books in my library and looking at the pictures on the walls of my bedroom.*

Such is the welcoming spirit of George Whitman, proprietor of Shakespeare and Company bookstore in Paris.

George spent time in his youth wandering through South America and the generous hospitality of the locals burrowed its way into his soul. When he found himself in Paris at the end of the war, he enrolled at the Sorbonne and began building his legendary book collection inside his hotel room on Boulevard Saint Michel. He invited booklovers to come browse his library of English translations and walk out, beaming, with a literary treasure or two. George's reign of bringing people to books began.

Shakespeare and Company is snuggled inside a little green-painted shop on the rue de la Bûcherie with the Seine so close it nearly runs through it, across from Notre Dame. *When I opened my bookstore in 1951, this area in the heart of Paris was a slum with street*

theatre, mountebanks, junkyards, dingy hotels, wine shops, little laundries, tiny thread and needle shops and grocers, George wrote in his bookstore's brochure-booklet-manifesto. He's always considered himself a modern version of the *frère lampier*, the sixteenth century monk whose job it was to light the lamps outside the building, then a monastery.

For sixty years, George has provided a sanctuary for writers and artists, whom he calls "tumbleweeds." This is the creed of the tumbleweed: *Give what you can and take what you need.* He invites all to stay in his house provided they read a book a day and put in a few hours at the cash register. These young, bright-eyed literary angels float around fingering, adjusting, straightening. They lean against the display table and fervently recommend their favorites. They discuss authors with the air of heirs to the throne. *We wish our guests to enter with the feeling they have inherited a book-lined apartment on the Seine which is all the more delightful because they share it with others.*

George, at ninety-seven years old, is now retired and only descends from his upstairs lair to grab a book, greet a guest, or wave to his minions. His daughter, Sylvia, a young woman in her early thirties, swirls through the shop in a pretty skirt and blond ponytail with the poise of a prima ballerina.

Sylvia orchestrates the constant stream of literary events held outside on the sidewalk under the Parisian blue sky, or in George's own private library upstairs which includes books once held in hands that penned the classics of modern literature—Graham Greene, Jean-Paul Sartre, Simone de Beauvoir and others. Their spirits linger to listen and loosen tongues at the poetry readings and writer's gatherings that bring strangers shoulder-to-shoulder, hip-to-hip, on the benches that line the walls. A trip up the narrow staircase at the back of the store brings the visitor face-to-face with furrowed brows, heads bent over scratching pens, or giggling children squeezed together on the floor eager for a story. An advertisement for a recent event captures the mood that resides in the room atop the rickety stairs:

Tonight Shakespeare and Company launches Bard-sur-Seine. *We're planning to live up to our name by staging readings of the great Bard's plays hosted by* Leslie Dunton-Downer *and* Alan Riding, *authors of The Essential Shakespeare Handbook. The first play in the series will be Twelfth Night.* Please note: all the roles in this session of Bard-sur-Seine have now been filled. As there are only players and no audience in this special production, we ask that only those who have signed up attend.

It is easy to imagine the Bard's ghost as the lone member of the audience, sitting up straight, hose-clad leg crossed, Elizabethan collar sticking out stiffly. George would peek out of his bedroom door and shuffle across the room in his slippers to join him, and they'd laugh themselves into stitches at some private joke.

In this age of eBooks, audio books, downloadable and virtual books, George holds steadfastly and single-heartedly to the rectangular real thing, which are scattered, staggered, and strewn about when they are not picked up, pored over or propped open.

These weathered books contain poetry the literary monarch knows by heart, heroes he has been, women he has loved, villains he has vanquished, and orphans he has rescued from the streets. They have taken him to countries he has dreamed of and lands he has conquered. As Nietzsche observed, books speak out the most hidden and intimate things to those who love them.

On the top shelf, toga-clad Socrates poses a question to bespectacled Sartre. Seneca flourishes his stylus and writes, *The good man possesses a kingdom.* Rumi rubs shoulders with the irreverent Rimbaud as the wine sings in their veins. *Gandhi's Autobiography* sits straight and still upon *A Hundred Years of Solitude.* Miller spoons Nin. Gide, squeezed next to Gibbons, glances across the room and winks at Wilde. Pink paper-backed Nancy Mitford nestles next to Thomas Mann. Balzac and Tom Wolfe, thrown together unexpectedly, exchange ironic eye-rolls. Dumas challenges

Dostoevsky to a duel. Dante burns, Vronsky seduces, Quixote shouts. Gavroche dances in the street.

The action floats out into the city of Paris. Right up the street, Hemingway and Fitzgerald putter in from their rainy, spirit-swilling road trip—the Renault crawls down rue Jacob. Across the river Quasimodo swings from the bells, and one can hear the guillotine clatter and slam as it slices the naked neck of Marie Antoinette. Simone de Beauvoir calmly sips a *café crème* up the hill at Les Deux Magots.

The bookstore's namesake boldly assures his company:

Not marble nor the gilded monuments
Of princes shall outlive this pow'rful rhyme

George Whitman loves books with a pure love—hardback, paperback, shiny-new, well-worn, leather bound, cloth bound. Many of them still hold his salty tears within their bindings. Some he has immersed himself in and then tossed lightly aside, some he has hurled from him with great force. Some he has read again and again. A few he has memorized. This elderly hero is convinced he is living inside a novel. Who can question this?

The most tantalizing books on these shelves are the ones he has never read. They are virgin territory, uncharted seas. Between their covers he may find the key to his heart or instructions on how to release his sword from its stone. They may hold the secret of the fountain of youth and make him live forever.

Henry Miller called Shakespeare and Company a wonderland of books. Allen Ginsberg enjoyed hanging out having tea with George, as have countless others. He has engaged in mind-bending conversations with both the famous *and* the starving writers who are guests in his castle. His brain has been rubbed and polished to a brilliant shine, even as age approaches its edges.

As George sits on his low stool cradling his precious book, a woman approaches and he gallantly offers his leafy hand. His face opens in welcome. George at once apologizes for his disheveled appearance, he says that usually these days he stays upstairs in his pajamas. The two discover they have a friend in common. "Ah, of course I remember, he stayed here!" The timbre of his voice belies his age as he politely inquires, "Are you a writer too?" When she nods, he invites her to stay for as long as she wants. She is more than welcome anytime she's in Paris, anytime at all.

The two discuss the book he's holding and the bond of two bibliophiles is fondly established. They share the anticipation that builds when the cover crinkles open to the first line on the first page. Both have tumbled over the waterfall-plunge into a story and found themselves engulfed in characters. They've traveled to the center of their own souls while buried between pages. Both know the heartbreaking finality of the last line on the very last page and the sinking feeling when the cover is closed. For a long moment, George and the woman stand smiling at each other.

It's clear that George Whitman has fashioned a life for himself that brings together the two things he loves most in all the world, books and people. This combination makes him tick. Old age without loneliness is unusual; George always has a house full of friends. Fragility without weakness is seldom seen; this man is thin and frail, but his presence is noble. He is the rarest of editions, a truly happy human being.

I may disappear leaving behind me no worldly possessions—just a few old socks and love letters, and my windows overlooking Notre Dame for all of you to enjoy. And my little Rag and Bone Shop of the Heart, whose motto is: Be not inhospitable to strangers lest they be angels in disguise. I may disappear, leaving no forwarding address, but for all you know I may still be walking among you on my vagabond journey around the world.

Every evening as George dims the lights, caresses one last book, and glides through his labyrinth as effortlessly as the cats that purr around his ankles, he has lived life to the fullest. He climbs the twisting stairs, bids a polite *Bonsoir* to the tumble-weeds, and then the old monarch lays his wispy-haired head upon the pillow and falls asleep in the lap of legends old.

George Whitman died December 14, 2011 at home in his rooms upstairs at Shakespeare and Company. I spent that fall as guest instructor of the Evening Writing Workshops, working with writers in the next room, George's private library, which he shared with everyone. The atmosphere he cultivated in his little bookshop wove its way into the hearts of writers for nearly 60 years.

In this and many ways, he lives on.

Dear Madame Renaud

Simone Renaud bridged an ocean.

—*Mother of Normandy* film and book

SHE TOOK ON THE GRIEF OF OTHERS. Six decades later, after she had been dead for twenty-two years, she did the same for me.

Madame Simone Renaud was the wife of the mayor of Sainte Mère Église, an obscure village in Normandy, France, the first town to be liberated on D-day. These two excerpts from actual letters to her written by American families, with all their imperfections and raw gratitude, introduce her well:

Harrisburg, Penns., Aug. 2nd. 1945.

Mme. Renaud
c/o May. Renaud
St. Mere Eglise, France.

Dear Madame:

In the issue of Life magazine for Aug. 7th, 1944 it shows a picture of you placing flowers on the grave of Brig. Gen.

Theo. Roosevelt, and we have just received word to-day from the War Department that our son was buried in this cemetery, my wife has kept this issue of the magazine ever since with the hope that she would receive word and somehow or other something seemed to tell her that this was where our boy was buried.

If I am not asking to much and in order to ease the suffering of a heartbroken Mother in this country would it be possible for you to look up the grave that I am listing below and place flowers on same, also if you could let my wife know that you have done this it would help. She is heartbroken over the loss of this boy...

Seattle, Washington. Feb. 4th, 1946

Dear Madame Renaud,

Your sweet letter arrived today. Most gracious lady, you are probably closer to us than any other person in this world, because you are so near physically and spiritually to our son...

On the way to the beaches of Normandy, I visited Sainte Mère Église, and Madame Simone Renaud's story held up a mirror for me. Here is my own letter to her.

Dear Madame Renaud,

Last summer, I visited your hometown, Sainte Mère Église. The sky was infused with a tinge of purple so subtle it was almost imperceptible. I noticed the mannequin of a parachutist snagged on the stone wall of the church, and went inside to see the scarlet and cobalt stained-glass

window showing an American
paratrooper landing at the feet of
the Madonna.

In a dappled prism of sunlight on
stone, I lit a candle for my sister
Allison's soul. My hand trembled as
the yellow flame flared on the wick.
She had died three years before, but grief still sloshed inside
me with the unpredictability of a rogue wave. I swallowed,
feeling my throat block the tide.

Outside the church, a market was set up on the village
square, and I watched people from your country and mine
mingle together, admiring colorful coats, tasting oniony
bites of andouille sausage, and inhaling the sweetness in
bunches of lavender.

I imagined you, sixty-four years earlier, under a sky of the
same startling hue: the mayor's wife, a tall woman whose
blunt features were softened by a string of pearls, walking
purposefully, your youngest son, Maurice, following behind
in his short pants and rumpled coat.

Next I fancied I glimpsed you with freshly cut red flowers in
the crux of your arm, your other hand digging in dark dirt, as
rows of crosses waited in the distance. Grass stains seeped
into your white wool stockings, and your face struggled as
if your heart simultaneously sank and rose to block your
throat.

Taking on the grief of another is not easily done. What made
you do it?

The night of June 5, 1944, you were inside your house on
the village square with your husband, Alexandre, and three

sons. That night you were probably asleep in your beds when you heard a sudden burst of gunfire, explosions, and shouts. The invasion was no surprise—you'd been expecting the Americans to come; your suitcases were packed, and all five of you had been sleeping in your clothes for a week, waiting.

The town hall of Sainte Mère Église had been smothered by the German swastika for nearly four full years; there is no doubt that along with deprivation, fear had become part of your daily diet. When discussing a possible landing by the Allies, the Germans had warned Alexandre: "You can count your houses. All of your homes will be kaput." So on this night, what you heard while crouched in the corner of your living room must have flooded your heart with terror.

The central position of your house gave you all what Maurice later called "front-row seats." American paratroopers of the 82nd and 101st Airborne Divisions fluttered down like giant snowflakes. Explosions and fires lit up the falling troopers, whom the Germans shot as they landed in the trees. Gunshots cracked and screams multiplied. While this chaos echoed, you must have tried to comfort your sons.

Right outside your door, boys not much older than your Paul who hid behind haystacks in the fields of Normandy were shot and fell with a thud. Boys far from their home were jerked out of approaching boats and sank into the icy sea, and were shoved off the cliffs they had just scaled to land in a lifeless heap on the wet sand below.

Finally, at 4:30 a.m.: silence. The American flag had replaced the Nazi spider. Sainte Mère Église was free.

The next day, June 6, you walked out of your house to what has been described as a macabre scene. Dead bodies littered

the ground and hung from trees, each in a white silk cocoon. Townspeople used the parachutes as shrouds and hastily buried the dead; later the fabric was fashioned into dresses for the girls. After the long nightmare of Nazi occupation, this day must have overflowed with both joy and horror.

I wonder if that night as you watched your sons sleeping, you saw safety hover like a golden halo over their soft, rumpled hair and eyelashes upon healthy red cheeks. I can imagine you placing your palm on a small, warm chest and watching your hand rise and fall with each even breath. Perhaps you imagined the vast vacancy of a world without this son, the mingling of emptiness and pain that would slice through you if he died—and felt a great gush of gratitude to those American soldiers.

I can see you sitting on the edge of that bed, visualizing the mothers of those other boys. That must have been the moment you thought of one little thing you could do.

The next day you set off with an armful of blossoms, little Maurice in tow. One by one, you began tending those graves, and the people in your village followed suit. Life magazine ran a photo of you placing a bunch of red flowers on the grave of Brig. Gen. Theodore Roosevelt, Jr., President Theodore Roosevelt's son. Letters began to arrive by the dozen, asking if you could find specific sites, which you faithfully did . . . and then went a step further.

You sat at your desk, which was becoming crowded with framed photos of American heroes, put a sheet of paper in your typewriter, and began to tap the keys. Soon, stacks of letters accumulated around your desk, for in the three temporary cemeteries in and near Sainte Mère Église, fifteen thousand U.S. troops were buried.

The families poured out their grief to you and you responded.

Every letter was answered, sending solace across the Atlantic Ocean, offering details of resting places to families who had no hope of coming to France and no idea when they could reclaim the bodies. Inside the envelopes you sprinkled a handful of the same dirt that covered their sons, brothers, or fathers, or slipped in a pressed petal, or maybe a photo of your boys helping to dig, plant, or tidy—like the one of Maurice at four years old hugging a cross with stenciled letters identifying John J. Lavin, Number 13177340.

Tending the graves was a kindness; communicating with the bereaved was a sacrifice. It seems to me that just when your energy would have been most depleted by trying to raise your own family in a village ravaged by war, you took on more strain. The moment each soldier acquired an identity, you opened yourself up to some of his family's pain.

I wondered if grief did to you what it always does to me: sucked strength and stamina from your core, filled your chest with a swirling tornado of pain, and left a rubbery residue inside your limbs. I thought the sorrow moved directly from the souls of those mothers, fathers, sisters, friends and lovers directly into yours, and in this way alleviated their suffering.

When I was in your village, Madame Renaud, I wanted you to do the same for me—with a desperation that took me by surprise. I felt your empathy flow into me.

My inner grief-barometer had steadily risen over the years; I knew it was all still in there. I'd measured out the sadness I expressed in precise doses so as not to bring people down, hiding the extent of my pain. I swallowed a lot.

Tears spilled out only when I was alone because I was afraid that the people who love me would become uncomfortable. It seemed they had: One night at dinner, I started to describe how Allison's death had been beautiful in some ways. My husband and sons looked startled, then flustered, and I awkwardly changed the subject. On a road trip with friends, I said that I still felt attached to my sister, like we were little girls buckled together in the back seat of our car, and an uncomfortable silence descended. Lowering the mood like that made me feel guilty; I didn't want to overwhelm people.

Grief was a fever I feared was infectious, so I never pushed beyond those hesitant moments.

But looking at the photos of you through the years made me wonder if sharing my burden might, instead of merely draining my friends and family, provide them with something else as well. I noticed a change in your face that made me believe taking on all that sorrow of others transformed you: June 1945, you stand in the middle of a group of American GIs, smiling, but your forehead is lowered over exhausted eyes; in another photo, taken on the frozen ground of the cemetery, your blunt features appear heavy with sadness; but years later, in your sixties, sitting on a bench chatting with General Eisenhower, you look more fresh and reflective, as if your energy had been renewed; and a 1982 photo of you wearing a beret with the Airborne insignia shows a softer look tinged with gentleness.

To my eyes, your expression changed from careworn to content, as if easing the distress of all those families caused something to grow inside you: Through your compassion, you gained strength yourself.

This made me think the people who love me can take it if I share a bit of my swirling supply of sorrow. I've had the courage to say to my friend Christina, as we sat on the beach, looking out at sailboats like the one my sister and I grew up on, "This place makes me miss Allison." In the moment of unsure silence, I knew it saddened my friend; but then I described us as little girls in our orange life jackets leaning over the side of the boat together, and when I opened my eyes Christina was smiling at me and we were in a place beyond silent self-consciousness, a place of comfort.

Gradually, I've revealed grieving weakness to my family, and the persistent pain of loss to my friends. When tears overflow, I no longer worry about being an excessive burden. As the people in my life have moved through awkwardness to true compassion, the level of sadness inside me has lowered steadily.

Madame Renaud, you are someone I never knew and you've been dead yourself for over twenty years, yet I thank you for your sacrifice, because you gave me a glimpse of what I needed. Somehow I feel you are reading this letter, and I imagine you inside your house on the village square in Sainte Mère Église, your three sons playing in the background, sitting at your desk with envelopes, paper, and red rose petals scattered across it, and tapping out a reply to me.

More information about Madame Simone Renaud can be found at www .motherofnormandy.com.

Don't Think

A Message from Henri Cartier-Bresson

You just have to live, and life will give you pictures.

—Henri Cartier-Bresson

⌒

A PHOTO TACKED TO A PERIWINKLE WALL: A seven-year-old, knobby boy-knees braced below shorts. Stock-still, attention riveted down to the box he grips. He's poised to snatch something like a firefly in a jar; some image has dazzled him and his mouth lifts in a victorious smile—he's about to trap it.

A soft cushion of sleep one winter night in Paris: swirling dream-shapes, dark, misty objects, night's silence.

"Henri Cartier-Bresson," a man's voice said.

My eyes popped open. I had *heard* this; my eardrums had vibrated. The air still rang with sound. But I was alone in my apartment at 3:30 A.M.

I knew with certainty that Henri Cartier-Bresson, the Parisian photographer of previous decades, whom I had only heard of, had a message for me. I sank back into fuzzy black static.

I awoke the next day with the conviction that I had to go to Montparnasse to the Foundation Cartier-Bresson, despite a dozen logical reasons why I didn't have time to trudge up the hill from Île Saint Louis.

My gut clung with claws: the voice was significant.

The walls inside the tiny, spiral-staircased gallery displayed no photos of Cartier-Bresson's, but works by Robert Doisneau, whom I'd never heard of. I berated myself for acting on a whim and headed for the door.

On the way out, I glanced at Doisneau's black-and-white images, which grabbed me by the collar: wartime wedding couples' intimate smiles, children playing inside a burned-out car in a field of rubble, a boy jumping in front of the mirror image of his profile in a tree branch.

Robert Doisneau had been a contemporary of Cartier-Bresson in the decades during and after World War II. Doisneau felt the photographer "must allow himself to be permeated by the poetic moment," and sharpen his instincts to become a sort of intuitive medium.

Tweaked: an internal pressure point.

I rushed back to my apartment and fired off three poems about Doisneau's photos. Writing poetry made my veins thrum with a faster beat than while I was writing articles or essays, as if I had caught something instantly, and euphoria rushed through my body.

This state, which I recently heard described as akin to some forms of Eastern meditation, had been my center when I was a child. I'd existed on clouds of reverie hunched over the corner desk in my room, writing in silence. Whenever anything happened, I rolled it around and around in my mind and didn't rest until the story emerged on paper.

In those days, I had believed in my own uncanny intuition and had floated along in the mystical, magical flow of life's current. Life gave me stories and I wrote.

As I grew up, I turned from this inner pool of intuition a fraction of an inch at a time out of the desire to be not different, but mainstream. Writing fueled me, but it made me odd, introverted, quiet, so I kept my passion to a minimum and hid my brooding nature. I avoided other creative types.

Forty years later, I had become a conventional adult who numbly swam against her own current.

At the time of the 3:30 A.M. voice, I was spending a month in Paris at the urging of Kristi, a therapist I had begun seeing a few years earlier when I'd surprisingly slid into depression. She said the way out of the abyss was to be guided by something different than my brain: my heart.

"Just do it. Go to Paris and write. Feel it. Don't think. You think so much it hurts my head." She grabbed her head the same way she clutched her stomach when I shared my calendars and lists, my rules and outlines, the secrets of my ordered existence. I'd been baffled at her insistence that I stop trying to pigeonhole life in order to make it all make sense. Life, she'd suggested, is not an abstraction. It's about living, feeling, doing, following your deepest-held leanings.

When I had begun writing again several years previously, after resisting the temptation for decades, the elation returned, as did the preoccupation. My friends and family were baffled at the drastic change that had transformed me into an intense person who skipped ski runs, tee times, and college football weekends to write. They exclaimed at how introverted I'd become, yet I could feel my essence re-emerging.

But when I began submitting stories for publication, I took few chances. I crafted stories carefully according to what was the accepted norm in a magazine or online publication. Poems, written only when I couldn't resist the urge, were hidden. I imagined the stifled smiles of my circle of friends, and couldn't imagine

sending off poems written off the top of my head only to receive a flurry of rejection slips.

The morning after my Doisneau-inspired poetry surge, I awoke at 5:30 and shuffled to the window. Through almost imperceptible, swirling snow, all the lights across the dark street two floors below were extinguished except one, at a shop called L'Île aux Images. In the golden-lit window was an assortment of poster-sized black-and-white photographs.

Riveting: an image of an older man with his chin on his hand, tilting his head to look straight up at me. A conspiratorial grin. Who was this?

Later that day, I stood outside the shop and leaned my forehead against the glass to peer at my new friend, whose eyes crinkled at the corners and seemed to see me, too. The writing underneath the photo identified him as Robert Doisneau. I had a hunch he approved of my poems, and he was somehow pointing the way to Henri Cartier-Bresson.

I spent the next few weeks studying Doisneau's work,

which inspired more poems. Cartier-Bresson's photos were, oddly, nowhere to be found. The library was closed at the Maison Européenne de la Photographie, and I could find none of his photos at any of the museums.

I felt blocked, a busy schedule crowded out writing poetry, and I gave up on the message my gut had been anticipating.

When I got home from Paris, I told Kristi about the voice. "You needed that voice to remind you that the world is so much

Image (upper): L'Île aux Images, 51 rue Saint Louis en l'île
Image (lower): Maison Européene del a Photographie, 5 rue Fourcy

bigger than you've grasped," she said. "It's the only thing that could get your attention.

"Go find out about Henri Cartier-Bresson."

But life intervened: I evaluated, planned, analyzed, and listed pros and cons for another trip to Paris. People were puzzled at the magnetic effect Paris had on me, so I had concocted a litany of reasonable-sounding reasons for my frequent trips: the lure of the Louvre, chic fashions, literary events, brie on baguettes . . . but my real reasons were more visceral. I *felt* vibrant and alive there. Again, the word "euphoria" came to mind, so I looked it up. Synonym: "on cloud nine"; antonym: "depression."

I didn't tell another soul about that voice. I was a little afraid: hearing voices in the middle of the night, thinking Robert Doisneau was communicating with me from a photo, foolishly writing poems night and day . . .

A few months later, I had my tarot cards read, something I'd always scoffed at but secretly desired.

The elderly Scottish gentleman who read my tarot went straight for the jugular.

The white-haired man's gnarled fingers flipped over faded, dog-eared cards. I focused on one of a jester in soft yellow boots, his knees bent in a jig, perched on a precipice at the edge of a cliff: The Fool.

"Ahhhh," the old man brogued, looking at me as if he read my mind as easily as he read the cards. I squirmed and directed my attention to the wall, upon which I projected an image, in the muted colors of the cards, of the old Scotsman cavorting, his yellow boots inching closer to the abyss.

He fixed me with a beady stare.

"Here's what I have to say to ye: Don't think so much, lass." He sat back and shook his head, rubbed his white-bearded chin, and regarded me with eyes that crinkled at the corners as he

flashed an annoying smile. He scribbled on a pad of paper: *This is not a pipe.*

"Have ye seen the painting by René Magritte?" he inquired with elaborate politeness as I ground my teeth. Yes, I'd seen it, I'd studied Surrealism in college, and steered clear of it ever since because I never "got" the disordered ideas behind the works.

"It's a painting of a pipe and it says underneath, *Ceci n'est pas une pipe.* This is not a pipe. Because, ye see, it's not; it's a *painting* of a pipe."

He leaned forward on his elbows and regarded me with shrewd, unwavering blue eyes. "Miss," he said, "life is not an abstraction. It's for the livin'."

I fumed. I'd wanted to know if I'd have fun that summer in Spain, if my book would be a wild success, and where my next story would be published. I'd wanted my future.

"I'm not buying this," I said with a frosty smile.

I didn't believe in tarot cards. My shield of arrogance was firmly in place and the message bounced off yet again.

As time went by, I couldn't shake the urge to write about Henri Cartier-Bresson. Eventually, I found his photos, his biography, and a couple of interviews on DVD.

Henri's goal was to position the camera between his subject's shirt and skin, "to grasp the interior silence." He caught the precise point of geometric perfection: a filthy street urchin leaning against the wall just when sunlight glows upon his triangular shoulder at the same angle at which he stands; giant tropical leaves swinging forward behind a haunted young Truman Capote, whose shoulders retract and lunge at the same time; Nehru announcing the death of Gandhi to a blurred crowd that spins with shock.

The power of these photos reverberated through my body from the top of my head to the soles of my feet.

Henri's pictures looked painstakingly set up, but there's no way they could have been: One photo, *In the Marais, 1952*, shows the courtyard of a gigantic stone building that echoes with boys' shouts. Concrete blocks, scattered like dice. Three skipping blurs dash across the scene with bent knees, arms pumping. Another boy runs, tipping into a dip, arms out for balance, heading toward three "big boys." These comrades hunch, knees touching, socks bunched at ankles, heads together, scoffing at something in the distance: a triangle of three faces, each a note of the same chord. All shapes are repeated with precision in the shadow patterns on the concrete walls and the blocks on the ground.

Snap: the very instant symmetry intersects with raw emotion.

I had to know how he did it. It turned out that Henri Cartier-Bresson was completely caught up with the Surrealist crowd, who conjured up their credo in the Paris cafés of the 1920s: expression "in absence of all control exercised by reason and beyond all considerations, aesthetic and moral." *Question all things at all times* was the mantra. The power of the imagination comes first, but you must *feel* it.

Surrealism taught Henri how to seize what he called the Decisive Moment: his own natural, internal response to all he encountered. Henri became part of the flow of dynamic action himself, seizing the image too fast to calculate, evaluate, or even decide. He prowled the streets of Paris and traveled to nearly every country in the world, stalking the split second, as he said, waiting for his body to signal him to trap "the core and the flying sparks" of what he saw. His approach was entirely intuitive and he was said to look like a dragonfly as he leapt around with his Leica.

Remember: living from this center.

In an interview with Charlie Rose, Henri Cartier-Bresson was a sweet-looking but rebellious old fellow. He told a story about how he had his tarot cards read once, and the reading had come

true. His motivation in traveling, he said, was to *live*. I hunched at my computer, riveted:

"The photograph takes *me.*"

"It goes all through the system." He swept his fingers, facing inward, up from his stomach to his chest, and out, palm out.

"Don't think."

Don't think: It raced through me like a high-speed train sparking the rails. I let it sink in . . . and sat down at my computer and crafted a detailed, well-researched piece about Henri Cartier-Bresson.

I was writing a story; I was painting a pipe.

Soon afterward, I returned to Paris (the pros outweighing the cons once again) and arranged to meet with another writer. I'd sent ahead my glowing piece, which highlighted the details of Cartier-Bresson's history while presenting perfect little vignettes of his photos, because I wanted the piece to be about Henri Cartier-Bresson, who died in 2004, and his black-and-white images of life.

"What is this?" my colleague asked, waving the papers in front of me as we stood in my apartment on Île Saint Louis. He sensed something amiss.

"Well, the title is "Henri Cartier-Bresson, Timecatcher of the Twentieth Century," and . . . "

"Are you really into photography?"

"Well, sort of. I wrote these really lovely little vignettes . . . "

"This is a very nice biographical essay, but it's an abstraction." Acting on a hunch there might be more to the story, he spoke for several minutes about the difference between life and abstractions, and the importance of *heat*, of writing from the inside out, letting it flow.

He moved: swept his hand inward over his stomach and chest, up and out, palm out.

"Why do you *really* want to write about Henri Cartier-Bresson?"

Intuition: awakened.

"Well," I said, diving in, "I heard this voice in the middle of the night." As I talked his eyes popped out, and I felt the powerful flow of the story emerging, the floating freedom of being carried on by my own river's current.

I kept the vignettes from the biographical piece, and spun them into poems in my writing room with the periwinkle walls, because Henri Cartier-Bresson's photos dazzle me. Sometimes, if you're lucky, life gives you poems, too.

Tastes of Place

A bottle of wine contains more philosophy
than all the books in the world.

—LOUIS PASTEUR

Image: Guest Apartment Services, 17 rue Saint Louis en l'Île

POUR YOURSELF A GLASS OF BORDEAUX, crack open a baguette, and slice a tiny sliver of Comté cheese. Let's philosophize.

Which places have you tasted?

Which back-alley street-food has snuck its way into your psyche: Tacos from a stand in Guadalajara, fried bananas in Bangkok, a hot dog with onions and mustard eaten on a bench in Central Park?

Have your travel memories become forever linked with food: a picnic in the cold, crisp air of the Alps, sushi served on a lacquered tray as you sit upon a pillow listening to a trickling fountain in Kyoto, wiener schnitzel before a concert at the Music Hall in Vienna?

Have your taste buds taken you back in time? Has cotton candy melting in your mouth transported you to a swinging seat high above the grounds of a county fair, or a tankard of ale tossed back in a Glastonbury pub caused King Arthur to appear across the roundtable, or chicken stewed with morogo (wild spinach) over an open fire in a three-legged *potjie* in Cape Town, South Africa evoked drumbeats of ancient tribes?

Break off a chunk of the baguette and feel its crust resist your teeth. Bite. Listen to the crunch, feel the soft, flaky center. Taste this.

I recently traveled to Paris and Morocco with writer Kimberley Lovato, author of *Walnut Wine and Truffle Groves*, the visually stunning, award-winning book of stories and recipes of the Périgord region of France. When discussing how tastes link us to place, Kimberley said:

> "It's impossible to bite into a baguette, smell Maman's bouillabaisse simmering on the stove, or sip wine made from grapes planted by the great-grandfather of the man pouring and not taste the local terroir on your palate and feel the weight of the regional history on your soul.

"If you don't taste it or feel it, then you're moving too fast. France is not a fast food nation. Sit down, close your eyes, and relish the local stories that live in each ingredient: imagine the centuries of decisions, arguments, trysts, and revelations that have transpired around family tables and in French kitchens, where recipes are cherished heirlooms, passed between generations."

"The Taste of This Place" is a story that offers bites of baguette containing morsels of past centuries.

Swirl the crimson wine in your glass and watch the "legs" run down the sides. Take a sip and consider how you settle into a group of people. Are you outgoing and bombastic, or shy and reserved? Do you jump in or hold back, jabber or just listen?

There is a moment during wine-making when wine from different varietals and vineyards—each having its grapes picked from their home-vines, crushed and gently mixed so the skin and juice produce its own color and flavor, each varietal coming from a different vat where it has fermented—is blended, before it is moved from vat to barrel, or placed in a series of barrels, bottled and corked. During blending, the wine is carefully tasted and the combination refined.

This is similar to what happened during a group trip to Saint-Émilion, France, in the story, "A Rare Blend."

Now for a taste of the *fromage*: smell its pungent twang, feel its smooth texture as you move the morsel of Comté to your mouth. Your tongue springs into action, detects salt, a secret sharpness, and something earthy that makes you wonder where this cheese came from.

The Franche-Comté region of eastern France is where the Jura Mountains offer their hills and valleys and villages. Gustave Courbet grew up here, in the town of Ornans, where he used a new process of painting and scraping with palette knives, mixing

wet and dry paints to create texture. Perhaps Courbet's best known painting is *L'Origine du monde* (*The Origin of the World*), which is a stark celebration of female genitalia. Courbet's work can be seen in the Musée Gustave Courbet, which includes a lovely garden, on the river Loue in Ornans.

Louis Pasteur also lived in this region, and his house, laboratory, and personal vineyard in Arbois are open to visitors. Pasteur spent many years here doing experiments using wine from the region.

Nans Sous Sainte Anne is a village in the Doubs department of this region, found in a valley of limestone cliffs and forests. The source of the Lison River is here. "Jurassic Cheese" is a story of a week spent exploring the origins of rivers, food, and stories.

I present one last question to ponder as the after-taste of the Comté lingers: What is the source of the stories that make up your life?

~

The Taste of This Place

Bread deals with living things, with giving life, with growth, with the seed, the grain that nurtures. It is not coincidence that we say bread is the staff of life.

—Lionel Poilâne

THE BAGUETTE BEGGED TO BE BROKEN. It lay on the wooden table, long, ridged, and pinched at both ends. I cracked it, and golden crust cracked with a *crunch* to reveal lacy layers of loose grains dotted with holes: *Baguette à l'ancienne,* the pride and joy of Boulangerie Martin on Île Saint Louis in Paris, had been reverently recommended by Christophe, my dashing concierge, who had leaned close in his leather coat and black-rimmed glasses. "You must try this special baguette, my very favorite," he'd crooned, his shining eyes rolling in ecstasy as he mimed breaking open a loaf with a flair that only a French man can flourish.

Now, the thick aroma of wheat made my mind reel.

Image: Boulangerie Martin, 40 rue Saint Louis en l'Île

The narrow room of my apartment, with its thick walls of yellow stone and windows climbing toward a dark row of 17th-century beams, seemed to spin and shrink into a cocoon. Floury warmth wafted up my nostrils. Ten thousand taste buds inside my mouth brimmed with saliva, prepared to revel in the five tastes: salt, sour, butter, sweet, and savory.

This time, the flavors those tiny flask-shaped buds received triggered something.

> *In squalid garret, on Monday morning Maternity*
> *awakes, to hear children weeping for bread.*

—Thomas Carlyle, *The French Revolution*

By October 5, 1789, bread, *pain*, was the staple of Parisian diets. When prices rose to over half a day's wages, the wailing of wide-eyed children was the tipping point and violence fomented. A huge swell of women rolled down rue du Faubourg Saint-Antoine, shouting for bread, forcing the bell ringers to sound the tocsin, raising the call to arms. They stormed up the steps of the Hôtel de Ville, ransacked and raised a little hell, then plowed through pouring rain roughly twenty kilometers to Versailles, over six thousand strong, waving pikes, crowbars, pitchforks and scythes.

The mob crashed into Versailles as the king was returning from a hunt. According to Christopher Hibbert's *The Days of the French Revolution*, the Bishop of Langres, who was in charge at the moment, proved quite incapable of controlling the rabble.

"Order! Order!" the bishop called, as the women clambered onto the platform.

"We don't give a fuck for order!" they shouted. "We want bread."

King Louis XVI arrived and attempted to placate frenzied Maternity, but the market women's response was, "We'll cut the Queen's pretty throat!"

The Revolutionary government tightened existing laws governing the baking of bread, confiscated the flour sieves of millers and bakers (symbols of fine bread), and decreed that all would now munch on the meager loaves known as *pain d'égalité*, equality bread—but this didn't save Marie Antoinette's pretty throat.

How horrid it would be to hear one's child cry for bread day after day.

These days, a fresh baguette each day is a citizen's due. As I savored mine, I glanced at a tiny alcove of old leather-bound books squeezed next to dusty, dog-eared paperbacks. A decade earlier, I'd read my first French classic, *Les Misérables*. I'd grown up with my nose in a book, but this story, with its intricate combination of characters and rich, thick historical substance, filled me like no tale ever had. After that, I couldn't get enough of the extreme highs and lows of Parisian history, which fired a desire to return repeatedly to Paris.

My teeth sank into the bread with ravenous hunger that had nothing to do with my stomach.

> *The hand grasped a loaf and the thief made off at a run.*
>
> —Victor Hugo, *Les Misérables*

As revolutions sliced through France's timeline, hunger, as Hugo hints, turned many a broad-shouldered and robust man, like Jean Valjean, into a common thief who victimized the esteemed baker.

The *boulanger*, as Alexandre Dumas described him, was one who *worked during the night, a half-naked being glimpsed through cellar*

Image: Victor Hugo House, 6 Place des Vosges

windows, whose wild-seeming cries floating out of those depths always made a painful impression. In the morning light, the weary *boulanger*, white with flour, carried a loaf under one arm as he trudged home.

The two boulangers at Boulangerie Martin were aproned ladies whose smiles were hard-won, depending upon my correct use of gender and pronunciation: *la baguette, une croissant, un millefeuille* were repeated until the *Baguette à l'ancienne* was bestowed, accompanied by an *à bientôt*, for they knew they'd see me soon.

As flaky crumbs fluttered, spinning in the sun, my teeth crushed the bread, grinding it down to a pulp—now salty, now sweet, constantly changing taste and texture. I thought about the fortunes and feasts of Parisians in the years after the Revolutions: now plenty, now want, always changing . . .

The greater part of Paris is living on coffee, wine and bread.

—Edmond Goncourt's Diary, 1871

Having survived repeated revolutions, the Napoleonic empires and wars, Paris next endured the first full-scale siege in modern history, by the Prussians. Trapped inside the city with no food coming in, coffee, wine, and bread was the fare, and for protein, horsemeat, and finally such delicacies as "a slice of spaniel," or one family's Christmas treat, a fatted cat "surrounded by mice like sausages." Only 300 rats were eaten during the whole siege, compared with 65,000 horses, 5,000 cats and 1,200 dogs—all served with elaborate sauces, for this is when many of the sauces of French cuisine were invented, out of pure desperation to make pets edible. Next, they broke the giant padlock on the gate of the zoo. Cherished must have been the sight of a beloved baguette, with caramel-colored crust encasing something familiar. Pure and simple *pain de siege*

alongside *cotellettes de chien* (dog cutlets) softened that terrible year, *l'année terrible*.

In the same way that Marcel Proust dipped his madeleine in a cup of tea and slipped his memory back to childhood, I dipped a little bread in my glass of scarlet wine, enjoying the earthy tastes of wheat and grapes mingling. I thought about the artistic, literary, and cultural offerings Paris presented: Vermeer's pinpoint-precise *Lacemaker*, readings in cafés and bookshops, violinists in the métro stations filling the air with voluptuous strains of Vivaldi.

As I sat on this island in the middle of the Seine, in this apartment with its wobbly wood floors worn down over hundreds of years, some kind of time-traveling essence arose inside my body. I felt as if the green tendrils that wrapped their tails around the black balcony railing were crawling into me, and the lion-head ornament on the stone building across the street growled inside my stomach: Paris soaked into my system.

Tastes can permeate people and eras of the past into our psyches with a distinctive flavor when we travel. Lamb stewed for hours in a heated tagine goes down spicy on a terrace high above the ancient hues of the Fez medina in Morocco, conjuring images of a 13th-century woman in a hooded *djellaba* crouching down to lift the lid, blinking in a cloud of steam as her daughter sprinkles in herbs. The last drop of Tuscano teases the throat as one sits under an umbrella of leaves on a sidewalk near Villa Borghese, evoking 5th-century barrel-filled wagons bouncing from Tuscany toward Rome. Coca tea pulses the heart in Pisac, Peru as it did when an ancient, exhausted Andean first placed a coca leaf into his mouth and felt a rush of energy.

I knew I'd never again eat a baguette in quite this way, as if I'd been uniquely deprived. I thought of the scarcity during the German occupation in World War II.

What was it like on that long-awaited day in August 1944? Barricades, like those of the Revolutions, had been erected, guns and grenades had been removed from hiding places in closets, drawers, or under beds, and Parisians fought the Germans with fiery fierceness.

Everybody supposed that with the Liberation, the departure of the Germans, life would immediately return to what it had been before they came. What actually happened was that, for one day, the bakers made white bread.

—François Maspero, *Cat's Grin*

After one glorious day, Maspero writes—in his semiautobiographical novel from the vantage point of Luc, an adolescent boy skulking around occupied Paris—the bread returned to its wartime shade of gray again, *with bits of sawdust in it and strange greenish agglutinations that smelled of mold.*

De Gaulle victoriously marched down the Champs Élysées, and the *boulangers* baked the longed for loaves Parisians hadn't seen in years, writes Sgt. Gaston Eve, Volunteer 1160, Free French Forces, in his account of the Liberation: "All around it was party time." Taste buds reveled in something imagined and even dreamed of, only to return to its paltry and putrid imitation the next day.

This reminded me of my desperate search for a true French baguette each time I returned to the states: prowling markets, squeezing brown paper casings claiming to hold "rustic baguettes," biting into pathetic imitations, and refusing to pay $15 for half a loaf imported from Poilâne in Paris. The quest for crust with just the right crunch ignited the frustrations of reverse culture shock, almost as if I were acting out my desire for the unobtainable: to find Paris at home.

Lionel Poilâne conducted research on the link between bread and humanity.
For him, bread was intimately linked with history, politics, art, language, etc.

—Website of La Boulangerie Poilâne

Pierre Poilâne moved from Normandy to Paris in 1932 and opened his shop on rue Cherche-Midi in the district of Saint-Germain-des-Prés. I said the names aloud: "Pierre Poilâne, Cherche-Midi, Saint-Germain-des-Prés." The nasal, narrow sounds echoed up to the ceiling beams. When finally confident after my aproned ladies' tutelage, speaking and listening to the rolling sounds of French always relaxed me.

Lionel Poilâne, who took over in the early 1970s, conducted research he called "retro-innovation" to combine the best of old techniques with the best of the new. He exchanged ideas with the artists of his day, even building a bedroom of bread for Salvador Dalí. Lionel believed bread was intimately linked with all aspects of life.

As I swallowed the last bite of this *Baguette à l'ancienne*, I believed it, too. I felt full, my hunger sated, for along with the usual flavors they detected each time a morsel of food entered my mouth, my taste buds had sensed the taste of this place.

⌒

Image: Boulangerie Poilâne, 8 rue du Cherche-Midi

A Rare Blend

And what wine is so sparkling, what so fragrant,
what so intoxicating, as possibility!

—Søren Kierkegaard

GROUP TRAVEL CAUSES ME TO ASSUME the emotional fetal position. As an introvert, I do not savor branching out. When I registered for a writing class in Saint-Émilion, France, I anticipated sipping varieties of *vin* in the châteaux of southwestern France, and digging deep into myself to write. I invited two cheery, outgoing friends, Ann and Wendy, who would act as shields so I'd have little interaction with other people.

As our taxi approached Saint-Émilion, the spire of its medieval limestone church peeked out above emerald fields. We passed under a Gothic style gate. Steep, narrow lanes of golden stone walls lined with ivy and red geraniums branched off in all directions.

Romans planted vineyards here in the 2nd century, but it wasn't until the 8th century that the monk Émilion settled into a

hermitage carved into the rock there and began to make wine to sell. I wondered what a hermetic lifestyle would be like, living a solitary existence in a hideaway as a recluse. At least Émilion had had lots of wine.

Inside the hotel lobby stood a group of a dozen people. My stomach plummeted; there would be no avoiding initial introductory encounters.

To introverts, it often seems as if strangers offer too much personal information. The small talk that binds extroverted people together seems to dry as fast as super-glue. Details of childhood vacations, twists and turns of career paths, intimacies of marriage woes, and confidences of spirituality from someone I do not know cause me to feel as if the person has attached himself to me like a leech, and is sucking energy out of my body. Until I know another well, smiles feel forced, stretched across my face.

I began a conversation with Liezie, a pretty woman in her thirties from South Africa, asking about her life, her writing, her home. Soon she was telling me tales of surfing with her Austrian boyfriend Marcus, with whom she owned a trendy café near a beach, and outlining her family tree. I nodded, feeling the walls close in and the super-glue stick.

Across the room, I heard Ann's laugh, saw Wendy's perky profile with her mouth a rapid blur. My shields were mingling with abandon.

I recalled that on the schedule there was one entire day that involved traveling on a bus all over the Médoc, the wine-growing region north of Bordeaux, packed with 1,500 vineyards. I get carsick and need breathing room. Restlessness spun in my stomach: What if, far beyond the sanctuary of my hotel room, I needed my three survival mechanisms: space, solitude, silence?

I have since learned that there are others like me, sensitive observers who process thoughts more slowly, do not think of

"party" as a verb, avoid the spotlight, crave only deep connection, cherish privacy and require quiet. We become depleted by interchange and energized by introspection. We are the ones depicted in the T.V. commercials that show a group of yellow smiley-faces gabbing away with one lone frowny-faced orb skulking outside the group. We are seen by American culture as too intense, needing help to attain the outgoing ideal.

In response to this, some of us put on a winning personality like a fuchsia feathered boa. I pretended to find Liezie's idle chitchat fascinating, and revealed the secrets of my existence by describing my friend Pete's apartment in Paris, his job, his temperament, his exquisite taste in wines, even as I felt the energy drain out of my body as fast as if a leak had sprung.

The first days were full of such encounters. I brandished skills I'd perfected during college as a member of a sorority and refined during years of Junior League meetings and cocktail parties, murmuring inane comments about hairdos, baseball teams, and travel sites. For an introvert, establishing a true connection requires wading through tangled weeds of banter in search of the tiny, bright coin of something under-the-surface in common, something buried. I hadn't found it with Liezie, chef and surfer. At home I was a soccer-basketball-baseball mom who happily flipped hamburgers on the barbeque while Liezie gallivanted the globe with Marcus.

At a small wine shop, Cave de l'Ermitage, a taste of Château Ausone Grand Cru: Currant, raspberry, and black cherry lolled around my tongue and rolled down my throat, warming the blood. Ann and Wendy, human comfort zones, were flirting with the wine merchants and posing for photos, so I was left to fling the boa around my neck and wait for it to choke me while I asked Jack, a photographer from Boston, about the shops on Newbury Street. I swilled another sip of Ausone.

I dreaded Wednesday, *the full day*. The possibilities of disaster were endless: Being utterly exhausted by the time the bus arrived at the first destination after chatter echoed in a tinny bus, suffering a desperate need to escape, or having to discuss the fermentation process with Frank, an older man with a shock of white hair and curiosity-crevices in his forehead, who was bent on exposing every detail of wine-making.

Socializing in groups causes introverts to imagine what we'd rather be doing: reading, writing, hiking, or even eavesdropping (although that always makes us wonder how on earth people can divulge their details so easily). Best of all would be a private, intimate conversation with just one person we know well. In a crowd, this presents a conundrum because getting acquainted with someone best happens in a party of two.

Monday was spent in garages. While there are dozens of grand châteaux in the area, the *garagistes* have recently created a stir by making award-winning wine inside their cold, whitewashed, tile-floored garages.

Michel Gracia, a bushy-eyebrowed gentleman, brought out photo albums of his grandchildren helping with the harvest. He and his neighbor, Michel Puzio, tossed their arms around each other's shoulders and spoke of intertwined lives, loves and vines. Intimate places, garages.

The next day, on a visit to Château Cheval Blanc (White Horse), I was astonished to discover that Liezie, Jack, Frank and the others were drawn to my put-on-persona and sought me out. Frank asked endless questions about *terroir* as we wandered through the cellar, a long room lined with cylinder-shaped vats. All the lines of the interior were soft and curved, as the guide explained that what made Cheval Blanc so special was that the grapes were combined when at three different levels of ripeness.

The aroma was of petals opening, and the wine tasted of plums.

The soil here, confided Frank, who had materialized next to me once again, included three unique types, gravel, sandy clay and blue clay, and it was this very combination that made the wine so rich. But why, I wondered, did it matter what was underground? Who cared about dirt?

I went outside and sat on the rounded entrance steps. Ah, peace. But before I could take a breath, Frank came out with his wife Barbara, and a group gathered around me for a photo. Feathered-boa-me was popular. I felt a bit of a fraud.

Wednesday, all fifteen of us boarded a bus, which moved beyond the boundaries of Saint-Émilion and barreled down the Route des Châteaux highway, home to 8,500 acres of vines. I sat next to Balash, a film writer from Iran who had spent the week quipping and networking with gusto. He'd chortled jokes with everyone in the group, who adored him, and I had pegged him as a playboy partier.

Balash had fled during the Revolution in 1979. He told me of his family back in Iran and his travels. The seat on the bus provided a private space, as if we were alone. Balash's long, dark hair was pulled back and his eyes, behind wire-rimmed glasses, held mine with intensity. We discovered we had the same ways of acclimating when we traveled (walking alone), the same response to art and architecture (tears), and the same rhythm to our writing days (silence, solitude, space).

Underneath his jovial exterior, Balash was my mirror image.

We arrived at the creamy stone, ivy-covered Château Magnol and sat down for our tasting. Purple-red wine illuminated the snowy-white tablecloths. Liezie wrinkled her nose and smiled. Frank—next to me again—was a candle flame, burning bright with the secrets of French *terroir*.

"I'm finally getting some *answers*," he said, in a voice deep with the rush of discovery. "I'm getting to it." His eyes twinkled under white eyebrows. I felt a flicker of fondness.

As we swirled, swished, swallowed, or spit, it was clear to me that something was happening.

We ran through a downpour and sopped back on the bus. An ease had settled on the group—this time when talk dipped into the personal, I was interested. Family photos were circulated and dirty little secrets of publication rejection were swapped. Balash and I sat in companionable silence and listened.

We arrived at our next destination and poured out of the bus. Château Lafite Rothschild's flag-flapping turret signified tradition itself. We crept past dust-covered bottles and ancient candelabra, down a dark hallway lined with wrought-iron doors. A guide told us that after the Rothschilds had fled France during World War II, their bookkeeper, Gaby Faux, had "cooked the books", transferring ownership of the wine in the written records, deceiving the Germans who occupied the château.

At the end of the hallway we emerged into a circular concrete room with wide pillars and a cool, blue feel. Flaunting our expertise, we held up glasses and examined them for hidden rubies. We sloshed the crimson liquid up the sides of long-stemmed glasses and held them up to watch it run down. Heads nodded, nostrils flared, lips smacked. The wine smelled of cedar and leather and tasted of *histoire*.

As we rambled throughout the Médoc, confidences echoed in the clattering bus. Anne, girlfriend of Jack the photographer from Boston, called out names of her favorite authors. Nick, the trip's leader, with a fringe of dark hair and red cheeks, talked about his twin sons' pursuit of his own favorite sport, soccer, and how much it meant to him that they enjoyed it. Sharon, a woman

Image: Cellar in Château Lafite Rothschild, Medoc

with short, swept up hair and a breezy manner, revealed she had spent years navigating her son's mental illness and had recently endured a painful marriage break-up.

"Today," she said, "would have been our anniversary."

I had thought Sharon carefree, had never suspected she was in the midst of trauma. I admired her unshakeable inner calm.

Awkward glances had become the nuanced gestures of friendship: winks, shrugs, and slow shakes of the head. Next, we would go to dinner; the best was yet to come.

We arrived at Le Lion d'Or in the village of Arcins. The proprietor, M. Barbier, smiling seductively in a photo above the entrance, stood directly underneath his portrait with a matching gleam in his eye, his mustache trimmed just so, his white apron pristine. He bowed and swept his hand in welcome.

The room in which our glittering table awaited was hushed and noisy at the same time. The heady aroma of juices, herbs, and hospitality filled us with anticipation. The waiter, with a hooked nose and drooping eyelids, an Adrien Brody look-alike, presented fistfuls of glasses held by the stems, and grinned.

Eyes sparkled and stories circulated. Denise had all of us doubled over as she described a man propositioning her when she lived in Italy. She'd had to explain to the *signor*, mostly by gestures, that she wouldn't abandon her kids on the playground to dash off for a *bella notte*.

M. Barbier shaved truffle and gingerly placed it on roast pork, then waited for our response as if he had proposed marriage. The truffles tasted of the earth and lured sizzling secrets out of the meat. We burst with exuberant exclamations and *le chef* beamed.

Image: Le Lion d'Or, 11 Route de Pauillac, Arcins

We tipped our glasses and imbibed like the wine connoisseurs we had become.

M. Barbier brought out a chair and placed it in front of our table. He whistled, and a little dog careened into the room and hopped up onto the chair. As the dog rolled over, begged, and performed trick after trick, I realized that once again I had been welcomed into the home of a stranger. I wondered if I had been over-armored, had protected my introverted self too fiercely. My shields had long since melted into the group, and I realized that during this day that I'd dreaded so distinctly, I had too.

In the five years since that trip to Saint-Émilion, I have been on several group trips. Recently, Christina and I led a group of writers through Morocco. I had, as always, started out in the fetal position, masquerading as an extrovert while inwardly gnashing my teeth, engaging in small talk that stuck in my throat. By the third day, as fifteen of us traveled in a large van through the green fields and hills between Fez and Moulay Idriss, I felt the now familiar pleasure of unfolding, and remembered that late night at Lion d'Or, after M. Barbier had taken his dog upstairs.

Frank told the tale of Médoc terroir: the melodrama of deep deposits of clay with patches of limestone and sand. Nick announced that Bordeaux flooded his soul. Silver-haired Barbara tiptoed toward the kitchen of the restaurant in search of more *crème brûlée*. My mouth curled into a comfortable curve.

As cognac lifted us to a floating haze, Barbara returned from the kitchen victoriously bearing a ramekin of *crème brûlée*. Balash snuck around the table draining half-empty glasses. He caught my eye and we laughed, not the polite chuckle of acquaintance, but the deep, body-mind-soul laugh of good friends.

I looked around the table, stretched, and savored the taste of this rare blend.

⌒

Jurassic Cheese

The secrets of great stories, it turns out,
are the secrets of the human mind.

—James Bonnet, *Stealing Fire From the Gods*

I STOOD IN THE FRENCH CHEESE SECTION in my Seattle market, mesmerized by triangles of white, cream, and yellow. The labels read: FROMAGER D'AFFINOIS, BRIE DE CHÂTELAIN, JURASSIC.

Jurassic—cheese from the Jura.

The Jura Mountains lie in the Franche-Comté region of France, near Switzerland. The Jurassic period is named for this place, where rocks of the age were first studied in the early 19th century. In the fall of 2010, a group gathered at a small château nestled in the Jura for a screenwriting and story seminar.

I was on a trip through Europe, and was able to set my own itinerary. At this time in my life, I'd re-dedicated myself to following my own intuition like a breadcrumb trail, and this was an opportunity to set off on an unknown path.

I planned to travel through Italy, Switzerland and France, and had precisely one extra week prior to Provence and Paris. Acting

on a whim, I googled "September 18-25 Writing Workshop France" and was directed to the Storymaking website, which advertised a seminar in Nans Sous Sainte Anne, a small village in eastern France. There was a photo of a man in a turtleneck with a neatly trimmed beard and wise eyes whose expression seized the top of my stomach as if he issued a challenge.

On a warm September evening, James Bonnet awaited at the train station in Mouchard, which is northeast of Lyon, France, and almost directly north of Geneva, Switzerland. There he was, trimmed beard, black turtleneck, challenging eyes, with the sophisticated air of an actor and screenwriter from New York who now lived in Los Angeles. I had read James' book, *Stealing Fire From the Gods*, and was here to delve into the heavy stuff of story. We assumed an instant rapport, but there was more: I felt a pushing sensation accompanied by a slash of fear. This teacher would require much of me.

We set off in a small car, with James' elegant wife Diane at the wheel, for the half-hour journey to Nans Sous Sainte Anne. As we climbed and dipped through the gigantic, green-saturated curves and cliffs, the car seemed to grow smaller each second.

The village of Nans Sous Sainte Anne lay in the rounded green bowl of a valley. James told me that the population hovered a little over one hundred, and the village had its own dairy with a selection of cheeses and fresh milk. The baker honked his horn as he drove through the village each morning, and the butcher visited twice a week.

We passed the town hall, a rectangle of cream-colored stone with a painted sign, MARIE, adorned with red geraniums and two French flags, and topped with a bell tower. In the surrounding hills, the ivy that covered the French and Swiss style chalets heralded autumn's first shouts of yellow, orange, and

red. The trees also were beginning to consider the prospect of changing color. We turned down a gravel driveway as day deepened to dusk.

The clean, white lines of Château de Vaux were stark against the darkening forest backdrop. Again, I felt with ominous excitement that I was here to learn something that would call upon all my resources.

A compact bundle of energy—Irishman Brendan Murphy—rushed out, waving a welcome, followed by his French wife Béatrice, a woman whose multihued blue eyes glowed as she approached.

Brendan hoisted my suitcase from the trunk, and Béatrice led the way up a winding staircase describing, in a deep, resonant voice, the details of my citrus-scented room, which overlooked steep inclines of pines. Through an open window, I could hear a rushing river.

This was the Lison River, and its source was a short hike away, Béatrice said. We would go later in the week. As I unpacked to the rippling, gurgling sound, I felt an empty gap inside of myself, a need for something.

Down in the dining room, Rogier van Beeck Calkoen, a young Dutch filmmaker with cherubic blond curls, leapt forward to greet me and rubbed his hands together. The group was to be small, with only four writers and James.

After serving roast chicken and potatoes, Brendan and Béatrice joined us around the lace- covered table. Soon, Wandra Raynor, a cheery blond woman from North Carolina, and her daughter, Dona arrived in a whirlwind of gasping explanations, slapstick luggage juggling, and exclamations about the château.

Béatrice brought out a platter of discs and triangles of cheese that came from this area, and we became acquainted as we ate.

We began our sessions the next morning in the light, airy salon. I was working on the outline of a novel about the French

Revolution, *Solange*. I had had a character, Julien, pop into my mind numerous times in a certain apartment in Paris, an 18th-century man who sat in a rocking chair near a fire, holding his newborn daughter, Solange. His wife had died an hour earlier and her body lay in the next room.

Whenever I stayed in that Paris apartment, I could not stop daydreaming about Solange. She was *there*, challenging her brother Christophe, falling in love with an aristocrat-turned-revolutionary, Luc, and trying to find a way to stop the carnage of the times.

I was here to learn how to write this story. I didn't want to mess with the magic that had caused these characters to appear. I had written travel articles and essays, but this was my first foray into fiction and I just wanted to let it flow. When I'd read *Stealing Fire From the Gods*, I had understood only a fraction of James' theory of writing, which holds that our creative unconscious is the source of our stories.

"The creative unconscious," James said, "is the force that would guide us if we were not cut off from it. It is where our wisdom is buried, and is the source of all of the higher, universal intelligence, wisdom and truth we possess. When creative people say they have tapped into the source, this is what they mean."

I had been enthralled for the past year by a reunion with my intuitive self, having spent years relying on intellect to the exclusion of heart. My brain had been boss for decades, and I'd lived cut off from my creative self. I thought of the creative unconscious as the instinctive self and I wanted no constraints on mine; I wished to bring this story to life in the purest possible way, with no interference from a mind that could easily take over. This talk of intelligence and wisdom made me nervous, but James was speaking as if our minds were only a part of our unconscious selves, not the driving force.

The days settled into a pattern of instruction in the mornings, afternoons of writing, and evenings spent around the lace-covered

table. One evening we walked in and a large, round appliance lined with pie-shaped openings sat in the middle of the table.

"Special dinner tonight," Brendan said. "Raclette." The word sounded like an invitation from the gods of pleasure.

Raclette means three different things to the French: a particular type of cheese, an electrical appliance, and a traditional way to make a party. Each person creates their own arrangement of small bits of potato, onion, and ham in small, triangular tins, and tops it with soft, yellow Raclette cheese, then slides their pans into the appliance.

Soon, the cheese bubbled and the aromas mingled as we exclaimed over our creations' stages and scents and moaned our way through the meal.

Our discussion of the creative unconscious continued, much of it centered around the concept of "the entity being transformed," the characters in our stories who were changed completely, and how we could find metaphors by probing our fascination and loosening our imaginations.

I had felt my imagination was too loose and needed reining in when I had begun having characters appear out of nowhere in that Paris apartment, and then the pendulum had swung, and I was afraid they would disappear.

"The curious tendencies of the mind that drive this natural Storymaking process, which we tend to regard as shortcomings, turn out to be the artistic tools of the imagination. And the creative unconscious uses these tools to create stories."

If our instinctive sides ran on memories, feelings, urges, and our minds were propelled by questions and decisions, which molded our stories, then it seemed James was talking about a combination of the two.

He worked with me for hours as I insisted upon letting Solange do exactly as she pleased and he suggested ways to guide her actions. One scene I wrote had her smuggling anti-Robespierre

articles by Luc out of prison and running through the streets of Paris to a clandestine print shop.

"Why not have her actually write a few things?" asked James.

"I just see her running through the streets."

"So, when she can no longer get into the prison to collect Luc's writings, why don't you have her write a revolutionary call to arms herself?"

"I don't see her doing this."

"Try to have her do something you don't envision. Play with this; let your mind weigh in. Maybe if she takes the risk and tries this herself, she will be transformed."

My intuition and my mind had never worked together in this way.

In the evenings, we pondered this as we lingered over four-course dinners, after which Béatrice brought out platters of cheese.

The first few nights we nibbled delicately, fussing about the fattening aspect of *fromage*. By the third evening, when Béatrice walked through the swinging door holding the plate high, we prepared ourselves to be transported.

Morbier is the color of a baby chick, a fragile shade, and soft, with a horizontal line of ash, which was traditionally spread on top of one layer to preserve it until the next milking. I imagined the cheese-maker, a man in a thick sweater and muddy boots, standing in a high-beamed barn while dust motes slowly waltzed in the sun, quickly spreading the ash to keep flies away, and stop the cheese from drying out, while he begged a cud-chewing, tail-swishing cow to hurry and lactate.

I welcomed a morsel the size of a fingernail, which my tongue grabbed and swirled. My teeth backed off in awe—the earthy Morbier pounced, and then melted almost instantly. The taste was like a whiff of campfire smoke, full of that same kind of musky promise as the air in that imagined barn, and it faded just as ethereally.

After a bite of bread, my receptors of taste, feeling decadent, reclined, rested, and then readied themselves for more.

Comté's hue is more ecru, and it's harder than Morbier. Intriguing and tangy, it waxed a nutty kick. This fromage was *fun*—it felt like a tennis match being played inside my mouth, to polite inner applause: The taste bounced back and forth. This was the cheese named for this region, the Franche-Comté, place of mountains and rivers and trees and small villages in which people sat at this hour behind lace-curtained windows and placed bits of this cheese on the tips of tongues.

There is a French proverb, *"S'il qui mange du fromage, s'il ne le fait, il enrage"*: He who does not eat cheese will go mad. I thought of the cultural differences between Americans and the French in response to the pleasures of the palate. During the actual tasting of food, we Americans keep our cool; it is later that we exclaim and praise "the best apple pie I've ever had," or "that steak I ate for dinner last night." We want the recipe so as to re-create the meal, but the French want the recipe so as to understand it.

I had read once that eating to the French involved a merging of body, mind, and soul. I had noticed that my French friends often invited the chef out to clarify matters: Had the fish been caught within the past few days? Where did the duck come from? Was the dessert Paris Brest named after a car race? When I'd eaten a forkful of the cream-puffed pastry, I could almost hear the roar of engines, see red and yellow-checkered flags. I smelled the sea as the salmon was reeled in off the coast of Normandy, and heard a mallard call as it lifted itself out of a lake in Picardy.

Knowing the path of the food from its origin to my palate had enhanced the pleasure of tasting it.

Now, sitting around the table with the mountain-black night silent outside the window, the lamps casting a yellow glow, and the candles burning in tiny flickers, I swallowed the Comté and sighed.

The next day, drizzle muted the greens as we set off through the forest toward the source of the Lison River. Drips and drops merged with rushes and gushes of the river as we navigated the path alongside it.

We stood in the middle of a bridge deep in the woods. In front of us crescendoed a waterfall. Above us was a ledge beyond which, if it hadn't been so slippery, we could have entered a cavern in which the river bursts from underground. The water emerged from this spring and gravity guided it over mossy-green steps of rock to the bottom of the cliff in crashing cascades of white spray. Contained by the riverbanks, the water was ushered toward the village in an unstoppable, undulating flow.

That night as we sat, dry and warm, around the table, I cut off a bit of Morbier and placed it in my mouth. It tasted of its source, smoky, musky, waltzy. I remembered the origin of my time here, when I'd instinctively typed in the dates of this week. I thought of the apartment in Paris, of Julien, Solange, characters and scenes that had sprung from my creative unconscious—and how I had learned this week to guide them. Solange had indeed written articles denouncing The Terror, which had helped bring about the end of it in Paris, and in doing this, she had herself been transformed.

I thought again of the underground spring, deep inside its lush and grassy forest, constantly emerging, changing from a falling curtain of bursting spray to a clear, receptive river.

That day in the market in Seattle, I purchased the Jurassic triangle, took it home, and peeled back the plastic. I inhaled slowly, and the room grew hazy with lamplight and tiny curls of smoke from candles. Outside, trees climbed like pine-scented towers in the gathering dark and I heard the melody of the Lison flowing swiftly from its source.

⌒

PART FOUR

Connections

Invisible threads are the strongest ties.

—FRIEDRICH NIETZSCHE

OUR LIVES ARE INTERLACED WITH JEWEL-TONED links between people, red bonds of love, resilient fishing-lines of family, spools of memory, dot-connecting marks between ideas and events, and black threads that weave in our heartaches and hurts and dark sides.

All of France, but especially Paris, is a place where such complexities and combinations have always been held up to the light and celebrated—in conversations that last past closing hours in cafés, in the literature of Colette and Anaïs Nin, in Rodin's *The Thinker* and van Gogh's self-portraits. Even I.M. Pei's glass pyramid in front of the Louvre ties the present to the past.

Often, a hunger for something, we know not what, gnaws its way through us. If we seek to be nourished, we can encounter on our travels that for which we yearn, but we had better be ready for a growth spurt.

For me, France has called up many such longings, which I have come to regard not as frivolous whims that wash over me at random, but as lights that indicate direction. "French Connections" is a story about something I sensed happening inside a Parisian café, and how it flicked a match inside me that lit up my own path as if it were lined with flaming torches.

Travel, in removing us from our sometimes numbing routine, allows us to reflect from a new vantage point and see patterns in our lives. Widely traveled Larry Habegger, writer and co-editor of *The Best Travel Writing* anthologies, known to many in the Bay Area as the godfather of travel writers, agrees: "It's easy to forget that everything in life is connected. But if we remain open to the world around us, our physical surroundings as well as our emotional and psychological cues, we are often astounded to discover the obvious in the mysterious. The person you meet for the first time but think you know, or the foreign place that feels strangely like home, are not illusions. You've been down this path before."

I experienced this through the string of events that led me to teaching writing, which is now an integral part of my life. It was like one of those connect-the-dots coloring books I used to love as a child: I to 2 to 3 . . . a few more, and eventually you return to I.

Voilà: there's the shape of a star.

I taught elementary and middle school in the 1980s, and although I adored the kids, I swore I'd never again teach. I was too introverted and had lost the desire to be onstage.

Years later, when I began writing, a friend suggested I find Shakespeare and Company Bookstore and meet George Whitman, which I did. The kinship I felt with him, and his bookshop gave me the feeling of opening at a book I'd been longing to read for ages: a book begging to be opened, to be devoured and savored, and (this made no sense to me at the time) a book in which I was a character.

I attended the Evening Writing Workshop in the upstairs library led by Anna Pook, and became friends with her.

When I returned to Paris, Anna told me she thought I'd be a good writing instructor, and asked me to teach a travel-writing session. I enjoyed helping others unleash the stories of their travels.

I returned and taught the fall session of the workshops.

Anna and I put together an anthology of writings from Shakespeare and Company, *Vignettes & Postcards from Paris*.

I continue to teach there several times a year, retracing the star one dot at a time over and over again.

Included in this chapter is the Introduction to *Vignettes & Postcards from Paris*, which weaves together the different voices, styles and genres of writers from all over the world.

Sometimes images link to something inside us instantaneously. One cold January day, I stood upon a weather-whipped plain in Auvers-sur-Oise, roughly 40 km from Paris, staring at two tombstones set side-by-side in a tangle of creeping ivy.

Ici repose Vincent van Gogh. 1853-1890.

Ici repose Theo van Gogh. 1857-1891.

The headstones were propped up in front of a low brick wall, which offered no protection against the chill winter wind. The sky beamed with the false whiteness that precedes rain, and beyond the wall a wheat field lay, empty of life—no person walking past in a straw hat, no livestock, not a single crow.

The brothers lay together forever in the place where it all went from bright to black.

I had read *The Letters of Vincent van Gogh* many times, and remembered that most of those letters had been to Theo, who was Vincent's financial, artistic, and emotional lifeline. I leaned in to look at the dates again, and noticed that Theo had been four years younger than Vincent.

These twin graves touched a raw and painful wound. Allison had been four years younger than me, and although she died in 2006 at the age of forty-two, there are times I still feel as linked to her as I did when she toddled after me at two years old.

It was an uncanny coincidence that six months after Vincent's death, Theo became ill and died. The two brothers clearly had a rare bond. "Vincent's Vision" is a story that explores the potential power of love between siblings, an invisible thread that connected Vincent to Theo, and will always link Allison and me in an unbreakable, glowing cord that breaches the boundary between life and death.

French Connections

*Electric communication will never be a substitute
for the face of someone who with their soul encour-
ages another person to be brave and true.*

—Charles Dickens

I OPEN THE DOOR, AND THE WARM AROMA of coffee, cinna-
mon-soaked apples, and herbes de Provence wafts out and curls
into the cold, indigo night. I catch a vanishing whiff of sweet
and salty scents. It's dimly lit inside, with outlines blurring softly
as in an Impressionist painting, and the view is hazy at first, as if
through layers of gauze—my eyes must adjust inside this place,
the Parisian café, Balzac's "parliament of the people."

Les Éditeurs at 4, Carrefour de l'Odéon, in the area of
Saint-Germain-des-Prés, honors the literary tradition with book-
shelf-lined walls and paintings of life *historique et moderne*. Framed
toe-pointed monarchs preside in a dignified manner over photos
of authors arm in arm with their editors. Round red chairs cozy

up to tables. Silver glistens seductively as the woodwork gleams a warm welcome.

Clutching my paperback conversation-repellent, I request *une table pour une.* I slip into a soft chair, shrug off my black wool coat, and order a glass of red wine and onion soup. A bald man dining alone on my right catches my eye and smiles. I avert my eyes, shiver, and pull my coat over my shoulders. Two women on the other side watch with interest. I reach for my paperback, open it, and stare at a page.

I feverishly wish the table was for *deux,* or *trois*—it is awkward being *une.*

With my eyes glued to page 56 of *Les Mandarins,* I breathe, and as the letters blur, my imagination starts to uncoil. The café hums with chatter, gossip, whispers, even the occasional shout, and my brain begins to buzz pleasantly. The aromas of sautéed potatoes and onions, *boeuf bourguignon,* and roast chicken combine with musky perfume, enter me, and float down the corridors of my body into an empty, unused room where they settle comfortably. I close my eyes and open up to the simple allure of the senses, savoring the scents.

I venture into delicious reverie, drawn to the tabletop, to a single rose inside a house of glass. I climb onto the smooth, emerald stem and slide around a few thorns to find myself traveling across a path of green, aware out of the corner of my eye of the snowy white ground far below. Slowly I creep to the crimson softness and bury myself in lush, intoxicating folds . . .

"*Le vin, Madame,*" near my ear.

Jarred from the fantasy, I feel the startling sensation of reality reaching its fleshy fingers into a dream, a feeling I was accustomed to as a head-in-the-clouds child but have rarely had as an adult.

A crimson reflected beam dances on the white cloth as I lift the glass. Sunlit-soaked grapes brought to the peak of their existence roll around my tongue, ease down my throat, and crawl into

my bloodstream, warming me in rhythmic waves that hum to the tips of my fingers. *Vin rouge* cajoles me to unwind, so I surrender sip by sip and look around.

In my peripheral vision, Monsieur Black-and-White waits, almost invisible, anticipating every wish. Cups clang, glasses clink. Lamplight illuminates lovers. Families laugh and friends linger. Tongues are loosened. Voices reign supreme: For the Parisian in his natural habitat, the words of the person sitting across from one drown out everything else, including insistent mechanical buzzing. Eye contact is essential and electric, and each body leans forward. One person's sentence flows into the other's, extracts the essence of meaning, and mines it for understandable gold. Ideas are held up to the light, examined, and dissected.

When communication is achieved, it is celebrated by synchronized nods and a sprinkle of agreement: *D'accord! Oui, oui!* This is followed by a waterfall of questions: *Pourquoi? Qui? Comment?* Clarification is victory. As the conversation surges, the river of words washes over me. I am loosened, and carried along on incomprehensible French currents.

A woman in a yellow-and-green blouse bends forward to better hear her companion. This is no idle conversation, it's what I used to call a heart-to-heart. Their eyes lock, their chins salute each other, and the two exchange a rapid succession of staccato statements as if they are playing a piano duet. At nearby tables, the concert continues.

My ears meet more phrases than I comprehend; my mind fills with narrow vowels and rolling consonants, colorful sounds that flutter together freely. It thrills me to be in the presence of such lively connections. I feel I'm in the midst of a million little miracles. Everything about this place *combines*—scents, flavors, sights, sounds, ideas, and personalities. To me, such combinations are the spice essential for life.

I sit absolutely still, filled to the brim with an odd desperation, a grasping hunger.

It dawns on me that I can't remember the last time someone leaned in to understand what I was saying, or the last time I had a conversation that was not interrupted by a ring, beep, buzz, or tinny tune. Through my mind flash memories of words flying out of my mouth, hovering in midair, then dropping to the ground, and of looking into eyes that registered, then all at once took on an iPhone-induced glaze. I realize I have grown tired of waiting, waiting, waiting for downcast eyes to read texts, distracted brains to listen, and attention to be paid.

I consider that back in the States, my day-to-day life has been wrapped in a world where people rarely look up, let alone *in*. I spend my days at the keyboard, alone during the day, but out with friends and family in my off hours. I attend sporting, social, community, and cultural events—I even create, coordinate, and orchestrate many of them. Yet at none of these events have I felt the level of personal connection that I feel inside this noisy Parisian café. I wonder if the reason for this is in the events themselves, or my own failure to seek this type of interaction with people I am truly drawn to.

The sight of so many people tuning out the world to focus on each other makes me want this with a fervency I can taste.

"*Soupe à l'oignon gratinée, Madame.*" Monsieur sets down a steamy circle in which sweet onions embrace their beloved *fromage*. The simple act of eating this soup sizzles and satisfies, because I am doing it slowly and attentively, in the midst of snapping synapses, of dynamic exchanges, which are the food I crave. Now it will be up to me to concoct the recipe for it.

This is not to be found only in a Parisian café, of course, but I am alone, outside my familiar world, in a foreign place, and thus my antennae are more sensitive. In this way, travel often makes me aware of the missing ingredients in my own life.

I consider my paperback: Why do I need a conversation-repellent at all? It might be in the way. I glance over and grin at the bald man next to me, and venture a *bonjour* to the women on my left. I spin a few comments in French about the cuisine. It doesn't seem like much, but it's a start.

Sitting here with my eyes wide open, I feel the synergy inside this café fuse with my craving for connection, and transform into determination.

I vow to myself that I will work toward deeper communication with people I meet, even when this visit to Les Éditeurs is long past. I will select events carefully, and mine each for gold, sifting through small talk and engaging fully in meaningful conversation. I start by setting as my goal to strike up intimate and lasting friendships during this time in Paris, and I will achieve it. To fortify myself, I slowly inhale one more heady breath and absorb it into my memory; the vow is sealed.

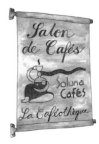

When it's time to leave, I put on my black wool coat and, with an *au revoir*, walk to the doorway, forgetting my book on the table, and step from the warm conversational cocoon into the January cold. The wind catches my turquoise scarf as I turn into the Paris night.

⌒

Image: Another favorite café in Paris: La Caféothèque, 52 rue de l'Hôtel de Ville

Vignettes & Postcards from Paris

*The only thing we are missing is angels. In this vast world there
is no place for them. And anyway would our eyes recognize them?
Perhaps we are surrounded by angels without knowing it.*

—Henry Miller, quoted in *The Rag and Bone Shop of the Heart*,
George Whitman's bookstore brochure

⌐

THE ROOM WAITS. VOICES AND FOOTSTEPS from the bookstore
underneath echo in the empty space. Through an open window
the buzz of traffic breezes in past pink geraniums which linger in
their wooden box, savoring the last light of day. Dust motes circle
in rhythm. An old table appears to have pushed aside a chess set
on its own top to clear space for paper and pen.

This is George Whitman's private library at Shakespeare and
Company Bookstore. For six decades, he presided at the cash
register, shouted commands across the room at random strang-
ers, invited many to tea or to stay, and swished between book-
shelves. But now, in September of 2011, he lies in bed inside his

Image: Vignettes & Postcards From Paris, 3rd edition, Reputation Books, 2016

apartment across the hall as life ebbs from his frail body. George's spirit still infuses the shop, but his is now a wispy presence.

The people clomp, stumble and tiptoe up the stairs. Collectively they read, write and speak in dozens of languages. They come from all over the world—Brazil, New Zealand, Ireland, Holland, Iran, Lebanon, and other places. Their communal consciousness overflows with precise details, harvested impressions and thriving ideas. On this warm evening, they come from all over Paris—on foot, on bicycles, on métro, on buses—to create something tangible out of the richness of their lives.

For three years, Anna Pook has been gathering with writers in this room. With her tawny hair and pink cheeks, she nestled in the corner, her back to the wall lined with signed editions of legendary writers. Anna spent weeks thumbing through piles of books, looking for excerpts that enticed her students to emulate the greats. She crafted prompts to loosen their pens. She learned each writer's interests, quirks and delights to cultivate an atmosphere of acceptance. Anna's gift of gentleness, combined with her unwavering insistence on honesty, inspired people to write stories, poems and essays that astonished even them.

But Anna has gone home for a few months to nurture her newborn daughter, and has invited me to serve as guest instructor for the fall session. To me, the room feels heavy with literary dignity, figures of the past float through the space, and Anna, in her thick gray cardigan, is one more ethereal image.

I sit in this library full of ghosts feeling the reality of this challenge. After several short seminars, this is my first lengthy workshop; my feet are on the precipice.

The room and I wait together.

People burst in, some out of breath, a few checking their cell phones, one woman rummaging through her bag. Anna's regulars have brought fresh-baked cookies and a bottle of wine,

 and tease each other with fond familiarity. Shy newcomers linger in the corner shadows. For a fleeting moment, I wish I could do the same.

They all settle in around the ridges of the room, and the crammed bookcases, musty cushions, and haphazard piles of books seem to shift to make space, inviting the writers in. Somehow the room lends encouragement.

The space grows quiet again. I feel the focus of experienced eyes and remember advice from a mentor, former writer-in-residence (fondly called "Tumbleweeds" here) Phil Cousineau.

"All you have to do," he had said, "is coax their stories out of them."

I can only be myself, not some brilliant word-fairy.

So we begin. I have planned a seven-week workshop, "Leaping Into the Void," with a focus on taking risks in writing. Their first venture is to write vignettes inspired by whatever seizes them on a half-hour expedition inside the bookstore or outside in the surrounding area. It has been said that if you dig deep enough you will reach something universal, and these writers begin their excavations.

Claire Fallou, a young French woman with a delicate curve to her cheeks moves the chess set a little farther over and begins writing about the paving stones of Paris. Maria Bitarello, brow furrowed over sharp brown eyes, strains to remember the pained limp of a man she met while filming a documentary in Brazil. Jean-Bernard Ponthus wanders into the adjoining room and squints to see colorful scraps of paper tacked onto a mirror. Catalina Girón twists a strand of hair while imagining a vivid scene at a métro station.

Often, an elderly woman in a long skirt and boots flounces across the room, George's black dog, Colette, on her heels. After

she's gone, we all exchange astonished looks—we have no idea who she is, but a hint of romance lingers in her wake as we begin our next writing task.

"What are you all writing?" she asks one night, as she disappears through the door leading to George's apartment.

We are writing about postcards. The sidewalks of Paris are lined with racks of postcards: sepia images of a grainy Louvre, black-and-white photographs of old men in berets, prints of Toulouse-Lautrec's cabaret dancers kicking up their petticoats. The writers create scenes drawn from one randomly chosen.

When the people read their work, synchronicities occur. Karen Isère, dark hair swooping down over one eye, reads her poem about the majestic fragility of Notre Dame, and bells from the cathedral chime as if on cue. In a quiet voice, Laura Orsal reads her story about a grieving woman weaving up toward this very room. She reaches the part when a young man begins to play the piano, and on the piano in the adjoining room, notes are plunked. Philip Murray-Lawson's deep Scottish voice rings with the same wit and mysterious intonations of his horror stories. Nancy Szczepanski pries open a foil-wrapped rectangle and, as she evokes her mother kneading and turning dough, the scent of cinnamon, sugar, and yeast fill the air.

As the stories take shape and are shared, they begin to reflect the writers' own places, events, and characters, their own wits and mysteries and shadow sides. To me, the stories written in this room imbue something else as well: a combination of the past literary genius-ghosts whose musty signatures grace the books, George Whitman's once formidable but now hidden presence, Anna's nurturing, and whatever caused those bells to peal and those piano strings to vibrate inside those precise moments.

There is a "something other" at work here, and it can be detected in these stories, now published in the pages of *Vignettes & Postcards*. I invite you to find it in Martin Raim's passionate

wooing of Lady Inspiration; in Jennifer Fleuckiger's vision of Homer and his pals scoffing at her from a cloud; in Manilee Sayada's trip inside Sylvia Plath's home the night of her suicide.

Perhaps you will catch a glimpse of this quality in Rosemary Milne's character Leila, an Algerian woman on the outskirts of Paris, or in Emily Seftel's wry observations of people watching themselves watch the Mona Lisa—or in Julie Wornan's two waiters, frozen in time as if inside an ice cube.

I suppose we all call it something different: inspiration, brilliance, insight or simply good writing. I call it Real Work. Fernand Pouillon, the twentieth-century architect and writer, wrote: *Courage lies in being oneself, in loving what one loves and discovering the deep roots of one's feelings: A work must not be a copy, one of a group, but unique, sound and untainted, springing from the heart, the intelligence, the sensibility. A real work is truth, direct and honest. It is simply a declaration of one's knowledge to the whole world.*

These writers cleared a space inside themselves—crushed internal censors, crawled out from under their own rigid expectations, and followed their instincts. They made room for their own Real Work to emerge. Look for the result in Sana Chebaro's view of a Degas painting, Leslie Lemon's street in 1950s Texas, Ann Dufaux's scene on rue de Seine during the flood of 1910, and Laura Mandel's depiction of her grandmother's last moments.

Find your own "something other" inside these stories, essays, poems, vignettes and postcards. You may even start to wonder what would happen if a story or two were coaxed out of you.

Vignettes & Postcards was launched in Paris in May 2012 at an event in the upstairs library at Shakespeare and Company. The rooms were packed, with people seated on chairs without an inch to spare, crammed into the back room against The Mirror of Love, peering out from around the corner of the piano

room, clustered at the top of the stairs in back, and through an open door, crowded on the side stairs and in the hallway that had led to George's apartments.

Tumbleweeds bustled about welcoming everyone, pouring wine, congratulating the writers, who read with unexpected individual flair: a Texan accent, a toss of the head, a voice pushing up through tears, a dramatic pause before an emphatic word. Something gave them an extra push . . . or perhaps someone.

George Whitman's physical body was gone, but his ghost leaned against the door-jam, his wiry hair springing out and bouncing as he nodded and clapped.

The room had waited a long time for this.

⌒

Vincent's Vision

The First of Further Letters of Vincent van Gogh

Now you must go out into your heart
as onto a vast plain. Now
the immense loneliness begins . . .

—Rainer Maria Rilke, *Book of Hours*

TWO ARCHED HEADSTONES OF GRAY STONE amidst crisscrosses of
emerald ivy upon a plain in Auvers-sur-Oise caused me to won-
der if perhaps there exists a parallel universe in which Vincent
van Gogh walked up the hill to the fields with his easel strapped
to his back that summer day in 1890, pulled the gun out of his
pocket . . . and hesitated.

This letter belongs in that invisible dimension.[2]

[2] My fictional letter is based on excerpts from *The Letters of Vincent van Gogh*, selected
and edited by Ronald de Leeuw, translated by Arnold Pomerans.

Vincent's Vision

1 August, 1890

My dear Theo,

I should probably have written to confess this before now, but until today I hadn't the heart for it. It seemed useless to tell you and I didn't want to worry you, but now the danger has passed.

I'd felt the familiar pull of darkness tugging at my sanity for several days, and then one morning awoke with cold dread in the pit of my stomach. The one thing that reaches me during those times is color; blue, green, and most of all yellow can plunge into the depths of my misery and haul me out of it.

I packed my paints and grabbed my canvas and folding stool, knocking over some tobacco and cold coffee that were on my desk on top of my writing papers. I turned around and without thinking opened the drawer and——so quickly I could pretend I hadn't done it——took out the gun and slipped it into my jacket pocket.

As I clumped down the stairs, the heavy bulk in my pocket smacked my leg, reminding me of its lethal purpose. I stepped through the door to the sound of chairs scraping the floor and cutlery on plates in the café, out into the warm July morning, strapped my easel on my back, strode rapidly around the corner, and trudged up the hill to the fields behind the château full of yellow colza blooms and tawny wheat under a cloudy sky, the kind I think of as troubled. I set up my easel and began to apply globs of thick ochre, but fear rumbled inside me and I felt so sick at heart that my arm refused to move. The brush fell from my hand.

A dull roaring began inside my head, and my hands shook as I slowly set my easel on the ground——thinking to myself I would never retrieve it——and started off, walking along-side the low stone wall of the cemetery up there on the hill, where ivy, twisting and winding around itself, tangled under my feet, tripping me up so that I stumbled every few steps. I staggered across the field toward the château. My vision blurred and I squeezed my eyes tight to stimulate some kind of equilibrium.

The heavy gun pulled the cloth of my coat tight over my shoulder as I stopped and looked around. Green potato fields, purple-tinged earth, clover with pink flowers——the colors were there, but they skimmed the surface of my ret-inas without sinking into my soul, which echoed empty and colorless.

Gone was even the lush black of depression, rich, shadowed folds in a cushion I often sink into, impossibly darker the deeper I go; absent was the dull pewter-gray of desola-tion——for that lost, hopeless feeling is a color to me as well. I've always seen loneliness as milky white with a blood-red jagged edge, but right then: nothing. I was beyond color, in an unreachable place, Theo, and this I could not stand.

I wrapped my fingers around the cold, rough handle of the gun and pulled it slowly out of my pocket. In the distance, a window of the château caught the sunlight and flashed. A restless breeze crawled under my collar and chilled the skin on my neck. I raised the gun to my chest and sucked in a shaky breath. A crow screeched and I looked up.

That's when I saw you, Theo.

In my mind's eye I saw you standing across a great abyss, your dark hair falling over utterly exhausted eyes. You looked at me and sighed, a slow, tired exhale. Your head was tilted a bit to the right. Your broad shoulders hunched with the weight of worries about the illness of your son, little Vincent, whom we stood and admired together just days ago as he slept in his wooden cradle. Your back stooped with the guilt of having to worry your wife about money matters. Your mouth drooped, dejected at ill treatment from your bosses, Boussod and Valadon.

Theo, I saw in your weary eyes that you knew my own desperate state as well. And I saw that your heaviest burden was me. All through the years you have sent money, bolstered my spirits with your company and your letters, and depleted yourself in fruitless efforts to promote my work. Perhaps my nearness—living here in Auvers so close to Paris—has been toxic for you.

As we stood with the chasm gaping between us, guilt and love clashed inside me. I knew in that moment that if I pulled the trigger, you would remain on Earth and become paralyzed, unable to go on. I knew I could not leave you, for we have grown together like the freshest of intertwined ivy.

We have had our outbursts of temper and riotous rifts, but a sibling provides a steadiness no other can: reaching out a hand to help you up when you fall, laughing with you at some silliness in daily life, collecting without scorn your unfiltered thoughts and dreams. To remove all that a brother gives is to extract some essential ingredient from every cell in one's body, the same ingredient that adds fragrance to

wheat, insistence to a crow's call, orange heat to a flame, and blue to a sky.

Standing up on that desolate plain, I saw in an instant that the brightness of our bond is such that if it is severed by death, life would fade for the one who remains.

I let my arm fall and loosened my grip so the gun smacked with a *crack* against a stone on the path, then thudded onto the grass. Relief flooded into me in waves——lime green, burnt orange, periwinkle, gunmetal gray, and finally my beloved sunflower yellow. I squinted at the grassy fields, the plum-colored earth, the pink flowers nestled in their cushion of dazzling clover.

Purpose swirled inside me once again as I returned to pick up my easel; I hauled upon my back again my own burden, which is to show the world the hues I see——white's purity, black's mysterious textures, blue's endless variety. The spectrum that burns in me with an insistent flame.

Call it an apparition, a waking dream, or a vision, but I saw you standing there. I tell you, Theo, it was no hallucination I saw on July 27, for I more than anyone know the difference. Did you see it, too? On that day, did you see me across a yawning abyss? Did you somehow sense that you saved my life?

So for the last two days I have been lying in bed upstairs in my little garret above the café at Auberge Ravoux. The days passed rhythmically: Early in the morning, the heavy footsteps of the young Dutch painter next door clunked down the stairs, and at noontime the smell of roasted chicken and

Image: Auberge Ravoux, Place de la Mairie, Auvers-sur-Oise

vegetables wafted up to me along with the boisterous laughter of my friends at the painter's table. At midday would come the timid rap on the door and the youthful voice of Adeline Ravoux, the daughter of the house (whom I've painted so often) asking after me, "Mr. Vincent." Then the pastel lull of the evening sunset was followed by the blue-black silence of the starry night—for the fire flickered inside me once again.

My eyes open every minute, I watched the light come in from the window above and change by the hour upon the green wall cupboard and the angles of my room. I smoked my pipe, filling the space with spirals of rich, pungent smoke.

I lay curled up for hours upon hours, gazing at the painting I had tacked on the wall, *The Church at Auvers*. I wrote you once that inside churches I get frightened, and the eerie daylight/nighttime quality of that one is no exception. I painted the interior of the church as indigo and empty as the sky, for I feel a lack of God there, an absence of forgiveness.

My sanity has slipped so many times, Theo, I don't know how to make amends. I've thought of writing Gauguin, but I've not the heart to evoke the evening I came to holding my own bloody ear in my hand, or the times I snapped into consciousness standing over him gripping a razor. Again, the clash of guilt and love.

I thought of Dr. Gachet, the country doctor who lives at the end of the village here, who, although he is melancholy himself, offers care and real friendship. I visit him often at his house overlooking the village, where I recently attempted to capture his sad, gentle, and intelligent face. It is my deepest hope that my portraits will appear as revelations a hundred

years from now, and maybe someday that one will speak to someone. Of course I gave Dr. Gachet the painting. He has provided help to so many of us and been paid only in paintings. He has quite a collection——Cézanne, Pissarro, Monet, Renoir——if only the canvases were worth some money!

Yes, for the last two days I have rested here, smoking, staring at the wall. My dream for an association of Impressionists has made my insides stir again. I've given up on that place in the south where we could live and work together, but perhaps we could all meet in Paris at some hotel near a train station, preferably near the Louvre. Let's set the date for sometime in September. That would give us time to get the word out and for Monet to plan the trip from Giverny, even for Cézanne to come up from Provence and Gauguin to arrive from wherever he happens to be.

And, brother, I've reflected on our friendship. I have always been able to write you about anything—my despair at my illness and yours, my secret fears, my most desperate hopes—and I anxiously await your letters, too, which are full of your own unvarnished truths.

Truth. That is what I've tried to paint. I blend complementary colors to signify the love of two lovers, place light against dark to express thought's illumination. I paint a star to raise hopes and a setting sun to evoke passion. I want my pictures to console as music does, and to have the radiance of a halo, symbol of the eternal.

Someday perhaps people will see they are worth more than the price of the paint.

My thoughts return again and again to my namesake, little Vincent. I hope his soul will be less troubled than my own. It is the thought of him, and of you, that gave me the strength to swing my legs over the side of the bed, shuffle over to the desk, sit down, and pick up this pen.

Writing to you has always made me feel better, but I am weak and fear that *la tristesse durera toujours:* The sadness will last forever. But I know that our own bond will last forever, too. I embrace you in my thoughts.

Your loving Vincent

Of course, in this visible universe, on July 27, 1890, the prevailing theory is that Vincent walked to the wheat fields behind the château in Auvers, pulled the gun from his warm pocket, and shot himself in the chest. He was thirty-seven years old. This is the account of his death in *The Letters of Vincent van Gogh*:

Severely wounded, van Gogh stumbled to the Auberge Ravoux, where Dr. Gachet was summoned when the suicide attempt was discovered. At first, van Gogh seemed to be holding his own and, despite the severe pain, lay on his bed smoking a pipe. . . .

Vincent finally fell into a coma, and died in the early hours of 29 July in his brother's arms.

A letter from Vincent's friend Émile Bernard described the day after his death:

On the walls of the room where his body was laid out all his last canvases were hung making a sort of halo for him and the brilliance of the genius that radiated from them made this death even more painful

for us artists who were there. The coffin was covered with a simple white cloth and surrounded with masses of flowers, the sunflowers that he loved so much, yellow dahlias, yellow flowers everywhere. It was, you will remember, his favourite colour, the symbol of the light that he dreamed of as being in people's hearts as well as in works of art.

Near him also on the floor in front of his coffin were his easel, his folding stool and his brushes.

At three o'clock his body was moved, friends of his carrying it to the hearse, a number of people in the company were in tears. Theodore van Gogh who was devoted to his brother, who had always supported him in his struggle to support himself from his art was sobbing pitifully the whole time. . . .

The sun was terribly hot outside. We climbed the hill outside Auvers talking about him, about the daring impulse he had given to art, of the great projects he was always thinking about, and of the good he had done to all of us.

We reached the cemetery, a small new cemetery strewn with new tombstones. It is on the little hill above the fields that were ripe for harvest under the wide blue sky that he would still have loved . . . perhaps. Then he was lowered into the grave. . . .

In September 1890, after years of fruitless attempts to interest art dealers in van Gogh's canvases, Theo held a memorial exhibit of Vincent's work in his Paris apartment. One can easily imagine tiny Toulouse-Lautrec in his spectacles, the bearded Monet, even growly Cézanne gathered there.

Interest in Vincent's work began after his death and has increased steadily over the years. In 1990, *Portrait of Doctor Gachet* sold for $82.5 million, much more than the price of the paint.

The Musée d'Orsay in Paris, once a train station and hotel, holds the world's largest collection of Impressionist art

and includes the vast private collection of Dr. Gachet. The Impressionists are indeed gathered there.

The van Gogh Museum in Amsterdam hosts over a million visitors annually. October 2009 marked the culmination of fifteen years of research into van Gogh's correspondence with the release of a new edition of the letters, in both book and digital form, and an exhibit that put over three hundred original works of art next to more than 120 letters.

Much debated is the spirit of these letters, between experts and the simply curious alike. Vincent's voice is self-absorbed, narcissistic, unstable, and temperamental, yes. An art critic I am not; yellow and ochre skitter across my retina at equal speed, but I see in his correspondence with Theo a most intimate and loving prism reflecting Vincent's colorful soul.

The letters include requests for money and long missives on his failure as an artist, but always an inquiry into Theo's well-being and later, greetings to his wife, Johanna, always a blessing for little Vincent, a fond memory or two, and a closing endearment, a handshake in thought from Theo's loving brother.

If Vincent had indeed had a vision of Theo up on that windswept plain of Auvers, he might have found the strength to go on.

Theo van Gogh suffered from headaches, hallucinations, and paralysis. January 25, 1891, in Holland, six months after the death of his brother, Theo himself could not go on. His remains were moved to the cemetery in Auvers, where on a summer's day the sky blazes with endless varieties of blue, and fields roll from gold to violet.

The brothers rest together next to a low stone wall the color of cream, underneath a tangled mass of brilliant green ivy.

The Mystique of Art

When the mind's eye rests on objects illuminated by truth and reality, it understands and comprehends them, and functions intelligently . . .

—PLATO, GREEK PHILOSOPHER, 427–347 B.C.

THE ARTS OFFER IMPRESSIONS AND IMAGES that have been passed on through the ages. From the cave paintings in Lascaux to the thousands of statues which preside over parks, places, and porches, France is drenched in art.

There can exist a loop of meaning from artist to viewer that carries the joy of Kandinsky's greens and yellows, the sorrow of La Bohème, and the audaciousness of Eiffel's design. Michelangelo sculpted his *Slaves* during years of unceasing labor for pope after pope, often waiting for payment, and to me, the marble captives carry his own desperation. An elderly Renoir strapped paintbrushes to his arthritic hands, and yet his *Gabrielle à la Rose* has skin soft as a petal. The more we know of the artist—from a prisoner in Ravensbrück who sketched women in a variety of faceless poses to a child who survived a tsunami and drew a picture—the stronger the jolt.

Discovering the personal hero's journey of the artist can allow a work to inspire something new in the viewer's life. Edgar Degas created luscious paintings, but also experimented with lithographs and photography. After his death, hundreds of statues were found in his attic, revealing yet another medium mastered. These works, on display in Musée d'Orsay in Paris, urge us all to try something new.

The way we approach art can make us a vibrant part of this flow of electric meaning. We can approach reverently, using some of the aspects of religious pilgrimage. Or we can wander through a gallery attuned to our own inner signals to stop in front of this work or that, as I did once in Museo del Prado in Madrid, and repeatedly "found" the works of the same artist scattered throughout the museum; or we can search for the specific: *The Venus de Milo*, The Leaning Tower of Pisa, Neruda's *Ode to a Lemon*.

Travel often inspires artists: Isak Dinesen's Africa pumped ink through her pen, as did Morocco for Paul Bowles, and both inspired films. New York's skyline reflects the influence of many

an architect's travels, and choreographer Pina Bausch's dance themes spanned the globe. It has been said that few photographers ranged so far across the surface of our planet as did Henri Cartier-Bresson. "À Propos de Paris" is a story about what he did when he returned to his home, and how he challenged me.

Another challenge, almost the opposite, was given to me from a canvas upon a wall in Musée d'Orsay, which was once a station where trains sparked the rails as they set off on their circuits to the provinces of France and back to Paris. It is still a place of motion and journeys to me. "Eye to Eye with van Gogh" invites you into this vast space, to weave your way through crowds until Vincent's eye catches yours.

The work of art that has most chiseled its way into my own life is the Greek statue Winged Victory of Samothrace, who has done nothing less than give me her wings. How can a statue give a human such a gift?

I have experienced a process I think of as "the mystique of art"—an on-switch for the live current—in which three essential things occur: First, an artist creates a work that is honest and authentic, with the artist holding nothing back. One can see such an artist operating in this flow—he is the writer whose pen seems to fly, the sculptor who coaxes angels out of marble, and the dancer whose body moves as if by an invisible hand.

Next, the viewer must be receptive to the idea that he may have an unknown need or hunger, and open to the possibility of art touching upon it. Again, the more one knows about the artist and the work, the better.

Finally, the timing must be right, the stars, as they say, aligned, to position the person in front of this work of art. One must seize, as Cartier-Bresson would say, The Decisive Moment, and follow the magnetic pull, the trail of breadcrumbs, or our own inner compass that leads us there. We find ourselves facing something that causes a *frisson:* the visceral, physical reaction we

humans have when we are truly touched, a thrilling shiver, a tingling shudder, chills, or goose bumps.

When these three conditions are met, this mystique of art just happens. It can occur with all of us—you, me, a Harvard doctoral candidate, a world leader, or a five-year-old. A case could be made that the five-year-old has more open channels along which to receive these gifts, thus has an advantage over all of us—if you doubt this, keep your eyes peeled next time you are near a child who is mesmerized by a statue or a painting.

"Winged Victory" is the story of how this mystique of art occurred and the statue's spirit entered my bloodstream.

If it can happen to me, it can happen to you. But, images in a book are not the same as the real works, so after you read these stories, I invite you to venture out, follow your fascination with an artist or a branch of the arts, and find a masterpiece to let your mind's eye rest upon.

Catch the live current of art.

À Propos de Paris

To find the extraordinary aspect of the ordinary,
that's what Henri Cartier-Bresson does.

—Ben Shahn, photographer, 1947

"I BROUGHT MY EYE BACK TO THIS PLACE," Henri said as he materialized and joined me on my walk along the left bank of the Seine. He's French, but he speaks to me in English. He died in 2004, but to me, he is in present tense.

French photographer Henri Cartier-Bresson is my mentor in a strange way. Uncanny synchronicities often happen to me related to him, and sometimes it seems he's inside my head. Henri reappears with a message every so often.

"I grew up here in Paris wielding my camera, but my creativity let loose when I traveled to Africa's Ivory Coast in my twenties, then Eastern Europe, Italy, Spain, the U.S., and Mexico. Like you, new people, new sights, and differently charged air in a place far from home ignited my artistic fire."

We continued along the quai. January sunlight lit the gray water and the varnished boat decks below, and shone gold on people's cheeks, the only skin showing beneath black berets and coats.

I squeezed my fingers out of tight red gloves and wrote some notes, because I was inspired by Paris, this place far from my home, whose centuries-old façades and tiny neighborhood shops captivated and offered rich stories.

"I got my first camera in 1915, when I was seven years old. That's how old I am in that photo you keep upon your wall at your home in Washington." In the photo, Henri is in shorts and jacket, with a fedora perched on his head, which looks down into a Box Brownie.

As the young Cartier-Bresson senses one of his first Decisive Moments, his face has the look of absorbed fixation I have always felt when my pen is poised over paper.

The Baroque cupola of the Institut de France glittered as we crossed Pont des Arts, the bridge that leads to the Louvre. From here, Île de Cité's medieval turrets and towers bulged, and bridges reached out like arms on both sides, as in Cartier-Bresson's photo of the wispy-treed tip of the island.

Henri stopped in the middle of the bridge.

"This is the spot where I photographed Jean-Paul Sartre. At that time, 1946, Sartre's Existentialism addressed the conflict between strict conformity and authenticity. After the war, the world needed something to grasp, so this made Sartre a sort of philosophical hometown hero." I remembered the photo: The dome in the distance, Sartre sucks on his pipe with the look that accompanies startling ideas—forehead furrowed, eyes rolling off to the side, mouth in a grimace.

In my mind's eye appeared an image of Terri Herren, my neighbor and friend back in Washington, principal of the local high school. Terri dedicates her life to raising the academic and

emotional bar for hundreds of teenagers. She is the students' touchstone, and greets them with her arm out, a kind eye, and an ear for their troubles and hopes.

I told Henri about a day when I'd stopped by her office to say hello. A scowling boy waited on the bench, repeating to the school secretary, "I just want to talk to Mrs. Herren." Terri walked out of her office, sat down, put an arm around his shoulder and said, "Okay, tell me what's going on." As he spoke, he visibly thawed.

I realized that Terri ventured into the territory of each student's life, be it friendly or hostile terrain, making her a hometown heroine in the way of Sartre in Cartier-Bresson's photo.

I had a hunch Henri saw the connection, too.

After escaping from the Germans three different times during the war, Henri photographed the Liberation of Paris, then traveled the world in the twentieth century, preserving most of mankind's pivotal events—the death of Gandhi in India, the Revolution in China, independence in Indonesia, daily life in the U.S., Mexico, and Cuba—but repeatedly returned to photograph the prospects and people of Paris: animated statues, beckoning bridges, and droll-eyed Frenchmen. I had read once that his photos were taken "in mid-air, without tricks, without letting it get away." He was like a dragonfly, darting here and there to capture images that epitomized his home.

In the other photo upon my wall in Washington, Henri, now middle-aged, has returned to Paris, and stands on a ladder which leans against a stone building. He holds his small Leica camera, his eye trained on some scene below. He has, in his words, "prowled the streets all day, feeling very strung up and ready to pounce, determined to trap life."

Henri developed his eye elsewhere, as Vera Feyder wrote in the Introduction to *à propos de Paris*, the collection of Henri's photos of his home: He "holds still for an instant, with a look in his eye like one of those polar explorers who comes back from the

great open spaces—if they ever do come back—with something of the aching wonder of it all in their eyes."

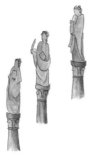

"I'd seen the verdigris statues on the roof near Notre Dame's spire my entire life," said Henri. "But in my photo, they *move*." Taken in 1953, his photo captures the impossible: one apostle twists under the blackened spire, behind him, another holding a sword rotates on his heels, and yet another slowly raises his arm.

"You enhanced what was already there," I told him.

"It's easy to see foreign places and be charmed," he said. "But you must develop an eye for your home."

"That's easy for you to say," I snapped. "Your home was Paris. Every side street presents layers of charm and textures of iron, stone, and history. I'm from a small town in Washington where it rains constantly, there is no Louvre, and very little happens."

"But after I traveled, I had to rededicate my focus to notice women pushing strollers on the tip of Île St Louis, or crisp, diagonal patterns of people strolling along the quais. I could easily have become blind to the familiar and let it become ordinary."

As we meandered, Henri reminded me of the manner in which I had written about my home. The few pieces I'd penned had been about the desire to escape American culture after watching *The Today Show*, and losing my patriotism during the Bush years only to find it along a road in Ireland. Cynical pieces, certainly, and nothing at all about Washington.

Henri and I wandered into the Latin Quarter's Place de la Contrescarpe, and went inside Café Delmas, where we sipped

sweet mint tea from delicate green glasses and watched people summit rue Mouffetard.

"You know the photo I took here, *rue Mouffetard, 1952*?"

A boy, limbs growing in bumps and angles under baggy shorts, narrow belt flapping. His chest is puffed out, chin raised with a bursting grin, his heavily lidded eyes jauntily greet admirers. He is the carrier of important cargo: under each arm is a shiny wine bottle.

"I took it because that boy, Michael Gabriel, symbolized Paris coming out of a decade of occupation and deprivation."

I had a memory of a scene from the previous year: My son's friend Garrett hobbling up our front steps on crutches, a baseball hat on his hairless head. Garrett had been on an arduous climb out of a year of chemotherapy, fighting a cancer that threatened to take his life as it had taken his father's. Our community had rallied around Garrett's family, the kids shaving their heads in solidarity, the moms making meals, Terri raising funds at the high school to buy him a laptop so he could keep in touch from the hospital.

Henri tapped me on the shoulder.

"That photo of the boy with the bottles shows the light side of those years, but I showed the dark side as well, as in the photo taken on rue Saint-Honoré during the Liberation, of men in shirtsleeves and suits, Résistance members and fathers and grandfathers aiming guns at Germans. Thousands were killed and injured during those days.

"I captured exhaustion in a line of grimacing people in drab coats passing through a street market in Bellville. I showed Paris beginning to heal in my photo of a group of boys playing in a bombed-out courtyard in the Marais, the Jewish quarter."

I knew I'd written about the negative aspects of my home, but not the positive.

Henri nodded.

"Later, after traveling to India and China, I returned to the Paris riots of 1968. I saw the damage in the courtyard of the Sorbonne, graffiti, wreckage, a fire in front of the entrance steps, but also noted hope in my photo taken on the Champs Élysées of a college girl standing on the back of a bicycle holding a French flag.

"I made Notre Dame's statues move," said Henri. "Now you do the same with Washington state.

"Your eyes have been opened by Paris, so bring home the vision. It is *à propos*, the right moment, for you to make metaphors for the shimmering shade of green that only appears after constant precipitation, the silhouettes of fir trees in your front yard at bright blue dusk, and the colors of Washington state. Write about the miracles Terri has performed with teens and the grace Garrett showed as he struggled up your steps."

Now, years later, here in my home, in the room with the periwinkle walls, I feel Henri watching me through the viewfinder of his Box Brownie, and looking down from his perch on the ladder against the stone building in Paris.

Cafés here do not offer intricate tea glasses or seventeenth-century ceiling beams. Bridges do not arch their backs in welcome, and the sun rarely lights up the river. Every single crevice seems seeped in raindrops.

But I've just driven across Washington to see my son Brendan, now at Washington State University. He's told me how well Garrett is doing now that he's recovered completely. At the high school barely a mile away, Terri twists through crowds of ordinary kids in the hallways, her eyes rolling over

the students' heads as she asks about their lives and raises her hand in greeting.

I look out the window, and see freshly watered roots sending up bursts of vivid leaves, branches, bushes and stems that look as if they've been dabbed by a paintbrush dripping with green paint.

My eye is dazzled by the aching wonder of it all.

Eye to Eye with van Gogh

*I should like to do portraits which will appear as
revelations to people in a hundred years' time.*

—Vincent van Gogh, letter, 3 June, 1890

I WAS THERE TO SEE HIS WORK, but it shocked me to bump straight into *him*.

A faceless clerk took the museum pass and I stepped inside the cavernous, echoing expanse of Musée d'Orsay in Paris. I hurried past dancers by Degas and millers by Millet, clattered up stairs, and twisted through backpack-toting kids, slow moving seniors, and hand-holding couples. Cézanne's colors vibrated in my periphery vision as I rushed toward *his* room.

I entered and there he was, as if waiting for me: *Self Portrait, September 1889.*

His eyes bore into mine from a canvas thick with turquoise and grey swirls. I recognized Vincent, not with the usual: *This is a van Gogh painting;* but in a more personal way: *Ah, Vincent.*

Image: Saint-Paul Asylum, Saint-Rémy-de-Provence

I knew by the time he painted this, he was weary from his quest to express himself against insurmountable obstacles. Vincent had his first mental breakdown in December of 1888 when he was in the south of France in Arles, spent time in a mental hospital there, continued to suffer mental collapse, then moved to another asylum in nearby Saint-Rémy. In July, he swallowed dirt, paint, and turpentine, and was kept from painting, but allowed to resume at the end of August.

I remembered his wish, written a few years earlier: *What I really hope to do is paint a good portrait.* And here it was, leaping off the wall toward me.

I had recently read *The Letters of Vincent van Gogh,* century-old personal letters written to his brother Theo, his mother and sister, and artist friends, which discuss everything from the waxing and waning of his faith in God to feelings about fellow artists and his pain at the dismal failure of his art to move anyone at all. Through the years since their publication in 1914, many have analyzed these letters to try to pin down the essence of van Gogh.

The letters reveal the mass of contradictions which makes Vincent, and all of us, human: discouragement *and* optimism, joy *along with* despair, victory *in the midst of* defeat.

The letters written during Vincent's last tumultuous months—in the asylum at Saint-Rémy and during the last few months of his life in the little village of Auvers-sur-Oise—reveal his anxiety that repeated hallucinatory spells would threaten what he called his infinite objective: to paint a portrait without telling a lie:

> *Supposing I get out of here one day, wouldn't it be far better if I came back infinitely capable of doing a portrait with some character?*

Again and again he felt *too feeble to fight*, but persisted as he lurched in and out of lucidity. About this self portrait, he wrote:

> . . . *when you put the painting with the light background that I've just done next to those portraits I did of myself in Paris, you really will see that I look saner now than I did then, indeed much more so.*

This self portrait does differ from others Vincent did—one is dark and streaked with intense blues and oranges; another shows a nearly bald, gaunt van Gogh, his red beard in hideous constrast to a green background; another a grim man in a fur hat with a bandaged ear. His expression in *September 1889* is intense but focused, and his face blends with the pastel colors of the background to create a peaceful mood.

I looked around the room, crowded with Vincent's work: a peasant couple napping in the hay next to a wagon, their feet touching, *The Arlesienne*, a woman with fine, narrow features; *A Starry Night* painted in 1888, of reflected stars and lights on water.

The Church at Auvers filled me with a hollow feeling. The dark blue inside the church has the same quality of the air outside it, a church devoid of anything. Loneliness had a torturous grip on Vincent in those months before his suicide, and his faith toppled. Religion for me has often felt like the emptiness in that church.

I remembered slides on the wall of a college classroom: bold yellow sunflowers, stark and simplistic faces, and wildly exaggerated forms. I had wondered then, years earlier, why people were so passionate about these childish paintings, and they had failed to move me.

Seen in reality, Vincent's work cuts deeper than mere color and form. *The Bedroom* had previously struck me as a seasick scene of lurching furniture, but knowing that Vincent painted it partly *to rest the brain, or rather the imagination*, the actual canvas made me

feel as if I entered the room, walked across the wood floor, sank down upon the bed and burrowed under the red blanket. Vincent loved this painting, and carefully positioned it on the wall inside the Yellow House in Arles to greet Paul Gauguin when he arrived for what Vincent had planned as their idyllic artist's retreat, but which ultimately ended in ear-mutilating agony.

Musée d'Orsay has been remodeled since that earlier visit, with the works of different artists mingled together, Monet next to Manet, Renoir alongside Cézanne. In one of the new rooms, van Gogh is side-by-side with Paul Gauguin in a way he couldn't manage to be in reality. This is an intriguing arrangement, but the punch of purity I felt when standing in a room surrounded by the work of one artist is diluted. When I go there now, I miss Vincent's room.

Musée d'Orsay has retained the hustle and bustle of the hotel and train station it once was. It opened in 1986 as a museum in which the whole range of the fine arts between 1848 and 1914 are represented. Three million annual visitors scurry around inside the arched glass and metal structure—gazing out of the giant wall of windows under the famous ornate clock, gliding up and down ten flights of stairs, enjoying *foie gras* in the elegant Café des Hauteurs, and milling around the sculpture, decorative arts, architecture, photography . . . and paintings.

That day I was drawn to Vincent's room, I remembered something I'd read about creativity. Fernand Pouillon, twentieth-century architect, wrote this about what he called Real Work, work that is true, direct and honest:

> *Never is one's courage courageous enough, never is one's sincerity sincere enough, nor one's frankness frank enough. You have to take the greatest possible risks; even recklessness seems a bit halfhearted. The best works are those that are at the limits of real life; they stand out among*

a thousand others when they prompt the remark, "What courage that must have taken!" Enduring work follows from a leap into the void, into unknown territory, icy water or murderous rock.

Self Portrait, September 1889 was van Gogh's leap into the void. He looks fearful inside his cocoon of gentle swirls, but his eyes sustain calm. His sensitive mouth shows a warrior's steely resolve, and between his lips is the thinnest of blood-red lines.

The bloody line is Vincent's harsh truth. It emerged during those times he had to dig deep to find the strength to pick up a paintbrush, for any stability he had was fragile. Was it absinthe liquour, epilepsy, or plain old insanity that lashed at him and made it a battle to the death? The answer is unknown. He conquered starvation, fear and madness to paint not just what he saw, but the very essence of what he *was.*

It is difficult to know oneself, but it isn't easy to paint oneself either, Vincent had written. In this work, he did both.

We know van Gogh was not a worldly success. In his lifetime he sold only one painting, yet he slogged on, writing that he didn't want to be thought of as melancholy, sour or bitter. He wrote of his experiments with color, *I dabbed the dirty mixture over the painting, behold, at a distance it softens.* Vincent felt the human messiness, imperfections—the dirt in his life—softened and refined his own character. I could see this in the way he painted his own face, but there was more.

In my pictures I want to say something consoling, as music does. I want to paint men and women with a touch of the eternal, whose symbol was once a halo, which we try to convey by the very radiance and vibrancy of our colouring.

This Real Work holds inside it an eternal truth: It requires extra courage for all of us to include the dirty smudge that

smears—the emptiness of a church, a frightened look in the eye, or our own oddest perceptions and weaknesses. It is easier and often prettier to leave out the sad, silly-sounding, or strange details. If Vincent could reveal himself so honestly to the world at his weakest moment, so can all of us.

What courage that takes.

That day as I moved away from Vincent's portrait painted over a hundred years earlier, I imagined him dipping a tiny brush in red paint, leaning in close to the canvas of pale greens and blues, and with delicate care, touching the brush to his fragile lips to add the thin, bloody line.

Behold, at a distance it softens.

⟋

Winged Victory

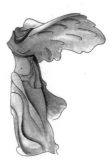

Vita brevis, ars longa.
Life is short, art endures.

—Hippocrates, Greek philosopher, c. 460–400 B.C.

IMAGINE BEING PLACED AT THE TOP of the main staircase inside the most visited museum in the world. Daylight streams from a ceiling of high, white arches, bathing and illuminating you in shimmering light. You are exposed with no shield from thousands of daily visitors. You have neither head nor arms.

Winged Victory leans forward on the prow of her ship atop the sweeping Daru staircase inside Musée du Louvre. Her legs, caressed by wind-whipped fabric, are sturdy. Her chest is held high and her feathered wings fly out behind. She beams with boldness, as if she knows exactly who she is.

I clicked along the marble floor in my Franco Sarto boots, a modern woman, chic, savvy, worldly. But when I saw her poised up there, admirers from all over the globe gazing worshipfully, I stopped and stared. I'm not easily intimidated, but she had me.

Winged Victory had something I lacked.

As I had prepared to travel to Paris that January, I'd remembered a lecture by writer Phil Cousineau. He'd been speaking about his book, *The Art of Pilgrimage*, which urges us to *reimagine* the way we travel: to weave our way through disappointments and follow the hunger for something deeper, be mindful and alert, and cultivate the ability to respond from our most authentic place. As we travelers then progress through seven stages of pilgrimage—beginning with the longing to go, continuing all the way through to returning home and reflecting on the trip—the journey becomes transformative.

As I listened, I had tried but couldn't quite locate this authentic interior place, the source of all that was me. This sensation of searching, as if digging for an underground spring, was so familiar that I'd forgotten what I was looking for.

Cousineau's voice had trembled with the powerful potential of this type of travel. "The truth of your life is as close to you as the vein pulsing in your neck," he'd said.

> *All of the answers are within us, but such is our tendency*
> *toward forgetting that we sometimes need to venture to*
> *a far away land to tap our own memory.*

–Phil Cousineau, *The Art of Pilgrimage*

Paris was a place I'd visited many times—sipped wine at sidewalk cafés, dashed from the Left Bank to the Right, listened to violins inside cathedrals and jazz in crowded clubs.

I looked out of the window of the airplane as it descended, and remembered that on previous trips I had felt the city tug a string inside of me, as if threatening to unravel something tightly knit. I had been certain Paris could untangle me, but had scolded myself for this strange, flighty thought. I didn't need untangling. This time, reflecting upon Cousineau's words, I knew there were

twisted knots covering up my own original self, and I was disconnected from her.

She was buried inside, but I had a picture of her: a four-year-old sitting in the front row of a 1963 black and white pre-school photograph, staring at the camera with penetrating eyes and a tiny crinkle between her brows.

My lower lip sticks out a fraction to indicate I would fold my hands in my lap, but would assume no grinning pose, just my own unwavering, challenging stare. My shoulders are slumped, relaxed. I remember this time in life—I saw under the surface of things; a million questions rolled around inside my head. I was content to be inquisitive, for it was my natural state, and I was comfortable in my own skin, but grown-ups had grown weary of my constant questions. I was different and I knew it, too intense, serious, and direct for the comfort of the adults in my life. My parents blanched when the pre-school teacher told them I was not perfectly cooperative, indeed was the most independent girl she'd ever seen.

In my first grade class photo, this girl, in the back row, tilts her head, shrugs prettily, and stretches her lips wide in a smile that carves dimples into both cheeks, but does not come from within. Her eyes are cheerful, unseeing crescents. She looks fun, not fiery. This child is Well-Behaved, far easier to adore than the unblinking little owl. She will grow into a chic, savvy, worldly woman.

Was it America's expectation of little girls in the 1960s that made me hide my brooding introspection? I remember making the conscious choice that it was easier to cultivate perkiness and soon I felt compelled to be cute.

Over the years, the mask morphed into a costume that never quite fit on an actress who played her part to perfection, but would have preferred to be narrator, waiting in the wings. In school, I felt like raising my hand a hundred times a day, instead I told giggly jokes. As an adult, I desired a life of learning and study, but instead became an elementary school teacher. When

I longed to listen, I talked. The extroverted shield I took up appears in the stack of photos that chronicle my life: laughing teenager, gregarious sorority girl, effervescent wife and mother, accomplished public speaker, group leader.

This persona still clung to me over four decades later as I walked off of the airplane into Charles de Gaulle airport.

One of the ancient functions of pilgrimage is to wake us from our slumber. [3]

A light drizzle fell as I climbed into a taxi. The cab glided into the city as streetlights gradually came on. Paris was luminous: the huge Corinthian columns of the church of La Madeleine held a white glow within and the opulence of Opéra Garnier gleamed against the indigo sky. As the taxi circled the Place de la Concord, its obelisk soared out of the mist and the gigantic medieval palace of the Louvre exuded a beckoning air of mystery that seemed directed at me.

My self was here, I thought. *My self was here?* It sounded melodramatic and new agey, not at all like me, I began—but then I remembered her. In the taxi floating around the brilliantly lit city, she stirred, stretched and blinked sleep from her eyes.

Pay close attention to any dreams still frothing on the surface of your mind.

That night, as I swooped in and out of sleep, I dreamed of The City of Light waiting outside my hotel room. The history of Paris is not for the faint-of-heart: the scarlet blood of its kings and queens has trickled along the cobblestones and mingled with sticky redness spilled out of the poorest street urchin. Everywhere one encounters statues of history's great thinkers. Museums hold

[3] All quotations are from *The Art of Pilgrimage* by Phil Cousineau.

priceless artistic treasures, bookstores cradle the questions of writers and philosophers. Cafés hum with contemplation.

There is nothing frivolous about Paris; it demands to be taken seriously.

The oldest practice is still the best. Take your soul for a stroll.

Every time I stepped outside, my feet insisted I wander the streets, where I greeted people with a perky *Bonjour*. Tree branches were outlined stark against the sky, stone buildings frozen solid. Notre Dame's stained glass was colored ice, and the clanging of its bells cut through the frigid air.

I let the magnet inside draw me to the Louvre, where I walked slowly up the staircase, never taking my eyes off Winged Victory. Called Nike by the ancient Greeks, she is the goddess of victory and the decisive moment in life—in athletics, war, even love—when we are at a crossroads and must draw upon all we are to spring forward.

The statue—made of Parian marble, the coveted prize of the Greek island of Paros: fine-grained, semi-translucent, pure and entirely flawless—was once nestled in a niche carved out of a rock in an open-air theatre on the Greek island of Samothrace sometime around 190 BC, the sky above her blending with sea-blueness on the distant horizon.

Winged Victory was unearthed in fragments, brought to Paris in the 1860s, and has been reassembled in stages since her discovery. Her outstretched right wing is a plaster version of the original left one. In 1950, a hand and the tip of a finger were discovered on Samothrace, and the rest of this finger and a thumb were found in a dusty drawer inside a museum in Vienna. These pieces now rest inside a glass case near her podium.[4]

[4] Winged Victory has recently been restored. Details will be explored in the Signs chapter of this book.

I wondered what it felt like to be removed from one's niche bit by bit, transported to a far-away land, and reassembled.

I viewed her from all sides: from afar, her wings were spread wide in a kind of challenge; up close, the smooth texture of her leg contrasted with the creases in her drapery which cut deep shadows; from below, her torso, slightly twisted, exuded strength. I knew she had a message for me.

I wondered if her head and arms had weighed her down like so much ballast. Without arms, the intricate, scalloped design on her wings stood out in high relief; the lack of a neck accentuated the arch of her torso. What she had more than made up for what she lacked.

I felt envious. How could I emulate her?

Uncover what you long for and you will discover who you are.

I peered into a café where cups steamed and lamps shone halos upon the walls. When the door opened, an aroma of coffee and buttery croissants wafted into the street. I looked in at the people; there was something in their faces that reminded me of the statue in the Louvre.

A young student wearing glasses, a scarf slung around his neck, puzzled over something his friend was saying. His forehead scrunched and his eyes darted as his brain twisted and turned. He contemplated.

An older woman with white hair and coral lipstick sat alone and meticulously sipped from a white cup; I could see her inner poise, elegance, and utter lack of pretention. She sat there quietly, comfortable in her own skin.

A boy of about nine years old leaned toward an elderly man, likely his grandfather. The boy's brows were knit and I could tell he was asking a string of quite serious questions, which his grandfather pondered. As I looked through the window I knew

that these faces revealed the true spirit inside with the same self-possession I'd noticed in Winged Victory's pose.

I could see in the window's reflection that my own face wore a smile, and it suddenly felt heavy. It was ballast, not part of my essence. Slowly, I let the mask drop: forehead, eyes, mouth, cheeks, chin. Something surged from deep within me. My brow lowered, my eyes opened wider, my mouth melted into its own serious expression. The muscles in my face felt lighter and I could feel my cheeks loosening, my shoulders relaxing, the vein pulsing in my neck as if attuned to an inner rhythm.

We learn by going where we have to go; we arrive when we find ourselves on the road walking toward us.

During the next ten days, the self of the pre-school photo emerged. I welcomed her back, shedding wide-toothed smiles and letting the quiet observer emerge, watching, pondering, day-dreaming. I mulled over questions rather than eagerly spilling forth answers. I let myself sit, unsmiling, sipping a glass of Bordeaux.

For the first time that I could remember since the age of four, I was myself with the world.

In sacred travel, every experience is uncanny. No encounter is without meaning.

As if a cast assembled to help, the people I encountered showed me how I could *be.* In a tiny upstairs nook with books crammed in every crevice, a group of reflective writers recited prose that revealed their wishes and heartaches in voices that rang with sincerity. Michèle, an artist who had carefully cultivated her observer's eye, shared her personal and creative secrets with me; we felt our spirits kindle. A shy Irish poet spoke his thoughts with quiet confidence inside his lyrical accent. None wore a false mask of frivolity, and when I was with them I didn't either.

The challenge is to learn how to carry over the quality of the journey into your everyday life.

Now, I prepare to depart Paris. It is night, the lights outside blink and flash. I settle in the airplane seat and consider how I will blend my inner and outer colors when I am home. I worry that I will become too intense, too shy, not fun enough, but I will continue to excavate traits I forgot I had. I am the girl in the pre-school photo *and* the woman who walked the streets of Paris. I am charged with the current that flowed from the statue at the top of the stairs.

The airplane rumbles along the rough runway, gaining speed. I can feel the nose tilting up and the smooth, weightless sensation of liftoff.

I think of how Winged Victory moved from her niche in Samothrace to her pedestal at the top of the stairs. She is in the precise place where the loss of her head and arms enhances her ethereal beauty.

Late at night, the Louvre is empty, the security systems are activated, and all is still. It is dark, the arches above her fade to black, but she glows golden, illuminated from within. She stirs and stretches. Her wings shiver and shimmy, her feathers flutter.

She lifts, she ascends, she soars.

Victory.

PART SIX

The Storykeeper

But words empower us, move us
beyond our suffering, and set us free.
This is the sorcery of literature.
We are healed by our stories.

—TERRY TEMPEST WILLIAMS,
AN UNSPOKEN HUNGER

Image: Plaques marking crash, rue Pajol

RENÉ PSAROLIS HAS BEEN AWARDED the Medal for Veterans of Foreign Wars from the U.S., but he holds within him the highest gift bestowed upon the keepers of stories.

Maya Angelou, who spun her words out of dark places, glowed with it. Joan Didion's spell of grief began to break as she told her own story in *The Year of Magical Thinking*, creating something new inside her. Vanessa Croccini, filmmaker of *Get Together Girls*, which presents stories of transformation in girls of Nairobi's slums, radiates this quality. It resonates in the voice of writer Tim Cahill as he tells stories of orphans he has met over the years on his semi-annual Proper Walk through Kenya. And it connects in a visible, illuminating bond the storytellers of old with the eager-to-learn youth in Café Clock in Marrakech, Morocco.

René was seven years old in 1944, in Nazi-occupied Paris, when a USAF B-17 bomber crashed in his neighborhood. The explosion, and the sight of three dead American airmen being pulled from the wreckage, impacted René in a way that the hardships of the occupation had not.

Graham Green wrote, "There is always one moment in childhood when the door opens and lets the future in."

This was such a moment for René.

Each of us has a memory of the instant we first glimpsed life's harsh realities. For some, it is the death of a loved one who does not, in spite of childish wishes, materialize the next day. For others, a bloody car accident, anger escalating to violence, or the moment hunger becomes starvation.

When did such a moment occur in your life? One second you were a frivolous child, the next a knowing being.

What René ultimately did shows how we can take the stories that touch us and offer them to the world in a way that unleashes the power of the universe.

James Bonnet, ever since our first seminar in the Jura, has taught me much about this.

"Unlocking the secrets of story awakens the power of story within us," Bonnet said to me. "This power stimulates our imaginations and give us little tastes of paradise, which trigger fantasies that lead to desires for positive actions in the real world.

"Each story reveals a little bit more of the hidden truth. And piece by piece, bit by bit, drop by drop, the whole truth is revealed."

Over a period of many years, René pieced together the story of the plane crash. He didn't quite know why he pursued it, except, as he often said, he would not have survived another winter of the occupation. I believed him, knowing the conditions in Paris outlined in "Mentalité Terrible." His mother protected him, as you shall see in "The Boy and His Shield," but a child growing up in an occupied country bears scars that remain.

Somehow, during the process of gathering and offering these stories, René himself was healed.

Perhaps this is how it works. If we do the best we can to honor the tales that come to us, the gifts of compassion, forgiveness, understanding, and peace return to us in a cycle, causing an inner alchemy. Do you have an image or scene that haunts you? I urge you to excavate your own stories and continue to stir them up, shaking them like rocks in a pan, for I believe they hold glinty flecks of truth that can change the world, and the telling of them can transform you.

"Storykeepers" is my essay about René's collecting and generous offering of stories, and how Dutch filmmaker Rogier van Beeck Calkoen and I created the award-winning documentary film, *The Storykeeper*.

Edouard Duval, who is in the film, once said to me, referring to the Allies actions in France, "My family has always had a love

for Americans." For years, I have felt the gratitude that continues to flow from the French to Americans, but at the Hot Springs Documentary Film Festival in Arkansas, I felt something new.

René and his wife Ann had come from the U.K. for the festival, as well as Michèle Duval, my good friend and the wife of Edouard. Family and friends of Kirby Cowan, one of the airmen, were among those in the crowded theatre. Upon the film's conclusion, the audience rose to their feet in an outpouring of appreciation for this Frenchman who had honored Americans.

René's eyes brimmed as he extended open arms.

It was an exchange of love and respect between the people of two countries I love, and I had been pining for it ever since the days of Freedom Fries and the Coalition of the Willing. Something lustrous lit up within me.

This is the reason we storykeepers do it.

May you be inspired to share the stories you hold dear, when you see for yourself how René Psarolis has received a gift that remains: a luminous, glittering alcove of pure gold inside of him.

Mentalité Terrible

Paris now enters a dark night, the darkest, longest fifty months of all her long existence.

—Alistair Horne, *The Seven Ages of Paris*

EVERY EVENING SINCE THE YEAR A.D. 358, when the Romans settled on a small, leafy island in the middle of the Seine, the Parisian sky had sheltered her people. For more than one thousand five hundred years, as this place had endured conquests, upheavals, and revolutions, this particular sky had comforted Parisians.

But on a warm evening in June of 1944, the sky—looking particularly lovely in a shade somewhere between china blue and robin's-egg, strewn with scalloped clouds, shedding a soothing amber glow—could not alleviate fear inside her people.

This is the city in which the boy, René Psarolis, lived.

Hitler had been in power in Europe for more than eleven years. Goebbels, Göring, and their agents had been ruling Paris for four. Fear, like static electricity, was everywhere.

With no credible newspapers, Parisians learned of events through word of mouth. One woman had seen a lorry piled high with corpses cruise down Boulevard Sebastopol, a group of boys had seen an old man trip on an outstretched jackboot and have his head blown off. French gendarmes had been seen marching into schools and coming out herding groups of children who soon vanished.

The worst crackdown had begun in the spring. Green trucks rolled over the pavement and cobblestones at a deliberate crawl, like angry, salivating beasts. The helmeted soldiers standing in them, guns at the ready, were indeed trolling for prey. Anyone aiding downed British or American airmen? Shot. Assisting the Résistance? Shot. Listening to the BBC? Reading a clandestine newspaper? Taking a photograph? Shot. Using forged rationing coupons, violating curfew, being in the wrong place at the wrong time . . .

In the month of March alone, 4,746 people had been arrested; by June, many people stayed home, and those who ventured out moved like robots. Place de l'Opéra was vacant but for an occasional shiny black Mercedes with swastika snapping in the sun and officers' elbows sticking out of the open windows, and a few horse drawn carts and battered bicycles. Panzer tanks rumbled down the Champs Élysées, packed with men in black uniforms whose berets' SS insignias clashed with pink cherry blossoms lining the avenue.

Paris had to envision a new self portrait; she could no longer recognize herself. Whispered across café counters, mumbled along sidewalk queues, and discussed as people leaned across balconies, each new rumor that rippled through the city seemed more atrocious than the last:

At Gestapo headquarters on Avenue Foch and rue des Saussaies, screams and shots were heard every evening now.

French were increasingly turning in fellow French to face nightly firing squads inside these headquarters, which were indistinguishable from the neighboring apartments—white stone, wrought-iron balconies in neat, tidy rows—but for shutters closed to block the light and contain the darkness within. Inside were iron bars, stark rooms, instruments of torture, and of course, echoes of screams.

This created what was known as *mentalité terrible*, when even long time friends and family members began to distrust each other. Desperation drove many to become informers, and collaborators flaunted their new bicycles, thick coats, sugar, meat. Political beliefs collided as Communists clashed with Résistants. Tempers flared, and, for the first time since the revolutions, the general term *citoyens* no longer referred to Parisians as a cohesive group.

The Germans, foreigners, had been a threat from the beginning but bared sharper teeth steadily as time passed. Now the danger was the person one brushed past on the street, the neighbor whose eyes had suddenly become shifty, the uncle whose table had radiated welcome each Sunday. People drew into themselves, snails squeezing into shells.

Résistants and Communists were being executed in the woods near Mont Valérien.

Three or four victims at a time would be lashed to posts and face a long line of Germans glaring down the barrels of rifles. Eleven thousand were killed in the cellars of Château Vincennes and the woods of Mont Valerien.

After the Allied landing in Normandy, some towns had tried to liberate themselves and received terrible reprisals—hangings from balconies, trees, lampposts.

In one such town, Oradour-sur-Glane, in the Haute-Vienne, the Germans massacred everyone: 642 people. The men were machine-gunned down, the women and children shoved into the church and burnt alive before the town was razed to the ground.

The Allies were bombing the industrial outskirts of Paris at a frenzied, furious pace.

On April 21, 1944, a barrage of bombs had decimated the La Chapelle district in the 18th arrondissement. There was a deafening racket, and then cups bounced on counters, photos hopped on mantles, chandeliers swung from the ceiling. Sirens and blasts screamed in alternating rhythm.

Afterward, the night sky glowed red with what seemed a million crackling torches that illuminated the dead bodies of more than six hundred men, women and children. The area was a mountain range of debris—steel beams, crushed stone, tree branches, bed frames. Apartment buildings were blown to bits, façades had gigantic, ragged holes, windows had no glass, entire walls hung precariously. Corpses of all sizes were spread out like rag dolls.

The next day, it was all gray dust except for a yellow shirt with its sleeves spread; or a red sofa, coils springing out, stuffing spilling onto the rubble; or a dead orange-striped cat. Fires flickered everywhere and the stench conjured images of hell. People tended each other's burns, gashes and broken limbs, or stood in stunned silence, smelling the burning wood, appliances, and flesh, holding bags of whatever belongings they'd managed to salvage, and staring at the wallpaper, crown molding and fireplace mantles which were suddenly exposed. Their homes were *kaput*, as the Germans would say.

The danger in the streets came from the desperation of the cornered beast, for the Germans knew that the Allies had landed at Normandy. The danger from the skies came from the

Allies ferocious attempts to stop the war machine, not always perfectly aimed.

The Germans were killing the Jews they'd taken.

Two years previously, in what was known as the *grand rafle*, more than 13,000 Jews had been arrested, herded into the Veledrome d'Hiver cycling stadium, crammed onto cattle trains and rolled off to camps. The next year, a roundup in February seized hundreds of children. One school in the Marais, where many Jews lived, lost 500 students.

Since then, thousands of Jews and political deportees had been sent to camps in France—Drancy, Beaune-la-Rolande, Pthiviers, Compiègne—or on to Germany.

Few Jews were left in Paris, and the Marais, where so many had lived, was like a ghost town with its boarded up shops and empty, looted apartments.

It was said that in Le Struthof (Natzweiler, in German) camp in the Vosges Mountains in Alsace, behind a beautiful, old stone fence, there stood a whitewashed building with windows boarded up that was used as a human oven.

The fate of those missing was beginning to dawn on Parisians.

Men were disappearing off the streets, taken to Germany to work.

An official program had been in place, *Service du Travail Obligatoire*, which allowed the "requisition" and transfer of hundreds of thousands of French workers to Germany to work in camps, factories, farms and railroads. By June, this requisitioning consisted of snatching able-bodied men off the streets with no questions asked. Men disappeared without a trace.

No more meat would come into Paris again and people were dying of starvation.

Even dogs and cats were eaten. Children grew so slowly that their bodies were unable to summon puberty.

The previous winter had seen the end of coal; babies had frozen to death in cradles, the elderly in their beds. Electricity and gas were rarely on, maybe a half-hour a day. Mothers were petrified that their children would starve, fathers panicked when they were out of sight of their families, even children feared to play freely on their own streets.

This was Paris in the summer of 1944.

The sky, now streaked with darkening lavender and mauve, with the last golden sunlight of the day outlining the edges of clouds, could not protect Parisians from the harrowing certainty that the rumors were true.

The Boy and His Shield

Mother, you made him small, it was you who started him;
in your sight he was new, over his new eyes you arched
the friendly world and warded off the world that was alien. . .

Ah, where are the years when you shielded him just by
placing
your slender form between him and the surging abyss?

How much you hid from him then.
The room that filled with suspicion
at night: you made it harmless; and out of the refuge of your
heart
you mixed a more human space in with his night-space.

—Rainer Maria Rilke, *Ahead of All Parting*

RENÉ PSAROLIS WAS HAPPILY WRAPPED in his own insulated world.
He was busy trailing behind his big brother Henri and his pals,
walking hand-in-hand with his papa, and blooming under the

nourishing care of his maman, who cleared a path for light in the darkness of the German occupation.

René's maman had very dark hair and eyes, with a bold, level brow identical to the one he saw in the mirror each morning. Her smile was solid and steady, and created two creases that made a perfect triangle from her mouth to her nose. When she smiled at him it was utterly impossible for René to stay miserable, mad or afraid.

The mother of a seven-year-old boy instinctively knows the precise dose of the poisonous evil of the outside world that her boy can successfully integrate into his psyche without it spilling into his soul. She cannot prevent his exposure to violence or wickedness, especially if his country is trapped in a brutal occupation or has suffered the ravages of war, but according to his temperament, she runs the worst atrocities through a filter of sketchy details, vague explanations and sudden distractions so that her boy receives life's shocks in smaller, less lethal doses.

If a mother is vigilant in this way, the torture of innocent people, cold-blooded murder, and the dangerous possibility of becoming a target himself remain hazy ideas that hover beyond her son's radius. But like the sharp, shiny tip of a pin approaching a balloon, reality advances toward the imagination of a boy this age gradually, until all at once it bursts in. Wise is the mother who knows that, though she shields her son, she has no real control over when this moment occurs.

René was born between the two world wars. When he was three years old, Germans took over Paris. The occupation meant fewer toys; candies and sweets disappeared, but he didn't miss them. He spent the next few years in the warm embrace of his family and did not feel deprived in spite of increasing scarcity.

The Psarolis family of four lived on the second floor of a cream-colored apartment building on rue de la Chapelle, facing the bulky church of St. Denis-Jeanne d'Arc. René's jolly Uncle Basile and his wife lived on the sixth floor. The stone façade on

the entrance to the building was slightly curved at the top, and in the middle was a man's face with a curly-carved beard over full cheeks, and stern eyebrows. The face appeared to be looking down upon all those who entered with a fierce but protective gaze, with iron balconies rising above in loops and swirls.

One day, René noticed that more American bombers were flying overhead, and Papa pointed at them.

"See son," he said, "those are Americans; they are our friends. We will soon be free."

René didn't quite know what the word "free" meant, but he was lifted by the surge of something unrecognizable in his father's voice.

More frequent wails of the air-raid siren meant trooping down the stairs, across the courtyard to shuffle into the shelter and huddle with the neighbors, who whispered about the Americans landing in Sicily, fighting over in Italy, and bombing the suburbs here to knock out the Jerries' war machinery. That same odd lilt was in their voices that he had heard in Papa's, but René hadn't enough experience of this to recognize it as hope.

Soon the sirens came so often that sometimes the family didn't bother trudging down to the shelter.

The Third Air Division of the United States Air Force continued hitting heavily. One evening just before curfew, René and Henri were walking home on rue de la Chapelle and looked up to see an aircraft being shot down on the horizon, quite far off. Through the darkness, the bright torch plunged to earth, and an explosion shook the ground. They could see the fiery orange glow of flames darting up into the sky, but it was way in the distance, beyond the buildings in their neighborhood.

The next day, rumors started spreading that the whole crew had been killed. "Bodies here and there," people said. Two days later, Papa said that the German press was showing pictures of a body they said was the pilot's.

"I heard the body was picked up by a French family," said Papa, proudly. "They covered his face, out of respect for the guy."

After that, during that particular hour of evening as he and Henri headed home from their afternoon play, René's heartbeat would quicken and he would pump his legs faster and hear his footsteps slap the sidewalk. Even though that flaming airplane had landed far away, he began to envision one spiraling down out of the sky and smashing Henri and him, or Papa on his way home from work, or Maman as she went out to find food. But when they walked under the entrance to their building, the carved face looked down as if to say, "You're safe here," and they scrambled up the stairs. Once home, René forgot his fears—the impact upon the boy was muted by the routine of his family, kept in rhythm, as such routines are, by his mother.

Winter meant bitter cold and less and less food.

René's maman had to queue for hours just to get a drop of milk, if she was lucky. Sometimes she'd spend half the day inching toward a shop, reach the door, and there would be nothing left. Shutters would slam down with a tired voice saying, "Come back tomorrow."

All there was to eat were turnips. Henri would reach over and pinch René's nose, he'd open his mouth, and Maman would put a spoonful in.

"One day," she would murmur, "you'll have something sweeter."

There were no phones, no radios, no real news, for the newspapers were all run by Germans and collaborators. If a camera was discovered, it would be stomped upon and smashed. René had never actually seen a German up close, only in the backs of trucks trolling by, but their presence had continued to create a long list of things René and Henri were absolutely *not* allowed to do when out in the neighborhood—pretending to be soldiers, or

waving airplane-hands and wailing engine-sounds at the top of their lungs were *Verboten*. Still, whispering, chasing each other, and jostling games were enough to keep their boy-spirits up.

Such is the way of a seven-year-old boy. He exists in the now. Whatever didn't make sense yesterday is gone; whatever will happen tomorrow is hazy. Life is all about the action of his body, the way he can make things move through space, and his place in the hierarchy of his pals. In this way, René floated through life with buoyant boyness.

One day Papa did not come home. By evening, Maman was desperate. She could not have gone into the local police station and said to the gendarmes, "My husband has disappeared, help me find him." She knew they would have just laughed in her face and told her to go home and maybe someday she'd find out what had happened to him.

An icy hand of fear gripped René's throat every time he thought of Papa. At night it squeezed tighter and his eyes were open so wide that he could feel cool air swirling around their edges. But Maman sat on the edge of his bed for a longer time than usual, so he slept.

Three days and nights passed with no sign of Papa. On the afternoon of the fourth day, someone knocked on the door and Maman signaled for the boys to stay back. She opened the door only a bit, but through the crack they recognized a friend of Papa's.

"I've no one to keep the boys after curfew; I'm bringing them," Maman said in a low voice which the boys strained to hear. After he left, she said nothing, just continued washing socks with the soap that turned her hands red. After dark, Maman, Henri and René walked through the silent, deserted streets to the friend's house and there was Papa.

The four of them embraced as relief flooded through each of them in different waves. René's throat opened and his breath flowed in and out freely.

"Did you see anything, any people looking in the alley? Nobody, no stranger?" René had never heard Papa's voice tremble like this.

Maman assured him there was nothing unusual, and reminded him that the concierge would chase away anybody who didn't belong.

After a few days, Papa returned home but didn't go out.

After the boys were asleep that night, he told his wife what had happened. He had been grabbed off the street by two Germans who forced him into a wagon packed with men, a few he recognized. They were headed toward Gare de l'Est, where Papa knew soldiers were putting able-bodied men on goods trains; they needed manpower to work in Germany as forced labor. When the wagon slowed, Papa and two other men opened up the door and jumped out. They knew the Germans would be searching for them, so they had to lie low for awhile, thus it was three or four days later that he reached the friend's house, but of course he couldn't come home too soon. The Germans had eyes everywhere; they would have been waiting for him. People did not ask questions anymore for fear of being beaten and taken away.

For a while, whenever friends came to visit, the adults would speak in whispers. René's ears perked up as he tried to make sense of the whole thing, but Maman took care to distract him by a task or a treat. His mood bounced back up as a cork does after being submerged.

One night in April, René was jolted awake by his father's voice.

"Get up, this time we have to go to the shelter," Papa said loudly. The air raid sounded its usual shrill, cascading wail through the window, but there was additional booming and it

sounded as if it were raining hard. The sky outside glowed red into the room.

The intensity of the noise was horrific.

The four of them headed downstairs to cross the courtyard. At the bottom step, they stopped short.

Debris was falling onto the stone floor of the courtyard in a deafening downpour. The air was an eerie crimson and it was raining shards of metal that flashed and crashed to the ground. René could not even see to the other side of the courtyard. It was like the sky had broken and all of it was being dumped on this square of stone right in front of their faces. On their own square of stone.

For children, at times the whole world seems a chaos of showering events, and they sense that the day will come when they must step into it and enter a time when nothing will shield them from sharp edged shrapnel.

The family sat down on the steps, Henri and René in front of their parents. René began shivering, although he was not cold. He smelled a rush of Maman's orangey scent and felt something soft laid on his shoulders and smoothed across his back. It was her sweater. He leaned back against her legs, keeping himself inside her safeness. He soon stopped shaking.

"I know this is the worst night, but things will be all right," she whispered, but she knew the pin was edging ever closer to the balloon.

❧

Storykeepers

Alchemy: A power or process of transforming something common into something special; an inexplicable or mysterious transmuting.

—Merriam-Webster Dictionary

*"I haven't been a saint my whole life,
but I have done this one thing."*

—René Psarolis

⌒

As we crossed the Champs Élysées, I looked past Rogier's blond curls and the rumbling beast of traffic to the triumphal arch beyond, which held hushed shadows and autumn sun inside its simple shape.

I saw Hitler cut a swath underneath.

I saw the photo of a boy, his shoulders hunched and hesitant, his dark hair parted neatly but straining to spring out, a wide nose, a shy smile tugging his lip a little up on one side with the

Image: Lester Weimer and Kirby Cowan

soft shadow of a dimple. What shouts out of the image of this boy are his eyes, two pinpoints of light in sepia, as round as eyes can be, as bold as eyes can be.

Hitler had only been in Paris for a day, but his dark forces occupied this boy's childhood.

"Will we recognize him, do you think?" Rogier asked as he loped along in a confident stride that day in October, 2011.

"I don't know," I said. But I knew I would. And I knew he would ask me about Ginette.

From the first time I went there in 2005, Paris exerted a pull on me. I didn't know if it was the memory of a crackly slide of the Arc de Triomphe on the wall of my high school French classroom, or the pace of Parisian life that matched my pulse, or the stone philosophers whispering secrets to me, but I felt compelled to return, as if there were something essential I needed to find there.

I had been to Paris twice when I read *Suite Française*, a novel written by Irène Némirovsky, a writer of Jewish descent who fled Paris when the Nazis marched in. This book evoked Paris during the occupation so starkly that I began to travel there two or three times a year to do research on that time period. I spent hours in museums with my nose pressed up against glass cases, examining photos, handwritten letters, and mementos of Résistance members. I trailed after historians, scribbling details of Göring at the Ritz, or a school in the Marais where Jewish children had been marched out, or an apartment where an Allied soldier had been hidden. I stolled the stalls along the Seine looking for old magazines and books, and read everything I could get my hands on.

At this time, I wrote freelance travel stories and essays about culture, art and politics. I did not know why I fed this growing obsession with World War II Paris. It seemed to have nothing to do with me.

As Rogier and I crunched through red and yellow leaves toward Hotel Argenton, we reviewed our schedule. We would spend the rest of this day with our man. Tomorrow we would film Edouard on location on Blvd. Malesherbes and interview him in my apartment on Île Saint Louis. I glanced over at a sidewalk vendor's stand of vintage black and white postcards, and imagined the brutality of occupied Paris.

Edouard Duval was a business associate of my husband's who owned a factory in Gennevilliers, on the northern outskirts of Paris. He and his wife had become friends, and we would see each other several times a year in Paris or Seattle. Edouard was tall, distinguished, balding, and reserved with a gentle wit.

I remembered one evening in 2007 when Edouard said he had a story he'd like me to see, the account of Frank "Kirby" Cowan from Arkansas, who his uncle had met during the war. Kirby was now a dear friend of Edouard's who he would visit each time he went to the U.S. Edouard thought I might want to write this story someday.

Kirby had been in a USAF B-17G flying over Paris in June, 1944. The plane had been hit, and Kirby had parachuted down to land in a garden near the Aubert-Duval factory, which was at that time being run by Edouard's uncle, René Duval. Three teenage boys had shielded Kirby from the Germans as they rushed him over to the factory, where they hid him behind some barrels. Edouard's Uncle René drove Kirby to his own elegant apartment near the Arc de Triomphe for a few days, gave him a change of clothes (a pinstriped suit and wing-tipped shoes), then took him by métro to an apartment near Hôtel de Ville, on Blvd. Sebastopol.

Image: Former apartment of René Duval, 149 Blvd., Malesherbes

In Paris in June, 1944, anyone aiding an Allied airman would be tortured, then shot.

Inside this apartment lived Résistance members Georges Prevot (a policeman), his sister Ginette, and her husband Jean Rocher. They hid Kirby for a few weeks, along with downed Scottish airman James Stewart, who had been there for more than a month. Kirby and James were both caught at a checkpoint on their way out of Paris, thrown into cells in Fresnes prison, and taken on the last train out of Paris to Buchenwald. Kirby was then moved to Germany where he was shuffled from one POW camp to the next. Finally, Patton himself marched in, just a few feet from Kirby, and liberated the camp.

Kirby arrived in a flotilla in New York Harbor, almost one year to the day after his plane had been hit, and returned to Arkansas to live a full life.

Because of all my research, I fit the story into its context. My first thought was, *This is a film*, as I could so easily see all the action. But I didn't know any filmmakers, so I put the story aside, and continued to write about Winged Victory, baguettes, and Parisian fashion.

As the years went by and I continued to travel to Paris, I'd stretch in my airplane seat during descent, look out the window, and imagine Kirby dangling from his parachute, floating down: *I can see the Seine River winding through Paris. The rooftops getting bigger . . .*

The part that stuck with me most about the story was a scene in the apartment on Blvd. Sebastopol: *We'd sit around the table drinking cognac and talking until late.* Ginette, the woman of the house, would have been the one who prepared the dinner and cultivated the ambiance. Something about this woman piqued my interest and held it.

I envisioned Ginette serving the best dinner she could manage on meager wartime rations—perhaps potatoes, a few carrots, maybe turnips—to the four men seated at a table, with a small

amount of wine reflecting ruby circles through glasses onto a white lace cloth. I heard Kirby's halting French and Georges's booming laugh. I sensed the warmth Ginette may have felt at being able to create this mood even in such strained circumstances.

I felt the fire of cognac sneaking its way into each body.

In 2010, Edouard began to take me to the places in Kirby's story. He talked at length about Kirby, who had died the previous year. Edouard had gone to Arkansas to speak at his memorial service.

Edouard drove me out to the factory and showed me the area near the stairs where Kirby had been hidden by the three boys who had rushed him over to the factory. The workers had written "Unexploded Bomb" on some barrels to keep the Germans from checking there.

One cold day in January, he took me to 20 Blvd. Sebastopol. The pale green color of the door gave me the unexpected feeling that I'd found a rare treasure. Above the door was a plaque:

Ici Habitaient
JEAN ROCHER
Et le gardien de la paix
GEORGES PREVOT
Patriotes arretés par la Gestapo
Le il aout pour faits de Résistance
Puis déportes dans les camps
d'extermination, ou ils sont morts.
n'oublions pas!

Where, I wondered, was Ginette when this happened? Had she come home one day to find her brother and husband gone, along with whoever they had been hiding at the time? I imagined her turning the key in the lock and climbing five flights of stairs with the unsettling feeling she must have had every time she came home. Had she opened the door to find chairs upside down and curtains rustling in the breeze? Or had they taken her as

well—some German soldier snatching her arm at the elbow and twisting it as he pulled her down the stairs?

I touched the pale green door and a chill slid down the back of my neck. Why was Ginette not mentioned on this plaque?

The next fall, at the Storymaker seminar in the Jura, I met Rogier van Beeck Calkoen, a Dutch filmmaker who was interested in making short films of several of my stories.

The week after I returned from this seminar, I received an email from Joe Cowan, Kirby's son. Edouard had told him about me years before. I phoned Kirby's wife, Cloteen, who said he had not discussed his war experience much until his later years when he had been contacted by a Frenchman putting together a reunion at the factory in Gennevilliers.

The next time I was in Paris, Edouard told me about René Psarolis.

I learned that on that summer evening René was walking down his street, rue de la Chapelle, when he heard a deafening roar. He looked up and saw a ball of silver roar overhead and explode nearby. Flames shot into the air as he ran toward the scene. René saw a German, the first he had seen up close, moving three dead bodies into a truck.

This moment shattered René's boyhood innocence.

All through the Liberation celebrations two months later, this boy ran after the trucks, cheering and waving at American soldiers who tossed out candies and gifts. He thought of the men on the plane. He imagined them alive.

Image: 20 Blvd. Sebastopol, Apartment of Georges Prevot and Jean and Ginette Rocher was on 5th floor

157

René grew up and moved away, and gradually realized that all the men in the B-17G, even those who might have parachuted down, had probably been caught by Germans and shot. He returned to Paris for a visit in December, 1966, when he was in his twenties. He went out walking one dim and drizzly afternoon, and found himself in his old neighborhood. He continued walking as if pulled, and came to a stop in front of something. Through the gray mist, a plaque slowly came into focus.

à la memoire des 3 américans
qui le 22 juin 1944
ont fait le sacrifice de leur vie
pour que leur avion désemparé
ne tomb pas sur les habitations les cheminots des gares
de pajol et de la vilette
reconnaissants

The bomber had veered to avoid the train station, thus many lives had been saved. Who were the three dead Americans he had seen? How many had been in the crew? Had there been others who had fallen out of the plane, or even parachuted down into Paris?

René heard a voice very distinctly say into his ear, "Don't forget us."

This moment caused a change inside René. He began to travel frequently to Paris from the U.K., where he now lived. His family trailed behind him as he perused bookstalls on the Seine looking for old magazines and newspapers containing any news of the crash. He frequented the national library in the Marais, charming the librarian into retrieving boxes of documents from back rooms.

René's questions had transformed into a quest.

Gradually, René pieced it all together. The crew had consisted of ten men. The three he had seen were Lt Jay H. Horn, pilot, TSgt Henry G. Morris, and SSgt Anthony L. Moncaco.

Bodies had landed all over Paris and the surrounding area: Bois Colombes, Saint Ouen, Clichy, Gennevilliers.

He contacted historian Claude Foucher, who told him there were two survivors[5]: Steve Manzek and Frank "Kirby" Cowan. René could not believe it: Two of his heroes were alive.

René put advertisements in newspapers calling for eyewitnesses, and contacted officials in the towns where the bodies had landed. He pinpointed the areas where the two survivors had touched down, Steve in Saint Ouen and Kirby in Gennevilliers. He located the three teenage boys who had rescued Kirby. He found the current owner of the factory in Gennevilliers, the nephew of the man who had taken Kirby to the elegant apartment and given him the pinstriped suit: Edouard Duval.

"He saw the plane crash in his neighborhood and has made it his life's mission to collect all the stories of the crew members," Edouard told me. "He is the one who contacted me and told me about the actions of my uncle. I never would have known about it otherwise."

I emailed René and received this reply:

Bonjour,

The crash of the aircraft in my neighborhood has been with me since the age of seven and has stayed with me all this time. It is as clear today as it was then . . .

I wrote back asking if he would send me the details. I asked if he had found anything about the Résistance members in that apartment, especially Ginette. I told him about the persistent questions I had about her. René hadn't found much about that. He had focused his research on the crew, and offered to send

[5] A third survivor, Lt Harry O. Ubbins, died in 1987, before René learned the details of the crash.

me "a few documents." I received packet after packet of photos, telegrams, eyewitness accounts, letters, and newspaper clippings.

This man's meticulous collection of specifics brought these American soldiers to life.

René sent pages out of the co-pilot's journal in which FO John J. Murray wrote a few weeks before the crash as he lay sprawled on the grass near the B-17G:

> . . . in a few hours I would be five miles above it—in the cold, steely blue of enemy skies. Up there the temperature is 30, 40, or 50 degrees below zero; our planes struggle to fly in the super thin air that causes the weird vapor trails to swirl from the screaming propellers. Without life-giving oxygen man will die in a matter of minutes at this altitude. This is an ethereal world, high above the dazzling white cloud banks, high above the world of man. Men were not made to live up there. Some would die up there today. I might be one of them.

Murray had landed, dead, in a wheelbarrow in Saint Ouen. René sent me eyewitness accounts of people telling how they stood in front of the body and refused to let the Germans take it. The people wrapped John Murray's body carefully (they all agreed he had very clean fingernails), brought flowers, and sang *La Marseillaise.*

René collected the details, yes—this body landed on the roof of a theatre in Clichy, that one fell out of the plane and landed in the street in Gennevilliers, another shot in the air as he descended toward Asnières. But what René Psarolis did next changed him even more: he began to give these stories to the people who needed them most.

In 1997, René telephoned Steve Manzek and Kirby Cowan back in the states and invited them to Paris for reunions and ceremonies.

He took Steve to the place where he had landed in Saint Ouen, a back alley where people had given him cognac and signaled the

V for victory sign. Steve had sauntered down the street waving and flashing back the sign, two fingers spread under his nose. He had immediately been captured and gone on to endure a nightmare scenario out of which he was lucky to emerge alive.

René took Kirby to the garden where he had landed in Gennevilliers, and introduced him to those three teenage boys who had rescued him, now men in their 60s. He presented Edouard, who held a ceremony and reception at the factory. Kirby went back to the apartment on Blvd. Sebastopol and saw the plaque above the green door.

"All I've said for the past 50 years," said Steve in a televised interview filmed then in which a starstruck René translates, "is that I wanted to go back to the place where I landed."

Kirby nodded and mouthed the word, *closure*. René looked at him, and his smile held something of the boy.

René had plaques put up all over Paris to mark the landing positions of the men. A plaque was placed underneath the one René had come upon that day in 1966, listing the names of the 10 crew members, and others were erected in Saint Ouen, Bois-Colombes, Gennevilliers.

René worked with Kirby and Steve to find the families of the crew, and invited them to come to Paris.

The widow and grown son of Henry Morris came. Morris was one of those who had gone down with the plane, one of the dead bodies that René had seen. Morris's son, who had been a baby when his father had gone off to war, buried his face in the foliage near the plaque and sobbed.

Bob Murray, the co-pilot John's brother, thanked the people of Saint Ouen for the care they had shown his brother's body. Two of the women who had been 12 years old at the time opened

a bottle of pink champagne. He said that yes, his brother had always kept his fingernails clean.

All but one of the families were found. There is a plaque on a street in Bois Colombes, where Anthony Vigliante, an Italian from New York, landed, dead. Perhaps one day a family member of his will stand in front of it.

Everything René sent me I sent to Rogier. Gradually, it dawned on both of us that René was our real story. We agreed to focus on him in the film, and I decided to write a novel based on him, *The Storykeeper of Paris.*

René phoned me one day. "Something you wrote made me know I could trust you with this story. It's why I sent you all these documents and photos," he said. "You want to know about Ginette. I don't know much about that part of the story, but I know you will find out."

René agreed to meet Rogier and me in Paris.

That sunny day in October we walked into Hotel d'Argenton and waited a few minutes in the small lobby. All we had to go on was the old, sepia photo. The minute René walked through the door we recognized his round, dark eyes under heavy French lids, shining with the same eagerness in his seventies as they had at the age of seven.

He unfolded his own story for us. When René met Kirby and Steve for reunions and ceremonies in 1997 and the following years, these events had been the highlight of his life, for these were his heroes.

René's most lasting memory is a night at the Ivy Hotel when he and Kirby stayed up talking. It must have been four or five in the morning, he said.

We filmed him telling the story of the crash, lapsing into childhood phrases. We filmed him in the library in the Marais,

and on the streets of Paris. We filmed Edouard outside his Uncle René's apartment, telling the story of how his uncle took Kirby on the métro to Blvd. Sebastopol, and how, when Kirby raised his arm to hold onto a strap, his GI issued wristwatch nearly gave him away to two Germans sitting nearby. We filmed Edouard and René reminiscing about their friend Kirby.

"I was just a little guy who didn't want to let go," said our Storykeeper.

For his collection and sharing of these stories, René was awarded the medal for Veterans of Foreign Wars from the United States.

These days, René emails often, and sometimes telephones me. We discuss the film, which is finished and currently being shown in film festivals throughout the world, and my progress on the book. But, like a golden apple dangling from the thread of a branch, the question hangs.

"What have you found, my little one? About Ginette?"

René recognizes the intrigue of her story for me. He knows the inner alchemy that creates a quest. He offers advice and encouragement, and often challenges me: "You can probably find traces of her brother Georges at the gendarmerie." "This is how you get people to retrieve extra documents; you must be bold." "I see you have this photo on your website, is this her?" He has taught me how to pursue a story, collect scattered fragments, and gather details. But there's one more thing René Psarolis inspires me to do.

In addition to *The Storykeeper of Paris*, I am working on its sequel, *The Red Notebook*, about Parisians in the Résistance who hid Americans—one woman in particular who lives with her brother and husband on Blvd. Sebastopol. It's possible to work on both books at once because I spent years doing the research.

When I am done with both books, what I would most like to do is to find a distant relative of Ginette's, someone connected with her somehow, who has never heard the details of her actions. When I meet that person, whom for some reason I think is a young woman, I envision inviting her to my apartment in Paris, and sharing these stories with her.

I will tell her that I tracked down and contacted James Stewart, the Scotsman who was with Kirby in the apartment with the green door. James told me that as he was shuffled along in Fresnes prison a few days after being caught, he looked down a long hallway to see Georges, Jean and Ginette. On the same day her brother and husband were taken to Buchenwald, where they would be killed, Ginette was taken to Ravensbrük, and remained there until the end of the war. Then James found her a job as an au pair in his village in Scotland, and settled her in a cottage near his own for a few years before she eventually returned to France and died.

This young woman and I will talk about the meaning of the phrase on the plaque outside 20 Blvd. Sebastopol, *N'oublions pas*: Do not forget. I will ask her if she has stories she can't forget or questions that persist and answers she seeks.

Then we will sit around the table drinking cognac and talking until late.

⁓

Image (facing page, top): Plaque and building, John J. Murray, died 5 rue Lecuyer
Image (facing page, center): Henry G. Morris, died rue Pajol
Image (facing page, bottom): Building and plaque, Anthony Vigiliante, died 83 rue Gramme

Lieutenant Jay H. Horn, pilot: Down with plane.

First Officer John J. Murray, co-pilot: Body landed in wheelbarrow in St. Ouen. People wrapped his body, sang the Marseillaise.

Lieutenant Steve J. Manzek, navigator: Upside down in plane. Landed in St. Ouen. Captured. Died, 2003.

Lieutenant Harry O. Ubbins: Landed on rooftop in Clichy. Broken ankle. Captured. Died 1987.

Technical Sergeant Henry G. Morris, aircraft engineer: Down with plane.

Technical Sergeant Frank K. Cowan, radio operator gunner: Landed Gennevilliers. Passed through Paris. Caught at checkpoint leaving Paris. Fresnes, Buchenwald, POW camp in Germany. Died 2009.

Staff Sergeant Anthony L. Monaco: Down with plane.

Staff Sergeant Anthony F. Vigliante: Body landed in Bois Columbes.

Staff Sergeant Lester N. Weimer: Died in plane. Body fell out and landed in Gennevilliers.

Sergeant Clifford N. Mc Creary: Shot in the air. Landed badly wounded at Asnières (south of Gennevilliers). Taken by German patrol to Beaujon Hospital in Clichy. Died of his wounds in the early hours, June 23.

PART SEVEN

Transformations

*There are only two ways to live your life. One
is as though nothing is a miracle. The other
is as though everything is a miracle.*

—ALBERT EINSTEIN

TRAVEL CAN TRANSFORM US: fresh views shift our perspectives, we connect with people on a different level, or feel ourselves opening up to new experiences. Upon our return home after sipping coffee with the ghosts of Jung and Freud in Vienna's Café Central, we expect an exotic flavor from our Starbucks latte. Having seen children scramble for crumbs in Mumbai, we are aghast at half-eaten hamburgers and loose lettuce leaves left on plates. We rattle around in our SUV on a spacious freeway and recall standing on the curb of a moped-thronged, horn-blaring street in Hanoi.

We are not quite the same, and wonder how to adjust.

Years ago, my sons had two goldfish, Pete and Frank. Changing the water in their bowl was a delicate process: First, they were scooped out of their home into a plastic bag containing water from their bowl, with their eyes bulging and mouths popping. To calm them, we would offer a few flakes of their familiar food, which they would leap to the surface of the bag to snatch. Soon the fish's fragile systems accommodated to this plastic-bag-hotel, their body temperatures cooling or heating, tiny lungs filling, refilling, gills flapping. Next, the bowl had to be scoured without soap and filled with tap water of the exact same temperature. Then, the moment of truth: the thumb-sized creatures were placed, still inside the open baggie, in the freshly filled bowl. The old water and the new mingled. As their bodies again adapted, they would dart around their bag in pop-eyed wonder and finally swish into their home, now new to them.

This change has been the hasty demise of many a pet goldfish.

Pete and Frank endured many trips in and out of their bowl. They lived for two years, goldfish octogenarians. It was a miracle.

Upon returning to the U.S. after a month in France, my reverse culture shock was in many ways similar to those legendary fish's adjustment. "Bastille Day on The Palouse" is the story of my own return to the bowl that is home.

Arriving and returning is routine for Jeff Greenwald, journalist and author of *Shopping for Buddhas* and *The Size of the World*, who has skipped the globe for decades. "We never understand how fluid our powers of self and observation can be until they are shaken from the container of our habitual lives and set loose in new places," Jeff told me.

"Our self-image changes; we are swayed by new interests, curiosities and friendships that were never a part of our lives before. Our indelible realization—from that moment forth—is that the world is a tapestry of multiple universes: a million unique patterns, woven on the same loom."

Epiphanies in life are few, but stand out as eye-opening flashes of clear vision, instantaneous insights when we see, we recognize, we learn. When we experience a true epiphany, we do not labor to change; we already have. We do not look back; the future begins.

"Avé Métro" is the story of how, at one of the lowest points in my life, the sound of an oboe brought me to a standstill to experience such a moment.

When we are outside of our fishbowl, images, scenes and people often linger in our minds. When you consider your own travels, what appears without conjuring? What has stuck with you?

There are layers underneath the persistent memories of places we have visited, buried under these images that do not vanish. You can peel them back: Start with a specific recollection from one of your travels. *Know thyself*, as Seneca insisted. Take the same curiosity you extended to this new place and direct it within.

"Deep Travel, Notre Dame" traces my own method of extracting meaning from my travel-induced madness.

What exists underneath your own travel memories? What you find may cause you to sense that there are a million possible variations of the world . . . and of you.

⌒

Bastille Day on the Palouse

One of the pleasures of shooting (photos) in the Palouse is the ability to gain some elevation, to gain perspective on the landscape. But the inverse is also true, with small dips in the roads and valleys that provide an opportunity to see things at angles other than dead-on.

—Kevin Raber, photographer

THE PUZZLE WAS WORN, with many of its colorful corners curled away from the gray cardboard surface underneath. The kite strings lined up, providing hints as to where my five-year-old fingers could try the pieces. When assembled, the picture of red, yellow, and green kites flying in a cloud-spotted sky was worn all the way through in places, with holes where the yellow table showed underneath.

It was this fuzzy-edged puzzle that I thought of one day as I sat in my car in the parking lot of a strip mall in Auburn, Washington.

I was a piece from a different puzzle dropped from a great height onto that one. I felt as though the landing had broken off a segment, a pink curve, which had flown off into the gutter.

I'd been home for a week after a month in France, and *joie de convenience* had replaced my *joie de vivre*. Earlier that day, my car had lurched not over cobblestones but speed bumps as neon invitations flashed from every shop: Grab-n-Go purple-lit hangers, blinking offers of Airbrush Designs for my NAILS, Nachos, Pizza, Teriyaki, Cigars. I'd skulked in Safeway, fondling "baguettes" with flimsy crusts and perused the wine section with a sneer. I had trolled through the Starbucks Drive-Thru greeted by an over-caffeinated barista who offered danish-cookies-scones-and-sweeteners. I became so consumed by a gut-sizzling longing for stone cherubs and the clink of a china cup of *café creme* that I'd had to park the car and indulge in escapist memories.

In Saint-Émilion, where Romans had planted vineyards in the 2nd century and built a cathedral out of a limestone cliff, I leaned against a stone wall in a spot of sun and sipped a spicy Bordeaux while chatting with a Frenchman who had hopped off his motorcycle and removed his helmet as if it were a plumed hat. I glided down a hallway in the cellar of Château Lafite-Rothschilds as dust sprinkled from chandeliers. I beamed myself to Paris, where my teeth sank into the crust of a *baguette tradition* as the sound of accordions invited me to stroll the boulevards.

People always told me I was so Parisian-like in my tastes and style, and as I traveled there so often, I'd developed a view of myself as loftily looking down from this perch. As I sat inside my purring car, I was Josephine kneeling before Napoleon as he crowned me, a bird flitting to and fro between Notre Dame's towers, a stone beauty bearing the French flag atop the Grand Palais.

My pastel edges fit into *this* picture.

The next day I was to drive my son Kellan and his friend across the state of Washington from the west to the east, to Pullman, where they would attend college orientation, a trip I'd taken dozens of times for reunions and sporting events since I'd attended college there 25 years earlier.

It was July 14, Bastille Day, the day that commemorates Revolutionaries destroying the Bastille prison in Paris, the event that sparked the Revolution and was essentially France rebelling against herself. I awoke determined to dedicate the day to my soul-mate of a country, to block out my surroundings. We hit the road at 6:00 A.M., the boys sinking into instant slumber in the back seat.

I rolled down the window, visualizing haystacks tied with twine upon the soft hills of Normandy. My face was slapped with a cold smack of Pacific Northwest air, which slithered down the back of my neck. I buzzed the window back up. No matter: while passing through places with such unromantic names as Vantage and Colfax, I would inwardly gaze from the bridge in Monet's garden at Giverny, at waterlilies bobbing in the pond and pale-green-saturated shade dappled with golden orbs that swayed with leaves in the wind.

As the car climbed steadily toward Snoqualmie Pass, I became aware of tall, dark figures in my peripheral vision out of the window on my left, but held on to the image of Giverny. After a while, fir trees of deeper, denser shades moved over and melded with Giverny's willows in thick layers of green.

I blinked at this imaginary optical illusion and redirected my attention to the center line of the road. As soon as my driving assumed the auto-pilot state, I mentally flew myself to Versailles, where strains of violins echoed off mirrors. Manicured lawns and shaped shrubs shed an air of elegance that elbowed aside the untamed forest. Ivy-caressed statues and hidden paths beckoned.

But as the highway descended into the Kittitas Valley, my eye was tugged again to the left. Leafy domes arched over cornfields and buff-colored horses nosed grass. A road sign of a bucking bronco welcomed all to Ellensburg, Washington.

Friends of my husband and mine since college, Jeff and Susan have lived in Ellensburg for years. We had joined them

over many Labor Day Weekends for the annual rodeo and festivities. Susan grew up here; her family and this town have been intertwined for generations. The Harrel family always had several members in the Rodeo parade, a brother driving the 4-H truck, a niece cheerleading, a son marching with the band.

At the rodeo, we'd sit in the shade near the rail with the cotton-candy-corn-dog scent of the county fair permeating the hot air in the arena. Our *"oohs"* and *"ahhhs"* would roll into the rumble of the crowd as rag-doll-men flopped on the backs of rollicking bulls . It was, as the announcer Justin once said, "an old-fashioned good time with all the bells and whistles."

In the evening we'd attend the annual shindig at the Party Barn, where lights twinkled from rafters, drums and cymbals thumped, and corn was served on the cob, shining with butter and sprinkled with salt.

Ellensburg shoved the Eiffel Tower aside a few inches. This would not do. *Drive; don't think*, I thought. *Maintain your French edges.*

I conjured the aroma of *boeuf bourguignon*, wine, herbs and meat in the richest of broths, deep, dark, thick. In my daydream, inside a pretty yellow and white decorated restaurant, I leaned across the table toward my friend Martin. The conversation was of Things That Matter, punctuated by mouthful-inspired moans. We were just about to order *tarte citron* to share when I heard the hum of car wheels upon a bridge and came to awareness.

We glided over the Columbia River at Vantage. Surrounded on both sides by shadowed hills, the river was an indigo ribbon with thousands of sun-sparkled diamonds quivering on top. The blue lingered in my mood as the car dipped and rose. Soon the Palouse Scenic Highway leveled out like a ruler.

The Palouse is an area of southeastern Washington and northwestern Idaho where wheat, barley, peas, lentils and canola grow on hills and plains. Acres and acres of wheat choose July as the month to change from emerald to gentle gold.

I remembered that the Palouse is rooted in the French word *pelouse*: land with short and thick grass, and on this Bastille Day, the fields had transformed into amber swells that swished, a fruitful crop awaiting harvest. Clouds puffed out their cheeks like a drawing of the wind in a child's storybook. The sky widened, sunbeams descended, dust devils spun in the distance. Cows posed in profile as if for a portrait. Shadows skittered across dunes that seemed to roll in undulating rhythm as if the earth underneath slowly stirred the waves of grain.

My edges shifted outward a fraction, I pulled them in. My colors deepened, I resisted, for I had become attached to my reverse culture shock.

A silo painted white with red stripes: Othello, where every house and yard could be clearly seen from the road. Everything out in the open.

The car surfed rises and dips as a feeling of familiarity settled in my stomach. Letters on another grain elevator: Dusty, where clumps of trees surrounded small houses. Greetings from the General Store. Confident red barns dotted the landscape.

This route, which had taken me decades ago to a college life of football games, circles of friends, parties, and fun, loosened my grip on France. It was a floundering feeling that reminded me of that moment while sailing when the boat "comes about," changing direction. The sails flop, the boat hesitates, lurching this way and that, and finally the wind catches the sails and the boat changes course and flies forward.

In this moment of suspension I recognized the ridiculousness of over-identifying with France—I was not French, I was American. And, although I do not understand my place in the world all of the time, especially after traveling, I am not a set puzzle piece.

We can all shape-shift to fit wherever we are.

Long sprinklers on wheels, like giant pull-toys, assembled by the side of the road as if to watch us drive past. Smaller clouds bounced overhead, offspring of Mr. Wind. A mirage on the road appeared, disappeared. The rich, grainy smell of burning hay suspended time.

I turned off into the old town of Colfax, the last one before Pullman. Tick-Klock Drugstore was on my left, a giant painting on the side of a building advertising Rip-Proof Overalls was on my right. Stoplights changed red to green every block as I passed Eddy's Chinese Restaurant, the jade green Plymouth Church, and the light blue garage of Colfax Body Repair. Pullman, 15 Miles.

Pullman, Left ½ Mile. The campus waited as if in a green bowl, with blue hills reclining behind it: the red brick clock tower outlined in creamy white, Bryan Tower, turrets and rectangular classroom buildings, tall dormitories, Tudor-style fraternities and Grecian-columned sororities.

Kellan stirred in the backseat. I hoped he would soak up every drop of enrichment, friendship, learning and fun this place had to offer, as I had.

As we rolled down Main Street in Pullman, a street lined with brick java-and-study cafes and old-fashioned storefronts with bright awnings, I rolled down the window. Crimson and gray flags snapped as they waved from the sidewalks.

I felt at ease, I had my bearings. On Bastille Day on the Palouse, I'd found my way home.

WASHINGTON

Avé Métro

My job in this life is to give people spiritual ecstasy through music.

—Carlos Santana

DEEP DOWN UNDERNEATH PARIS, a man's full lips encircled the mouthpiece of an oboe. He positioned his fingers upon black keys and in one second breathed dreamy life into the steamy, subterranean chamber.

Music returned to me—it happened that fast.

Even before birth, the sounds of Dave Brubeck, Ella Fitzgerald, and Charlie Parker formed and nurtured my growing ear-for-music, and a record player was playing nearly every second throughout my childhood in the 1960s. I constantly pestered my mom to play my own records: Hans Christian Andersen, The Sound of Music, and Mary Poppins. When I was ten years old, liberation: My own 45 rpm singles blared from a new record player in my bedroom, and I sang into a hairbrush microphone to the Monkees and a band called Smash.

Then, one day in 1971, when I was twelve, my cool, long-haired, college-aged cousin gave my parents a shocking gift: a record album with a languishing naked black woman on the cover. Another lady, red and nude as well, stood in profile, straddling a drum: Santana's *Abraxas*. My dad, a drummer and pianist, a jazz purist, blanched and set the album down on the coffee table. I instantly seized it as my own.

I could not believe it. Santana. They'd been at *Woodstock*.

The family drifted off to the dining room and I was alone in the living room, just me and the giant, wood-paneled stereo console. I turned the knob, removed the black vinyl disc from its cardboard casing, slipped it out of its paper sleeve, and placed it in the elevated position where it wobbled and hovered, suspended above the spinning, plate-sized rubber disc.

The whir of the base circling emptily was interrupted by the click-clatter of the record dropping. The needle arm lifted and moved over above the record and then dropped. There was a fuzzy, anticipatory static followed by the whisper of a stylus scraping the groove . . . then . . . two dramatic piano chords, wind whirling through tinkling chimes.

A few more solid chords, tinkles. Notes ascending.

The wail—the primal, scintillating wail—of an electric guitar sliding, climbing, soaring. It was like a kite in a hurricane and I was attached to the string, legs flailing as the music looped and circled, suspended then swooped up, up, up—the highest I'd ever flown.

Exotic drumbeats along with untamed, unidentifiable sounds grabbed a place between my throat and my chest, pulled something out and used it to tie my stomach in knots. The electric kite pulsated into my body, then out, but I was still attached to it.

It was as if I danced with my own being, apart yet fused, separate yet one.

The shush between songs sounded for a second. Next came an eerie, mesmerizing melody and the guitar returned. In a weird

but really cool way this music was somehow calling to something deep within my skinny, knobby-kneed body. I stood with my hand on the trembling top of the waist-high console and the vibration traveled from my fingertips inward. I felt plugged in somehow: *Zzzzt.*

My hips swayed with a surge of naughty rebelliousness, a rising bubble of "No!"

A voice: "Got a black magic woman . . . "

From that moment on, I'd follow Carlos Santana wherever he'd take me.

Where he'd taken me with those two songs, *Singing Wind, Crying Beasts* and *Black Magic Woman* was someplace deep inside myself; he'd got his spell on me, baby.

Abraxas caused a riot in my adolescent body, mind and soul, although at the time, I didn't know what that meant. Now, forty years later, I think it meant I attained spiritual ecstasy through music. Even today when I listen to that album[6], my rib-cage vibrates and the soles of my feet tingle.

When I was twelve, life moved at a slow, mesmerizing pace with school, friends, tennis, and, as I was an introvert living a lonely life as an extrovert, reading in my bed until late at night. Permeating all of it was music. Maya Angelou once said, "Music was my refuge. I could crawl into the space between the notes and curl my back to loneliness." This, I did.

During high school, my favorite thing to do with my friends was skip school, spend the day waiting in line outside Seattle Center Coliseum[7] to see The Who, or Elton John, or Crosby, Stills, Nash and Young. Inside, the air thick with marijuana smoke curling in beams of spotlights, insistent stomping and clapping escalated, and finally the rumble of rock and roll would

6 I, like many another child of the 1960s and 70s, will always call them albums.
7 Now Key Arena

begin. Lighters flicked and flashed, fireflies inside the arena. We'd push our way to the front row where I'd dance in a trance, with arms raised, my chest smashed against a plywood partition, and the beat would weave into my body and out. It was an elevated state of the soul.

When life sped up with college, teaching, marriage, and children, music was shoved beyond the periphery of my daily existence.

The warp speed of adult life, spinning like the stereo turntable, relegated music to the background, too far away to reach me and to sink as deeply as the guitar of Carlos Santana or lift me as high as those concerts had. I no longer took the time to put my hand on the vibrating console, or noticed sounds shifting among my ribs.

Years later, when I began traveling to Paris, I noticed musicians everywhere: violinists leaning into it on street corners, jazz trios jamming on bridges, accordion players weaving through people on the subway cars, and singers strumming guitars in cafés.

That day in the Paris métro station when the oboe began its eerie call, I was in the midst of a personal crisis. My head and heart were spinning, and I was so exhausted that the prospect of plowing through the rush hour pack in the Concorde métro station made the blood slow sluggishly through every vein in my body, a gas tank sputtering on empty.

"The One toward La Défense, off at Charles de Gaulle-Étoile," I repeated to myself, looking for the yellow circle. I sucked in dank air that seemed empty of oxygen and reeked with sweat, urine, grime and grit. Muffled footsteps, clattering trains,

Image: Jazz trio on Pont Saint Louis

whooshing trains, screeching trains, voices, scraping. I stretched my eyes wide open, willing myself to keep moving.

I noticed a man propped against the wall moving a long, black instrument to his lips. The sound was minor, mournful and melancholy, and it struck the air, clear and hollow—just this one pure sound, alone, alone, climbing in the familiar Avé, song of holiday warmth, of candles and holiness. The sound emerged and slid forward as if on a silver thread.

I stopped.

Reality was suspended inside this silver-tinged stanza of time. The low ceilings lifted with every high note. The white tile walls decorated with letters shined, clean and white, and I breathed in fresh gulps of energy.

A surge rose from somewhere between the bottom of my rib cage and my stomach, and crashed like a cool, misty wave, washing over me in a cleansing rush.

I heard only this sound, felt only this wave, and saw people changing before my eyes. A German couple's steps, as they marched forward, became waltz-like, and I imagined them inside a palace deep in a pine-scented forest, dancing in a ballroom under chandeliers of cut-crystal that caught their reflection.

A briefcase-toting man became weightless, gliding above the floor, cradled in the arms of the melody. A boy who had been yanking at his mother's hand looked up at her and smiled. Her haggard expression softened, and I saw that her other hand supported a heavy, pregnant bulk.

The oboe's tones continued to reverberate, the music going from outside of me to inside, from my ears to my center, and I felt acceptance of what would come, an emergence of courage, of readiness, of "Yes." I felt the difference between comfort and healing: not just pain alleviated for a brief moment, but a change in my state of being, caused by this sound.

I realized that music had slowly faded to an incidental place in my life, and I was slammed by my need for it, anguished at the lack of it.

It had been there, like a swimming pool in my backyard, but I so rarely dove into its blue-tiled depths. I might never have seen this but that I'd been so devastated and low that the Avé had lifted me quickly, as dramatically as had Carlos Santana's soaring guitar.

One last lingering note sounded. I thought that perhaps when a piece of music is as sparingly lovely as this Avé, it can make the unthinkable inexplicably endurable for all of us—worries about loved ones, the loss of a livelihood, our darkest depressions, the ups and downs of life, and even the hour of our death.

Amen.

Deep Travel, Notre Dame

May you travel in an awakened way,
Gathered wisely into your inner ground,
That you may not waste the invitations
Which wait along the way to transform you.

—John O'Donohue, from the poem "For the Traveler"

STONE APOSTLES FROWNED DOWN over their curly beards, and I withered. Again and again, I had flown from the U.S. to France in an arc, but as organ music thundered from within, to step over the threshold into Notre Dame seemed a farther distance to travel.

Something near scratched my nerves.

Great cathedrals had often pulled me in against my will, and I'd gone: scurried down the cloisters in Salisbury to gape at the Magna Carta under glass; craned my neck in Cuzco and thrilled to the rebellious nature of Inca slaves who had slipped their own religious symbols into paintings of the Madonna done for their Spanish conquerors. I'd perused the storehouse underneath The

Vatican, wondering whether the treasures were rightfully gained or stolen by victors. Vow of poverty, indeed.

Inside these stifling churches where air seemed scarce, I had sought history, art, and architectural feats, but never God.

In my childhood, Sundays had been for sailing, not sitting in church. As our boat streamed out of the harbor with waves slopping the hull, my dad would curse the choice of a weekend day for being "stuck inside at some service." We were lucky to get away, but I was complicit in the escape.

At a junior high church camp around the campfire, I observed dramatic conversions: Kids, surrounded by groups huddled in fervent prayer, would suddenly stand, indicating they'd been "born again." Cheering rang through the smoke-filled air as the number of the doomed dwindled, with me among them. To repel this laser-like focus, petrified of burning in hell and feeling the pressure pile up, I'd staged a fake scene, leaping to my feet as sparks flew from the fire. Hands clapped me on the back and I was swallowed in an endless series of congratulatory hugs.

I felt nothing. I was a fraud, secretly unchosen.

As I grew up, wherever religion reigned, I asked too many questions, could not articulate the right ideas, never managed to be sweet and submissive enough, and did things for fun that were considered sinful. I defied convention and felt I was flawed. Even at my own wedding, I hadn't converted to Catholicism, so felt on the outskirts of the action.

I sensed the peaceful presence of Something at the edge of a thundering ocean, or in the deep pool of solitude, but I had drifted far off the coast of Christianity.

My new extended family, strongly Irish Catholic—including a priest, an ex-priest, and two former nuns—brought acceptance and love to my experience of religion, an oasis to a thirsty soul. Their faith was rich, textured, and generous. Family events usually featured a prayer, ritual, or mass, and I felt embraced by this

boisterous family and by extension, God. I began to sense an invitation when I was inside a church.

Years later, I joined the Catholic Church. The service seemed a combination of sitting *and* sailing: hand motions, kneeling, incense floating through the air, cool saints with adventuresome bios. There were relics—bones of saints, the shroud of Turin—tangible bits of history that fused reality with faith.

I became part of the action of our local parish, but soon a hierarchical structure became clear, in which people—me among them—were put on pedestals. Others seemed to admire me for qualities that, once again, I didn't possess. *Fraud.*

When the debate began over whether Iraq and Afghanistan were "Just Wars", I began to waver. The cover-up of sexual abuse by priests came to light, and I could not muster hard and fast adherence to the beliefs of the pope and bishops. Again, the narrow way was blocked. Although my family's acceptance by now was not hinged upon it, my faith plummeted. I stopped seeking spiritual sustenance in church and parted ways with organized Christianity.

My spiritual thirst was quenched with the poetry of Jelaluddin Rumi, and his simple Sufi insights: *The cure for the pain is in the pain. Good and bad are mixed,* he'd written, and *We move as particles. That motion is all we need do.* I was attracted to Celtic spirituality through the writings of John O'Donohue, the late Irish poet and philosopher who had left the Church in 2000. O'Donohue encouraged us to *succumb to warmth in the heart Where divine fire grows,* and to embrace life's mysteries. I thrilled to the Buddhist philosophy regarding the *self-imposed isolation of the thinking mind.*

I now found The Universe (a power or being I no longer thought of as God) in the odd synchronicities that occurred every day, the way events would line up to place me in a certain spot or with a person with whom I shared a deep connection, and

in certain "knowings" and unexpected tiny miracles, but never in the proximity of a church.

That afternoon I stood under the towers of Notre Dame, I remembered that the French were not avid churchgoers, with a majority rarely attending services. That thought lowered my guard and I ventured inside.

High above, a waterfall of sunbeams fell slantwise through the blue, purple and red glass of the round Rose Window. Flecks of dust sparkled like gold leaf in the sun, and spun in rhythm to the varied voices of a choir. A service was in progress, but throughout the rest of the vast space, people milled about in slow motion, wandering the nave under Gothic arches, lighting candles in alcoves. I drifted past sculpted angels with uplifted arms toward relics in throne-like cases: the crown of 70 original thorns, a nail, a piece of the cross. Mirroring the dust motes, I circled slowly, relaxed.

Bells clanged, a deafening vibration that jump-started me with a jolt. Panic bolted through me as I wove through the crowd and out. As I walked under the arch of stone apostles, I remembered that during the Revolution, their faces had been hacked off.

A year later, I began teaching a writing workshop, Deep Travel, most often at a bookshop across the Seine from Notre Dame. Deep Travel was both a model of travel and a process of writing that my friend Christina and I had developed based on this quote by Joseph Campbell from *The Hero With a Thousand Faces*:

> *The passage of the mythological hero may be overground, incidentally; fundamentally it is inward—into the depths, where obscure resistances are overcome and long lost powers are revivified.*

If the overground journey is an arc to a spot on a map, we taught, the underground journey is a U shape in which the traveler delves deeply into his or her own psyche to find how and

why they connect to a place or people and the reasons images and scenes captivate or haunt them.

We urged travelers to open all their senses, including their sixth sense of intuition, as well as to consider the destination's history, art, architecture, music, sports, food and drink—all aspects of the culture—and to interact with people in an intimate way. We asked our writers to consider prior expectations and preconceived notions in order to shake loose from their grip and embrace the new, and to notice their own reactions, whether admiration or puzzlement, disgust or delight, love or loathing.

"Listen to yourself talk," I'd say. "This may indicate the heart of your story."

We used a process of questioning to help writers narrow their focus. Mentors had done this with me and I'd discovered hidden meanings in my travels. *Why do you want to write about this farmhouse in Normandy, that statue in Christchurch, those brothers in Capetown?* The writers, as I often had, first sought answers outside themselves, and then began the inner quest, the underground journey.

Once I began working with writers in this way, I recognized in them the same resistances to their own truths that I'd felt myself; finding connections between a place and ourselves never makes for a tidy little tale. Did Sisyphus roll the boulder up the hill, rub his hands together, and head off to greener pastures? No, he had things to learn on that hill. When Alice stepped through the looking glass, her adventures did not proceed in a straight line.

The same had happened on my own travels: a beach in Ireland had conjured memories of a childhood I'd never had, van Gogh had shown me how to share my own harsh truths, and Madame Renaud had taught me how to unburden my grief.

Places touch us in a multitude of ways. An impoverished alleyway in Mumbai rubs salt in an open wound inside us, the Moroccan custom of eating with the right hand trips us up, the texture of a child's hand at a school in the Himalayas evokes

maternal yearnings, the reverent style of greeting in Thailand causes awkwardness. We react strongly to something, and begin to ask why.

We are beings being formed, and the universe gives shape and meaning to our lives in mysterious ways when we travel—our issues unravel further or are resolved, broken bonds are healed or severed, untranslated messages dropped or decoded, dashed hopes mourned or reborn.

With our Deep Travel writers, resistance would crop up like rocks at a certain point in the process. Places and people they had met on their travels touched them in sensitive spots that flinched to the touch, but when writers continued to push through these resistances and explore this inner terrain, meaning would surface: an Italian hillside became a place to part from youth, a graveyard in Prague conjured the confusion at a crossroads in one writer's career path, a guide in Mali aroused unsettling superstitions in another.

"Dig deep enough and you will reach the universal emotion," we would remind them, and each time a writer plumbed his or her own depths, he would find that his own reactions while traveling tugged various threads of his life. When we connect the black threads of our own dark sides, the red threads that unravel from our hearts, and the vivid hues of our memories with what we notice on our travels, we reach the dip in the U of the underground journey.

This murky ocean floor often is reached at the moment we feel far away from home, utterly overwhelmed with the otherness of a place, the strangeness of people. The buried treasures of our stories—chests overflowing with pearls, gems, gold and silver—is found here.

We can rise to the surface changed, having acquired new colors to weave into the tapestry of our lives upon returning home—we photograph our neighborhood children as we had

those living in a village in Nepal, we appreciate every bite of a simple meal as we had in Rwanda, we notice the silhouette of the skyline of our front yard as we had in New York.

I found it invigorating to travel, write, and teach using this model because there was always an element of surprise. I saw that travel revivified us, whether we flew to foreign lands or drove to the next town.

Since I usually stayed on Île Saint Louis, I passed Notre Dame many times each day. Soon after my quick dash inside the cathedral, I developed an interest in the differing views of the structure from afar, and pointed out "her" moods to anyone who walked with me.

From Pont de la Tournelle under pewter rainclouds, her flying buttresses seem to crawl forward, like the legs of a spider, which I found creepy.

From the wide, paved area in front of her, as the towers guarding her bells shone white, she appeared pristine, her façade was a party dress. She seemed so innocent but above, gargoyles crouched baring their teeth. She was not so naive after all.

Her bells rang out insistently, with a clear sound, sometimes bold and seductive, sometimes sharp and shrill. She couldn't be called quiet.

From the left bank side, as I strolled along the park past lovers kissing on benches and children chasing each other, the birds swooped so close. It seemed they were the only ones brave enough to approach her. Later, walking the opposite way at twilight, the little dollhouse-like treasury, shaped like a small château, had windows that shed a yellow, lamp-lit glow, with the South Rose Window's darkened glass behind it. I wondered who was inside.

The opposite side near the souvenir shops was her gritty side, where I felt a sinister chill and wondered if, long ago, some priest murdered someone here, maybe on the stairs.

My friends became as mesmerized as I, and we spent hours contemplating her, whispering, shouting, swooning or shrinking. But when alone late at night, I became possessed by a sense of impending doom. I'd scurry across Pont de l'Achêveché toward Île St Louis, with quickened footsteps. She was there, too close. Avoiding eye contact, I pondered her psyche as I passed: she was immaculate, yet mysterious, safe yet dangerous, good yet bad.

In some way, she and I were one.

A few years later, on March 24, 2013, on a Saturday afternoon just before dusk, Christina and I sat close together, elbows on knees, along the Quai de Montebello with what seemed to be all of Paris.

In a few moments the new bells of Notre Dame would first kiss the air.

The previous fall, bleachers had been erected in front of the cathedral, in Place Jean-Paul II. All through the fall and winter, people had settled themselves on the cold metal and admired the façade, imagining the sounds of the new bells, which were designed after the original ones, cast in 1686, all except one of which had been melted to make cannons and money during the Revolution. To mark the 850th anniversary of the founding of the cathedral, the new bells, all of differing decoration, had been displayed for everyone to see in the nave of the church. Now she held them in her pristine towers as they awaited their debut.

Clouds paused, poised in the purplish-blue sky. The moon appeared early, just to listen. People of all ages, dressed in suits, in skirts, in coats, in burkas and saris, in jeans and silk dresses, held their breath. Pigeons lined the roofs of nearby buildings and clustered together on tree branches, tilting their heads and rustling their wings, shifting.

One hollow, hushed tone rang out. Another, and another, sonorously swaying into a rocking rhythm of repeated chimes.

The sound of the new bells was softer.

Against the creamy stone backdrop of towers and turrets, statues and spires, four birds simultaneously swooped down from a rooftop into the center of the sky in front of the cathedral.

The birds soared as one, turned and circled in arcs and loops in perfect synchronicity as if they'd rehearsed for weeks, months. Their feathers aligned in measured symmetry, the distance between each identical, turning together, rising and dipping. With a final oscillating plunge, the birds darted in a string to a tree branch and turned their heads toward Their Lady.

The bells chimed again and again sounding their muted, gentle tones as two birds fluttered down from the rooftop in a flawless entrée, then pirouetted and plummeted with precision. All around, people's heads followed their movements. Several children pointed.

"Are these trained birds, brought in for this?" I whispered to Christina.

"How could they be?" she asked, astonished, as the pair twisted and spun in adagio agreement, and flew off-stage to alight on an outstretched branch.

The next group of four descended from the roof and continued dancing to the rhythm of the bells, choreographed by an unseen hand.

The Universe was serving up a miracle smack in front of Notre Dame, and it seemed as though the bells were asking what I thought of it.

A collision clashed inside of me, yielding no answers.

The next week, one night long past midnight, I walked home across Pont de l'Achêveché. Earlier in the evening, clusters of soldiers gripping machine guns had been roaming the Place du Jean-Paul II, and I'd heard the cathedral was closed down due to a terror threat. A protective panic had gripped me then—I'd never

once thought of Notre Dame as vulnerable—but now all was silent as I crossed the bridge, its metal locks incandescent in the moonlight. The only sound, my heels tapping the sidewalk. Fear, syrupy and familiar, rolled through my veins.

She called me to look again.

I stopped and faced the dark figure that lurked behind ghostly trees in the shadows. Violent images appeared: imaginary crusaders slashing throats with bloodstained swords, Inquisitors in robes pointing long fingers, my soul, a target. Revolutionaries hacking the faces off the statues on the façade with hatchets, turning to me. My heartbeat skidded and I recoiled.

Then I wondered: Why had I seen so much evil in this cathedral, why had she frightened me so? Why had I kept away from her hushed sanctuary for so long? Why, why, why?

I saw myself cynically critiquing Christianity, avoiding churches, dashing out of this one, pointing out her flaws. I peeled back these images, and underneath, saw a girl sailing out of a harbor, escaping; sitting by a campfire, petrified and inadequate; a young woman rejected, accepted, then repelled; a woman welcomed, then becoming angry. So afraid and angry that when I'd stood underneath carved figures, I'd felt their scowls.

My thinking mind had mistaken the blunderings of human beings seeking meaning for the character of a Creator. The rejection I'd felt had been from *people*, as had the acceptance from family I'd forgotten was ever felt inside a church. I knew I'd never leap back into the hierarchy, but neither did I need to avoid Christianity, for I am not chosen or unchosen; I choose.

I stared her down. Her scars and her sweetnesses were mine. Good and bad, mixed.

I remembered the meaning of the word catholic: universal. Standing there in the dark, it wasn't just Our Lady of Paris I

felt connected with. It was everything: the miracles that rotated Rumi's spinning thoughts, the ancient wisdom that flowed from O'Donohue's pen, the Buddha's meditations, the birds' wingspans, and the radiance spilling from the Rose Window. God and the universe were one.

Inside me, black threads spun together with red, flickered, and lit up this quote from a poem by Rumi:

> *This flame says, Nothing here but God.*
> *Everything, everyone, every moment.*
> *This fire says, That.*

With one last glance at her flying buttresses, poised in the dark not to lunge but to embrace, I continued walking. The bells began to chime, stoking the air with their sacred symphony of subtle sounds. The graceful birds, God's representatives on earth, had celebrated these revivified bells.

My spirit, lifted by an unseen hand, swooped up in an arc.

❦

Secrets

And above all, watch with glittering eyes the whole world around you because the greatest secrets are always hidden in the most unlikely places. Those who don't believe in magic will never find it.

—ROALD DAHL

WHEN WE LAND IN A NEW PLACE, our eyes are sometimes weary, sometimes wary, often confused or astonished or stunned. Rare are the times when our eyes simply glitter with the glint of curiosity, but this is the moment we must seize, for only then are we ready to uncover the secrets of a place.

The person I know who most emulates this kind of seeing is the woman known in my writing circle as the grand-dame of travel writing, Georgia Hesse, founding travel editor of Hearst's *San Francisco Examiner*, who seems to have uncovered the secrets of nearly every place to which she has traveled, a total of 199 countries. Marie Antoinette has taken Georgia on an intimate stroll through the gardens of Versailles, recounting her time there. Georgia has written of waltzing in the 17th century under the chandeliers in the Vienna Opera House, and of racing through inky midnight on *The Orient Express*.

Georgia approaches a place with a mixture of curiosity, a vast knowledge of its history and culture, and an awareness of her own limitations. She is not quick to judge, but observes meticulously, gathering tidbits gradually. In this way she has learned the secrets of many a country.

Places, like friends, must trust you before they confide. Perhaps this seems an exaggeration, but it has been my experience in France. Many have been the times I've leapt to conclusions and stated that French waiters are masochists or French men are innocently charming, only to discover—over time and upon acquiring a more humble opinion of my own assumptions—that the opposite is often true.

Parisiennes and French woman in general have a reputation for effortless grace, a certain sexy something that I've observed over the years. When I turned fifty years old, I consulted the collective wisdom of the French woman. I lowered my lashes and leaned toward her. I was all ears. What I heard is the story, "The Secret of It."

This story, which has brought forth vigorous nods at various readings here in the U.S., has been the launching point of many a debate with my French woman friends. I still hold to what I heard "her" whisper, but it is highly likely that the skin is always smoother on the other side of the salon. While my French friend Karen crosses her legs daintily and points out that a lot of forethought goes into the French woman's appearance, her hair curls willingly across her face in a perfect crescent as she effortlessly swishes her skirt. Michèle's eyebrows are the very definition of arched, and Patricia's shoulders curve prettily underneath any sweater she wears, so the conversation continues . . .

One area of Paris who is not shy about her secrets is the butte of Montmartre, a place that put me in my place in the story, "The Mirror of Montmartre."

For me to hear the faraway musings of the past, I must be alone, be silent, be prepared. I must, as Georgia has taught, know enough history, language, and background to be acquainted with the place first.

One visit to Rome found me in the Roman Forum, about to depart on a tour. As the group shuffled their feet and murmured, I imagined that through this noise, I heard voices of patricians and senators, of emperors and great ladies, regaling me with stories of wine and chariots, of plots and vengeance and power—but the sound was muffled. The thick roar of other peoples' touristic mumbling was drowning out the Romans. I bowed out of the tour and stood next to a an ancient stone wall with tufts of grass springing out. I waited, listening.

The stories began.

Always, to me, the whisperings of a place make my self shrink. I feel my own place upon the timeline of world history: I'm a minute speck, just a dash after 1959, a dust mote dancing near Notre Dame's Rose Window, a leaf fluttering in the Luxembourg gardens.

I've been presented, by a most unlikely source inside an apartment on Île Saint Louis, with scores of stories of characters from the distant past, of optimism and failure, of celebration and agony, of guilt and atonement, of children humming and violins sighing, of sweat and smoke and chocolate, of bitter cold and sweltering heat, of birds perched on a balcony overlooking an angry mob demanding the heads of royalty one century and silent snows and dire floods the next. I pass these on to you in "Wise Beams," a story which only requires belief in the power of history, the elasticity of time, and the incredible, life-changing magic of a place.

The Secret of It

Simplicity is the keynote of all true elegance.

—Coco Chanel to *Harper's Bazaar,* 1923

⌒

THANKS TO THE WOMEN OF PARIS, by the time I arose from the bench in the Luxembourg Gardens fifty no longer needed to dress up as the New Forty: it fit me like a contour-hugging skirt.

It was a cold Sunday afternoon in January on Boulevard Saint-Germain. Under the awning of the café Les Deux Magots, heat rose from bodies shoulder to shoulder, hip to hip. Elbows perched on tables and all eyes pivoted to the sidewalk for arguably the best people-watching anywhere in Europe.

As I sat in my skinny jeans with my legs crossed underneath the table, there was an ominous cloud hanging over my head: I had just turned fifty.

In American terms, I was developing the visible signs of aging, and it was taken for granted that my value was now dwindling. If by chance I held on to it, I'd be an exception to the rule; I could apply skin-repair cream and hitch myself up à la

Victoria's Secret, but whatever beauty I possessed was on limited time, and I'd better enjoy it while I could. I felt I was clutching an unraveling rope and my hands were slipping.

But the Parisian woman, like an older, more experienced friend, whispered some things into my ear that changed my outlook.

Aging need not be traumatic.

Squeezed in my café corner, I shifted a shoulder to look at the crowd flowing past the church of Saint-Germain-des-Prés. Most wore black, which enhanced dashes of color: Orange overlapped scarlet, cobalt brushed jade, red collided with violet and bumped up against white . . . all loose motion against the beige backdrop of the church. One figure stood absolutely still, a woman in a short black leather jacket with a flash of turquoise underneath, matching high boots, and a hip-clinging skirt. I admired her intrinsic chic. She flipped back her soft, brownish, shoulder-length hair; I dropped my jaw and my spoon.

She was at least seventy years old.

She was not seventy years old trying to look twenty, or forty, or even sixty. She was seventy years old looking like *herself*, and she did not appear to be trying at all. She radiated *It*.

In my quest to clarify what this woman possessed, I remembered a conversation I'd had one day. I'd asked my friend Michèle, who was in her sixties, a vision in soft orange and blue mohair, with matching orange ankle boots of the softest leather, if Parisian women were traumatized by getting older. She had arched an eyebrow and said, "What?" I had tried to explain that sometimes women eventually gave up trying and sort of let themselves go, but although Michèle and I communicated consistently about everything from our families to the dream we'd had the previous night, we came to a deadlock over the word "frumpy."

I began to wonder if Parisian women had an absence of angst about aging.

There is nothing to fix.

During another *déjeuner*, I told my friend Laura, a petite twenty-nine-year-old with black hair, black eyes, and a pert nose, that turning fifty was difficult for me, as it was for many women. She smiled at the waiter, tucked her hair behind her ears and tilted her head, perplexed. "Is that why they . . . you know?" She fluttered her fingers near her face to indicate plastic surgery. "Women do that a lot in America, no?"

Laura and I spent most of our time talking without pause, sharing our hopes, personal feelings, and thoughts about life—all that went on inside ourselves. Our discussions centered on how we'd been challenged, made mistakes, and grown. As I insisted that women everywhere resorted to the knife-lift, and tried to garner sympathy for my deepening crow's-feet, frightening old-lady hands, and upcoming surgery for varicose veins, the conversation seemed to sputter out.

Besides, Laura was having too much fun flirting with the waiter to focus on my obsession with the perfect fix.

Feel your femininity.

That day on Boulevard Saint-Germain, I was scrunched at a small table next to an elderly couple who murmured in seductive tones. They were exquisitely attractive, he in a heavy wool coat, she in a soft, creamy sweater. They crooned side by side, hands lightly intertwined, their white heads touching at the temples.

I knew the stone buildings surrounding this intersection were the same size as on other boulevards, but they loomed larger than life, like a giant stage set. Their iron seemed scrolled with thicker ornate curls; the awnings more precise, spotless, cleanly cut: CARTIER, SWAROVSKI, EMPORIO ARMANI. The awning of Brasserie Lipp flashed orange, black cars preened. From my perch at Deux Magots, even the waiter's "*oui*"s sounded more staccato.

In front of me on the boulevard, a silver-haired woman strode past in a black coat trimmed in fuchsia with a goateed gentleman clipping along on her heels. She seemed used to being trailed after, I thought; she had him on an invisible leash.

Everywhere I went in Paris, couples like this, no matter what their age, sank into uninhibited looks *d'amour*. No matter what else I'd heard about them, French men, I noticed, were not shy about expressing adoration for women, and it seemed to me from the way they leaned forward to catch every word, that they were interested in the *whole* woman.

Even the street sweepers who gathered in groups on street corners, instead of wolf whistling like the quintessential construction worker, asked, *How are you? Where are you from? What are you doing today?*

Perhaps this was one reason the Parisian woman sat with her back straight (slouching seemed sinful), stood like a ballerina, and walked as if she felt pretty—as if a handsome prince had just presented his arm, or she'd been handed a dozen red roses, or she was the lead in a musical. Perhaps it had something to do with her leading man.

I noticed these women dressed the part. Simplicity reigned, accessorizing seemed unnecessary. Some wore combinations that would land in the "don't" category of a fashion magazine but still somehow appeared sleek and effortlessly elegant.

Coco Chanel perhaps put it best when she said, "I don't understand how a woman can leave the house without fixing herself up a little—if only out of politeness. And then, you never know, maybe that's the day she has a date with destiny. And it's best to be as pretty as possible for destiny."

Your It is in here.

I spotted a nondescript mousy-haired woman of indeterminate age, slightly thick around the middle, wearing tweed, and I

prepared to exude sympathy for this plain creature. *Mais non,* for the second this very average-looking lady took a step and started to walk, her carriage carried a very above-average amount of . . . It.

This seemed to come from a different place entirely than the It I was familiar with, that which I had collected, cultivated, and clung to. I'm tall and thin, with a mane of thick reddish hair, and I work out every day; this is enough to turn heads in Seattle, where I come from.

The confidence of these French women—I always tested my theory by waiting for them to speak with a French accent—made me think this quality was not acquired, but innate. It was not *out there;* It was *in here.*

French philosopher Pierre Teilhard de Chardin once wrote that we are spiritual beings having a human experience. And we are having it inside a body.

But I read once that the body is in the soul, and the soul suffuses the body completely. It seemed to me that the essence of one's soul included our aura, spirit, self, and intelligence—everything that made us different. Our It encompassed the body, not the other way around.

The body might be thought of as packaging, I thought, but the plastic wrap is not the sandwich. The bottle is most certainly not the vintage wine.

You are unique.

It occurred to me that in this case, a cliché said it best. I started to see each of my fifty years, the lessons I'd learned, experiences I'd savored, all that had happened to me and that I'd made happen inside each twelve-month time span, as precious gems in the necklace that is me. As I had grown up, my differences—being tall, with red hair and freckles, constantly questioning everything, always going to extremes—had frustrated and embarrassed me. I realized that over the years I had enjoyed these qualities the most.

Months after my café musings, I stumbled upon a book that put into words many of these secrets Parisian women had whispered to me: *What French Women Know* by Debra Ollivier, who lived in France for ten years and still lives there part-time.

Ollivier points out that it all starts when French girls are very young. Instead of being popular, they are encouraged to be themselves, with the idea that a girl is more compelling if she doesn't fit into a standard mold. I recalled myself as a girl, trying desperately to make my red hair blond with lemon washes, covering my freckles with pancake makeup, and collecting acquaintances as if they were trophies.

What French Women Know describes the types of first bras French girls are encouraged to wear: satin pink polka dots, lace, or animal prints. The concept of the training bra, Ollivier illustrates, does not exist in France. I remembered hiding behind a dressing-room curtain in a department store while my mom handed me my first white elastic straitjacket.

On the subject of aging, this book directly addressed my dilemma and took my conclusions a step further. In France, Ollivier asserts, you don't fix yourself—you cultivate yourself. When we attempt to fix, she asks, are we age-defying or age-denying? She points out that the "sexy, older French woman" is a commonly held image.

It seemed she had been sitting right next to me at les Deux Magots on that Sunday afternoon in January as she wrote:

If older French women still seem like players in that infinite game of romance, it's mainly because they are comfortable being grown-ups.

*They covet the intellectual and seductive virtues that come with culti-
vating an inner life.*

French women know that an inner life is a sexy thing.

Ollivier introduces the saying *bien dans sa peau,* which means
being at ease in one's own skin. She elaborates that for French
women, this concept includes what she calls their "inner cargo."

Reading *What French Women Know* made me reflect upon the
last hint whispered in my ear by the spirit of the women of Paris.

Just walk.

I finally left the café and walked up rue Bonaparte, window
shopping, gazing at dresses that hung loosely on mannequins and
that I knew would defy gravity to flare wildly around even the
chunkiest knees of a Parisian woman. I turned my head this way
and that, then downward, scribbling notes. I sat on a bench in
the Luxembourg Gardens, watching, analyzing and pondering the
way women and girls glided along as if a book were balanced on
their heads, their elbows bent just so, their necks arched prettily. I
marveled at their perfect poise, the way they exuded equilibrium,
as if they were centered in themselves.

All at once, it occurred to me that one thing Parisian women
would never, ever do is sit around contemplating other women.
Perhaps I'd buried my own It under these layers of conclusions,
epiphanies, and insights. I thought of that seventy-something
woman who had really seemed to be thinking of other things.
Maybe, in fact, the secret was simple.

So I gathered my fifty glittering years, picked up my body like
a bouquet of roses, and, swaying my hips a little, glided off in the
general direction of my destiny.

The Mirror of Montmartre

The mirror does not flatter, it faithfully shows what looks into it . . .

—Carl Jung, *Archetypes of the Collective Unconscious*

SHE'S A TOUGH COOKIE with a caustic wit. The last time I visited her was seven years ago. I've meant to go again, have scheduled then cancelled. That time, I ended up feeling like a foolish freshman girl being flipped off by a worldly senior, and had had the submarine-like sensation of falling fathoms, fast.

She is Montmartre, and I admit, I was intimidated by her.

My three friends and I had arranged a private tour and our guide Muguet (pronounced Moo-gay) met us at the wrought iron Art Nouveau métro station entrance, the Place des Abbesses, site of an original Roman temple to Bacchus, god of wine, replaced in the 12th century by a Benedictine abbey where the nuns operated a wine press. I imagined Bacchus, his arm around a penguinesque nun, leaning against the famous wrought iron fence underneath the green iron-and-glass awning and yellow *Métropolitain* sign.

We had spent the previous week on a wine tour of Bordeaux, enjoying white-tableclothed tastings and sipping rare vintages out of sparkling glasses while sitting on Louis XIV chairs, and I had not once thought of Bacchus. My favorite wine, an extremely rare and expensive red, had been sipped with my pinkie raised in the cellar of Château Lafite-Rothschild, proving that although a new connoisseur, my taste was exquisite.

In Paris we were staying at my friend Pete's Haussmann-designed apartment, a lavishly appointed place with its balcony several floors above the green door of Gucci on Avenue Montaigne, one of the most exclusive streets in Paris, up the block from Plaza Athenée, the grande hotel with the famous façade adorned with layers of cherry-red awnings. We set out that morning from our ritzy accommodations and ascended to the butte of Montmartre.

It was my third time in Paris, and I was an expert at packing; never mind the cumbersome bulk of two suitcases, I had a different dress for every occasion, and looked smashing that day in a black-and-white flowered halter dress. I knew Paris intimately, with my vast knowledge of its history and elegant ways, and I could just imagine the magnificence Montmartre would offer me.

I was ready to learn all about this artist's haven, this home of cabarets. After visiting places like Victor Hugo's austere abode with its darkly polished wood and gilded frames, and window-shopping in the pristine sophistication of Avenue Montaigne, I was primed for more grandeur.

Muguet had a crisp voice, emphatic gestures, and a gleam in her eye. She taught us to pronounce Montmartre with a rolled "r" ending in a clipped "t" and led us up a narrow street that bounced with color and energy.

A drum sounded, striking up a march. Costumed revelers chased each other, shouted and sang at the top of their lungs. An elderly man in a rainbow wig howled with laughter as he

engaged in fluttering confetti warfare with a heavily mustachioed boy in a top hat. A woman in a pink wig with a wooden structure wobbling on top of her head handed us paper cones of confetti.

"In Montmartre there is always a parade," Muguet said as she tossed a handful of red, yellow, and blue bits.

These Montmartrois, as she called them, were celebrating a *faux* election, which had been a favorite activity here for more than a hundred years. In the 1920s, groups of artists, writers and musicians formed *Commune Libre* and *République de Montmartre*, fake political parties complete with mock manifestos. "Candidates" held rallies to promote idiotic ideas such as using toboggans or moving pavements to descend the butte, or public fountains spouting red wine. The groups frequently raced through the streets dressed in revolutionary garb, staging mimic bullfights and pantomimes of battles using cardboard swords, and shouting out slogans: "Anti-Skyscraper!" "No Winter!" "Vote Yes: Swimming Pool in *Sacré Coeur!*"

Muguet said that these elections were symbolic of Montmartre's desire to distance herself from Haussmann's perfectly planned Paris. *She* was the 18th arrondissement (or administrative district of Paris) but considered herself independent.

A toddler whooped past, his blond hair sticking out behind a pink pig mask, and a young woman with a dozen piercings blew a horn and danced a jig.

This frivolous mood contrasted with my own in discussions held during the previous week, which had centered on the wars, the economy, healthcare and a comparison of educational systems in France and the U.S., of which I was growing weary. I had gradually come to see how the U.S. was viewed abroad and had developed a chip on my pretty shoulder regarding my home country. Over and over while traveling, I had been asked about our aggressive foreign policy, our elections, the structure of our society. Why had we invaded Iraq in the first place? Were the

test scores really that low in American schools? Was it true there was no universal healthcare? Where there really guns everywhere? I tensed up and became embarrassed whenever I attempted to answer.

Back home, it was even more frustrating. Many acquaintances assumed that people all over the world admired Americans unequivocally, were envious of our wealth, or actually jealous of our freedoms. I had written a few cynical articles and op-eds about this, and privately compared the way America viewed itself in the world to the inflated perspective of a toddler. Why couldn't we see ourselves as part of a whole?

The people parading around Montmartre gave me a peek at my own scowling, over-serious face.

Cabarets have always been emblematic of Montmartre, thanks to Henri de Toulouse-Lautrec's can-canning dancing girls and the red windmill of the Moulin Rouge. With lifts in his shoes and a cane filled with booze, Toulouse-Lautrec had enjoyed hanging out in the shady joints and had painted and sketched the gritty underworld of prostitutes and dancers. Just the day before at Musée d'Orsay, I had assumed the role of art expert and pointed out that Toulouse-Lautrec seemed to have attained his goal of depicting "the true and not the ideal" in *Alone*, an oil on cardboard piece of a rail-thin woman collapsed on a bed as if she'd been poured there, evoking a feeling of utter exhaustion and loneliness.

Muguet told us that cabarets were the birthplace of *fumisme*, an art form that used satire and practical jokes to mock the status quo. Cabarets such as Le Chat Noir with its famous black cat logo (now gone) and Moulin Rouge were the home of a group of pseudo artists circa 1890 known as *The Incohérents*, who staged exhibits of such absurdities as sculptures of bread and cheese, paintings on sausages, and Mona Lisa taking a puff. Silly posters and puppet theatre scorned the powerful.

I imagined that that night, Moulin Rouge would likely exhibit a brood of incoherent tourists—a far cry from the original *Incohérents*, with whom the modern Montmartrois identified.

As we walked, my platform sandals wobbled on the uneven stones and I bobbled, feeling edgy. It seemed audacious to paint Leonardo da Vinci's masterpiece smoking, as if there were nothing safe from the pranksters of Montmartre.

Classical art was what I appreciated, I thought, as Muguet announced that the Dalí Museum was closed that day. If there was any artist around whom I was uncomfortable, even though he'd been dead for years, it was that Spanish nutcase with his bugged-out eyes and curly moustache. I was poked by the pang of a persistent memory of drooping, melting clocks, and works crawling with ants, snails, and locusts, and breathed a sigh of relief to be spared Salvador's shenanigans.

In Montmartre, Muguet continued, any member of society who took himself too seriously was fodder for wisecracks. She spoke of "Bo-bos" (bourgeois bohemians) who moved to this neighborhood to put on the costume of the avant-garde. Bo-bos took their image as bohemians earnestly, thus inviting the disdain of the villagers, who regarded them as interlopers. Muguet, animated, windmilled her arms and stood with her toes, bare in flat sandals, pointed as if she were a ballerina. Conspicuous consumers, she told us, from places like Avenue Montaigne, strode around Montmartre unaware that they were hooted at behind their designer-clad backs.

In the blink of an eye, I had a fleeting glimpse of myself, a woman in a garish dress teetering on high heels. But this vision was sharper; it encompassed my interior self as well: wine tastes elevated as high as the flag flying on Château Lafite-Rothschild's turret, two suitcases full of dresses, boots, jewelry, taking up extra space, a cherished view of myself as an expert in French culture, art connoisseur, and (although I had yet to send out any of the

snarky articles I'd written and had only had one tiny op-ed published) bohemian writer.

This vision of an annoying American in Paris flew through my mind as if it were a glamorous ghost. I rendered it invisible as fast as it had flashed, but was left with a feeling of prickly itchiness.

We continued down the hill to a scrawny vineyard, Vigne du Clos Montmartre, where the wine has always been auctioned for charity. Each October the harvest is celebrated in the Fête des Vendanges (Harvest Festival) culminating in another exuberant parade with a band of marching musicians ranging in age from five to ninety. Muguet whispered Montmartre's quote about what happened if you drank a pint: *C'est du vin de Montmartre! Qui en boit pinte en pisse quarte!*

Across from Clos Montmartre was the peach-painted cabaret, Au Lapin Agile—the site where Picasso and his pals gave the Paris art establishment another sharp jab in the ribs. In 1910, this group tied a paintbrush to the tail of Lolo the donkey. The resulting masterpiece, *Sunset on the Adriatic Sea*, earned lavish praise from the art critics at the Salon in Paris. The Parisian set was braying about art created by an ass! The imaginary artist, "Boronali," was lauded in Paris to the guffaws of the regulars at Au Lapin Agile, who tacked up a photo of themselves and Lolo wearing black masks, toasting their success.

I imagined myself pointing out to my friends the remarkable colors in *Sunset on the Adriatic Sea*, for I had held forth on all works of art from the Venus de Milo to Renoir's pretty *Moulin de la Galette*. I had not once mentioned the artist I truly loved the most, less well-known, Eugène Carrière, whose hazy paintings in plain

Image: Au Lapin Agile, 22 rue des Saules

earth-tones showed eyes, clear and bright, shining out of mistiness with an almost surrealistic clarity. His works, strange, mysterious and odd, moved me more than any others.

On rue Norvins we came upon a stone and bronze statue of a man trapped in a wall, his arm and leg emerging, in the act of stepping out. The statue, according to Muguet, was based on *Le Passe-Muraille* (*The Man who Could Walk Through Walls*), a short story written in 1943 by Marcel Aymé, in which the main character, Dutilleul, nicknamed The Lone Wolf, thumbed his nose at hypocritical society by using his ability to walk through walls to prowl around wreaking havoc, to the dismay of his power-hungry, hubristic boss. Alas, Dutilleul's magical powers came to an abrupt end just as he was halfway through the wall. He was still wailing in there, wrote Aymé: *If you stand at the stone wall, you can hear Lone Wolf Dutilleul lamenting the end of his glorious career and mourning his all too brief love affair.*

We arrived at Place du Tertre, a bustling square where painters perched on stools and leaned in with their brushes to dab or swipe with a flourish. A painter with Brillo Pad eyebrows and a bushy black moustache swept his arm up to show us a selection of his canvases. He and Muguet exchanged some snappish words about the idea of bartering with him for price. He valued his work in precise, non-negotiable terms.

As I looked at the artists painting away in their smocks and caps, oblivious of the swirling swishes of arms and paintbrushes of other artists and the footsteps and comments of tourists, I recognized how much courage it would

Image (top): *Le Passe-Muraille* statue, 2 rue Norvins

take to display my work as I created it, to have people judging it and accepting or rejecting it right before my eyes. My own artistic cowardice was evident from the drawer full of un-submitted stories I hoarded.

We scaled the steps of the giant cupcake of Sacré-Coeur, the sight of which had evoked our hushed exclamations when we'd viewed it from the restaurant Maison Blanche (15 Avenue Montaigne) a few nights previously. This, Muguet pointed out, was built in a joint effort of the government and the church to reprimand the rebels of the Commune, who had gathered in Montmartre to plan the Revolutions, and to remind them of who was in power. A gigantic ceiling mosaic, *Christ in Majesty*, said to be one of the largest in the world, portrayed Jesus and the saints. But we looked a little closer and saw a collection of nineteenth-century politicians in the mix, a combination that has never been appreciated by the Montmartrois, who preferred the humble simplicity of the little church that was hidden in the shadow of Sacré-Coeur, Saint-Pierre du Montmartre.

Saint-Pierre du Montmartre was so small it could easily have fit into Sacré-Coeur. Destroyed during the Revolution, it was rebuilt in a jumble of styles. Inside the center aisle glowed a carpet of light. The angles of stone and the neat rows of wooden pews eased the uncomfortable sensation that had repeatedly been stirred inside me that day.

As we walked out of quiet, unassuming Saint-Pierre, I looked over my shoulder, where filtered duskiness swept the arches in its nave.

Years later, when I read about the theories of Carl Jung, I had fleeting thoughts of Montmartre. Jung referred to our persona, a complicated system we ourselves set up in order to impress other people and conceal our true nature. The persona is the mask of the actor. *But the mirror lies behind the mask and shows the true face,* Jung

had written. He also was convinced we all have a shadow side, and that in the mirror was *the face of our own shadow that glowers at us across the Iron Curtain.*

To confront a person with his shadow, Jung said, was to show him his own light.

That day I was unmasked in Montmartre opened up painful rifts inside of me. It is an experience I've come to expect while traveling. I have embarrassed myself enough times since then to begin to be humbled. I have developed a taste for confusion, for being wrong about assumptions, and for having my notions about a place and myself upended and overturned.

I now enjoy emerging from walls of my own construction between people, ideas, and challenges. My political positions have cooled, and I've learned to consult my own taste buds and inner art critic. I have developed an aversion to the status quo, and on my last visit to the Pompidou I was shocked, seduced, and finally succumbed to the charms of the devilish Dalí.

No longer a tourist who sees herself as a savvy traveler, I am an awkward, awestruck bumbler who ventures out, most often, alone, and knows she is a tiny part of the whole world.

Montmartre unleashed my own shadow to knock me down a peg or two, but she murmured something I missed on that first visit. "Start again," I now hear her say.

Each time I've returned to Paris since that visit to Montmartre, it has been written on my calendar to go back. Something always got in the way—an unexpected lunch invitation or a workshop to prepare for, or a deadline to meet, but underneath was my own reluctance.

I will return to Paris this spring, and finally feel an eagerness to ascend to the butte and enter the fray. I'll join the parade, marching in my flat black boots. If a rainbow-wigged gentleman

and a kid in a top hat sneak up for a surprise attack, I'll shower them with red, yellow, and blue confetti. I'll sneak a wink to Bacchus and give a little pull on Dutilleul's arm to help him emerge from the wall. I'll stop in to say hi to Salvador and buy a small painting on Place du Tertre.

At the end of the day, I'll creak open the door and listen to the echoes of my footsteps breaking the silence inside Saint-Pierre. I'll sit for a while on a wooden pew in a beam of soft light and whisper my gratitude to Montmartre for creating the fissures that cracked inside me.

Everyone, even the most clueless freshman girl, knows that's how the light gets in.

Wise Beams

But when we have learned how to listen to trees,
then the brevity and quickness and the childlike hasti-
ness of our thoughts achieve an incomparable joy.

—Hermann Hesse, *Bäume, Betrachtungen und Gedichte*

BONSOIR. IT MIGHT BE BEST IF YOU READ THIS *in the early evening, after you have had a chance to clear your mind with an apértif or a glass of wine. You might be more receptive.*

Enchantée. We are a row of 17th-century beams set high in a ceiling inside an apartment on Île Saint Louis in Paris. We wish to tell of the passage of time from this vantage point—how minutes, separated by centuries, repeat themselves, how hours tick by slowly or fold in upon themselves like an accordion to multiply into days, weeks, months, years . . . centuries.

People of different eras have shown us that pain and pleasure, suffering and joy, plenty and want descend upon lives in the way of rain, sunshine, and wind. One might almost conclude that we are practicing Buddhists, but we have learned, as has France herself, the harm that religion or strict adherence to one philosophy can do, and have developed scorn for extremism and respect for . . . but we are getting ahead of ourselves.

We met the first time I came to this apartment on rue Saint Louis en l'Île. I crossed the wooden floor of the narrow room, my hand caressing the cool stone of the rough ecru walls. As I stood looking out of the window to the shop-lined street below, I sensed I was being watched from above, could "see" my reddish-blond hair curling around my black cashmere-clad shoulders as I parted the curtains.

I looked up and saw a row of ceiling beams, their wood thick and rich, with crevices and cracks making dark markings, their edges uneven and curved. The beams welcomed me warmly and told me how they came to live here. They began life, of course, as a tree.

In the 13th century, the tree, an oak, grew on this idyllic island where King Louis IX (Louis the Saint) liked to wander. One day, the king, who was handsome with a perfectly angled nose and straight brow, had just returned from one of his Crusades and had sprawled underneath the tree, leaning against its trunk and gazing up into its branches. The tree held its breath in excitement, for King Louis was much loved by the people.

The tree watched as Île des Vaches (Island of Cows) went from green grass to gold stone in the 17th century. The architect who designed Versailles, Le Vau, was offering the trees positions of honor in his creations, as ceiling beams who would remain in Hôtel Particuliers—fine mansions, townhouses for the wealthy—through the ages.

The tree was getting old and had seen many of its friends and family chopped down to clear land for the new construction. If it were to be selected to become a row of beams, it could have a new life. The tree hoped Le Vau would hear that once King Louis had blessed its branches.

The tree, then, was chosen. Workmen wearing shirts of a new, loose style free of doublets, and breeches instead of hose hoisted the tree, now cut into beams, up into their new perch

inside this home. Their wood gleamed shiny and new as bridges sprouted like branches from each side of the island. This was a more humble abode than the nearby Hôtel Lambert, where the philosopher and scientist Voltaire lived with his mistress, Madame de Châtelet. There, the beams heard through the Île Saint Louis grapevine, they held salons, gatherings where great minds discussed matters, but here the beams were happy to preside over domestic tranquility.

The beams observed the travails and traumas of families throughout the 17th and 18th centuries—those of a financier, a writer from the Académie Française, and a painter for the court—who enjoyed telling stories about gatherings at the first café, Le Procope, and rustling the pages of Paris's early newspaper, *La Gazette*.

Toward the end of the 18th century, the beams heard that the men at Le Procope had begun to brew rebellion.

In January of 1793, one morning before dawn, we looked down upon the dark head of a young father, Julien, who had often voiced vehement opinions he'd picked up at Le Procope. Julien was tall with shoulders so broad he had to stoop and turn a little whenever he entered the doorway. He would stride into the house, his black coat dusted with snow, his white collar showing underneath, and shake his head of long, curly hair off to the right side as was his habit.

That morning, Julien sat with unseeing eyes fixed upon the embers of a fire, a grainy strip of early light tracing his darkly shadowed cheek. A shock of black hair fell across his face. His jaw had dropped and his mouth was frozen into a grimace.

In the crook of Julien's arm curled his newborn daughter. Her eyes fluttered beneath dark lashes, her lips, still wet with milk, parted with a faint pop. Her arms and legs jerked with a start, unused to the air, remembering the watery depths in which she'd been floating and dreaming, the place her brain began underneath the curve of her forehead, the place her femininity was forged and her eyelashes had sprouted and grew.

We could see through the open doorway that her mother lay dead in the next room, blood still spreading in crimson wavelets on white sheets. She had died giving birth to Solange.

We knew, from the nightly glow of torches and wooden clogs thundering in the streets, from the parade of heads on pikes we could see out of the window, and from the stories Julien had told his wife, that the world this child had just entered was laced with violence and hatred. The mob had killed the King the previous week! We knew also that Julien, a good man who had loved his wife, was, through the numbness of grief, thinking only of how he could protect his daughter.

From above, we could feel Julien's despair spread through his limbs and pervade the smoky, gray air of the room to reach up and touch our rough grains. We tried to cover him with a canopy of care.

One day in 2011 my friend Anna brought her newborn daughter Maude to visit, wrapped in a rose-colored shawl. Maude's curving forehead and fluttering eyelids reminded both the beams and me of that other baby girl born more than two centuries earlier.

I wondered if Maude would one day skip through the room, absently humming, her ponytail bobbing; or curl up on the chair by the fireplace and read a book of fairy tales; or play games with a string looped around her fingers; or drink a cup of *chocolat* with a swish of it sticking to her upper lip, as had Solange.

I was telling Anna of some research I was doing on sculptress Camille Claudel, who had been brought into Auguste Rodin's atelier as an apprentice in 1885 at the age of eighteen. The two soon became lovers, but Rodin, at thirty-four, was sixteen years older than Camille, and remained with his common-law wife, Rose Beuret.

Earlier that week I'd been to Rodin's museum on rue de Varenne, Hôtel Biron, and seen Claudel's sculptures exhibited there. I told Anna about Rodin and Claudel's work displayed together in Musée d'Orsay, and described Camille's statue, *The Age of Maturity*, which had been shown at the Salon of 1899: a young

woman kneels, begging an older man to turn, while he is pulled ahead by a sagging, old hag. It was this work that caused the final break between the two.

Later, the beams told me they'd known Camille.

Camille came here often, as she had a studio just around the corner on Quai de Bourbon. She was close friends with an artist who lived here and by that time, in 1905, her fits of pique were legendary and we heard many a story about her hurling her sculptures against walls, then holding mock funeral burials. She was a temperamental artist, perhaps on the verge of insanity.

"Auguste has been vicious to me, oh yes he has," she shouted one day after storming in, smock billowing, long, thick hair disheveled, cheeks smeared with white plaster. "He hated my Maturity, knew it showed him for the weakling he was, following that old bitch. He stopped its casting in bronze, leaving me with a huge debt. He stole my ideas!"

And now," she wailed, "Paul, my only supporter, my dear brother, has turned against me! He and my mother have made such vile threats."

Later, Camille was committed to a psychiatric hospital against her will by her famous brother, a politician and writer, and her mother. We heard that Rodin had also been complicit in the plan. She'd been stuck in one place where no one heard her voice, something we can relate to. Camille was locked up, in spite of a letter giving the doctor's permission for release, for thirty years, until her death.

If only the right person had seen that letter.

One day I received a package with a book inside, *The Oldest Story in the World* by Phil Cousineau, a book that evoked stories told through the ages in all parts of the world. There was a hand-written card included wishing me luck finding my own stories in Paris. I placed the card on my desk next to a note covered with sketches Christina had given me that said, *"Riding a little wave of enthusiasm here!"*

I cherished handwritten letters and notes. The beams had shared many scenarios involving them, but the one that stayed

with me was of a young woman of about twenty years old in 1918, waiting for a letter from her soldier in the Great War, away fighting in Italy.

Laura fingered the lace curtains absently. She was trying to remember the color of his eyes, the color that had drenched the pit of her stomach when she'd looked into them. From above, we could see her scan the room looking for this hue. The indigo cover of her favorite book —L'Oeuvre, by Emile Zola, in which Claude, the artist character, lived on Île Saint Louis— was too dark, the teapot on the table too light. She looked out the window and even the springtime blue of the sky was wrong.

She couldn't see this color anywhere and the exact shade blurred in her memory. She strained to conjure it against the brown of his eyelashes and the toast of his skin and the gentleness contained in his gaze.

From above we could see something she had completely forgotten. The long silk ribbon she used every day to tie back her honey-colored hair was this very shade, a dusky grayish blue. All she had to do was look into the mirror above the fireplace and she would remember the color of her soldier's eyes; we called out to her, but she didn't hear. Not many people listen to those of us who were once trees.

She wondered if he had forgotten the color of her own eyes, which he'd said were the gray of thunder clouds, or if he had been captured, or injured, or if he lay dead in a trench somewhere, his eyes vacantly reflecting the sky, his blood seeping into the ground, turning it a dark rose color.

Her father's footsteps sounded on the stairs. He walked through the door, and we could see before Laura did the letter he held in his hand.

She turned.

The beams told me in that "war to end all wars," France lost over four percent of her population. But by the 1920s she was back on her feet, flourishing a palette of Cubism, Fauvism, Surrealism, and new Realism, a rich and heady culture that attracted expatriates from America, mostly artists and writers.

The beams and I had many discussions about the creative intensity of artists, about inspiration. I'd created my own writer's alcove in the apartment where I wrote poems about works of art I'd seen, and stories of my travels here. Sometimes I awoke in the wee hours of the morning and sat up bed, scribbling notes.

Another American writer had lived here, the beams revealed, in the 1920s. A woman who had been in the thrall of Parisian literary culture.

It was the time after World War I when the generation who had fought in the trenches, on the fields, and in the far corners of the world had returned and were casting about for meaning, for direction, for hope.

Her name was Kit, and she would wake up early in the morning to write, just like you do. She'd lift her head from the pillow, switch on the lamp, reach for her pen and notebook in one quick, graceful motion, and sit up in bed huddled over it. After an hour, when it was warm enough to get up, she'd scurry to the desk and scoot up to her typewriter. Her bobbed hair with the fringed bangs would bounce as she tapped out stories of history and culture, of lost eras and current trends.

Kit's friend "Hem" often ambled down from his place on rue Cardinal Lemoine just up the hill. He was another writer, who had started his writing career living by his rule: Write the truest sentence you know. *Both writers drew inspiration from everything in Paris, and they were happy to be away from prohibition and the uptight morals in America. The American President, Calvin Coolidge, had said that the business of America was business, and the way artists and writers were revered here in Paris made them feel valued.*

"I can hardly stop writing at the end of the day," Kit confessed one day.

Hem recommended Kit stop while ideas were still flowing: "Stop writing when there is still something in the deep part of the well, and let it refill at night from the springs that feed it. You need to get out more; you write all day and all evening!" We had been urging this for ages, but again our pleas had fallen on deaf ears.

Kit understood why she awakened so often at 5 A.M. feeling as if she were carried in the current of a rushing river. She agreed that she needed to go out more, and we cheered.

The two went to salons at the home of Gertrude Stein, who lived up near the Luxembourg Gardens, and who they said made one conversation and listened to two, and often interrupted one she was not making. She'd overheard the term "The Lost Generation" and used it to describe the younger people, a label they chaffed at.

Kit and Hem often set out for Shakespeare and Company bookshop on rue de l'Odeon where the owner, Sylvia Beach, was about to publish a wild creation by an Irish writer named Joyce.

"He's breaking all the boundaries, that's for sure."

One day Hem showed up in a morose mood, shaking water out of his sleeves. "The only sad time in Paris," he said, "is when the cold rains keep on and kill the spring; it's as if a young person has died for no reason."

Hemingway himself turned out to be a young person who died for no reason. When we heard about his death, we remembered something he had said: that when spring finally did come in Paris, there were no problems except where to be happiest.

You keep coming here and you seem happy, the beams said to me.

I felt a kinship with Kit. Christina and I often spoke for hours about how to best express our deepest selves through words. We read F. Scott Fitzgerald's work aloud to each other, woke up early to sip coffee as our pens scratched on paper, and stayed up late drinking rosé and dreaming up workshop ideas.

Christina urged me to get out more. One night as I sat in my alcove writing, she phoned.

"Come over to this party in Montparnasse now," she begged, for she knew once I was ensconced for the evening, I rarely ventured out.

"No, I'm not going anywhere."

"Well, will you come out Friday? These guys Ben and Gonzague really want to meet you; they're so fun!"

After I hung up, the beams chided me for my introversion.

Over these years, we have witnessed a parade of the collective unconscious, and we have seen this pattern before. You have spent much time with people who think your lone travels and artistic interests makes you odd. You are afraid of rejection. But these guys are creative types with whom you have much in common. You didn't even listen the other night when Christina told you they made a film about George Whitman, called Portrait of a Bookstore as an Old Man.

You need to get out into the world. We have absorbed your lonely snifflings into our fibers for years, and they have mingled with the tears of Julien, which had to dry up quickly; and of Camille, who never did risk again after Rodin; and of Laura's tears of joy when she read that letter, and later when her young man did return.

We are trapped up here, holding the weight of the struggles and triumphs and heartaches and joys that have been expressed by little boys, grandmothers, girls on the cusp of womanhood, and couples in love. We would love to lighten up, to go to a party, but we cannot. You can.

You have the chance to change if you can risk rejection. We are tired of your isolation and would much rather be misted with champagne that you have opened for a houseful of friends. Kit would never have met Hem if she hadn't ventured up to Le Select café in Montparnasse.

If you do not go right now, plan to go Friday. And you need to start having some parties here.

The beams regaled me with tales of escapades during Kit's salons, smaller gatherings than Gertrude's, full of talk of Surrealism, of magic, of the occult, just people trying to make sense of the world then.

It was the beams idea for me to hold salons there in the apartment. They wanted to see what people were thinking now about things like Joyce's style of writing and what artists were up

to these days, and they again hoped to hear the pop of champagne corks so that the fizz might permeate the beams' wood as it had back then.

I began having gatherings in the apartment. One night, my friend Philip sparked a lively discussion of Menippean Satire, which he said was a genre a bit like satire without an object, and he read a passage by Joyce. The beams adored Philip, who spoke with a deep Scottish accent and looked incredibly like Mick Jagger.

He's got a wicked wit, that Philip. He would have fit in well with a cabinet maker who lived here in the eighteenth century. Philip's wife, Nadine, reminds us of the pretty party girl who lived here during Paris's happiest era, the Belle Époque; her eyes are sparkling crescents.

Wit and cheerfulness are qualities inherent in certain people, but they can also be cultivated, and we have noticed them in many people throughout the centuries, for people are all connected. You think you are one lone woman, but you are a combination of qualities, both innate and acquired, that have existed in human beings since time began.

You are a dot on history's timeline and you connect to all the other dots.

One of the next times I was in Paris, I held a salon featuring my friend Gonzague speaking about his Love Letters Project, an art installation and film about the one hundred eighty-five handwritten letters Zag received the year he was named one of France's most eligible bachelors in the magazine *Marie-Claire*.

I set out cheese and baguettes and tartes and quiches. Guests began to arrive and the beams pointed out that Zag had the handsome stature and polite manners they had once seen in a seventeenth-century courtier.

Ben walked in and the beams gave an audible gasp. I saw him as if in slow motion. He swooped in, ducking his tall form a bit as he entered. His shoulders, broad in his black coat, took up

half the hallway and the collar of his white shirt showed under his usual five o'clock shadow. He shook his long, curly, dark hair out of his eyes in his usual way, and began telling me about his daughter, who had, the last time I'd seen her, entertained me with hand games with a loop of string.

Ben and Julien, two men separated by a curtain of reality and two hundred years. Ben, a journalist who pens pieces about weaponry and technology in modern warfare, stories of tumultuous times like the one Julien lived in. Then, the weapons were guillotines, pikes, pistols and swords, now they are technology, drones, bombs, and guns. Then The Terror, now terrorism.

Then and now, fear, uncertainty, anger, hope, hate, love, war, peace.

I saw as the beams saw, felt centuries dissolve. Inside this time-warped moment, the stories those ceiling beams had told me were as real as anything I had ever experienced.

I heard a pop and looked over to see my friend Jean-Bernard opening a bottle with one deft motion, his arm rising in an arc, foam spilling over the edges of the bottle and mist spraying toward the ceiling in a shower of barely detectable drops that blurred everything into an Impressionistic scene of blue, honey-color, crimson, dusty white, and the rich, dark brown of the wood.

Champagne. The beams soaked it up.

Signs

Thought is only a flash in the middle of a long night.
But this flash means everything.

—HENRI POINCARÉ, *THE VALUE OF SCIENCE:*
ESSENTIAL WRITINGS OF HENRI POINCARÉ

AT HOME, WE MAY SWISH THROUGH our daily lives, heedless of omens. But when we travel—find ourselves lost and rustle a map or peer at a screen to acclimate—we acquire a new alertness, and decipher meaning in things otherwise overlooked, a signpost here, a crowd gathered there, this park, that corner, these steps, those doors.

What we find depends upon what we seek.

In hindsight, when I began traveling, I sought history once removed. But when I began prying myself open in order to receive the spirit of the places I visited and the people of their pasts, I received undiluted doses of the past as if intravenously.

Years ago, in Washington D.C., exhausted after a long day of looping through the Jefferson Memorial, the Lincoln, the Roosevelt, the harrowing Vietnam Wall, I arrived at the Holocaust Museum. I was given an identification card, the identity of a Jewish woman who had been alive during Hitler's horrors, and taken to the top floor to begin the descent through the museum.

I sat in a real stock-car listening to the voices of various victims recalling a stifling journey, and walked down a hallway papered with photos of an entire village of people who'd been annihilated. There was a pile of children's shoes that had last touched little squirming feet before the toes were stiffened in death, and pictures drawn by tiny hands soon to be stilled. It was all too real, and engulfed me in an avalanche of sorrow. I bolted from the museum.

In New York, standing on a street corner in Greenwich Village, I saw a plaque that marked the site of the 1911 Triangle Waist Company Factory fire. Inside the factory, women hunched over sewing machines for over-long hours in precarious condi-tions that created a firetrap. There was no way out and many were barricaded inside, their faces pressed to the glowing, red windows. Some piled onto the fire escape, which melted in the heat, plunging them to their deaths. Others jumped down into

the shafts of jammed elevators. I heard screams, smelled scorched flesh, and felt so trapped I longed to claw my way out of this acrid, smoke-filled trap. Then I heard a taxi horn and looked around, realizing I was still standing on the street, shaken.

In Salisbury, England, a walk along a path through the village presented plaques every few feet, because Henry VIII, head of the English church, vacillated between killing off Protestants and Catholics: John Ramsey, Protestant, burned at the stake for heresy against the Roman Catholic Church. Next, a Catholic, hanged, drawn and quartered. Every few feet, a plaque, an execution, a corpse dangling, flesh curling, hair sizzling, a crowd swooning with fright.

In this way, history crashes into the present.

When I have set out with a goal of walking in a person's footsteps, I've often wondered if that desire itself sets in motion events that make it truly so. I went to Arles, France with the plan to follow the path of Vincent van Gogh there, and was plunged into a condition that was closer to his true story than I'd dreamed of. The essay "In Vincent's Footsteps" traces this experience.

Travel has presented me a chance to view life from different angles. Next to Stonehenge, I was a tiny figure on a vast plain. Standing on the edge of castle ruins high on a cliff in Spain, I knew my home country was a place that was undiscovered by Europeans at the time the castle had buzzed with activity. The more I attend to how I fit into new surroundings, the more I see that I am a fixed collection of cells existing at a certain time in history.

One day, my last in Paris after a month's stay, it was my own footsteps I was not paying much attention to. Distracted by my surroundings, I meandered through the left bank in such a dreamlike haze as to be absent from my own body. "Signs" is the story of how I was brought back to reality.

Though we leave a trail of breadcrumbs, we often venture deeper into the forest than we originally planned. It is dark there,

a place one might find what Spanish poet Federico Garcia Lorca called *duende*, a dark force which he specified is present in the deep song of Andalusia, flamenco, the bullfight, and in the art and literature of Spain. "*Duende* in the Louvre" is the story of how I experienced this blood-curdling force.

The discovery of places and history and the spiritual realms of light and dark is always possible in our lives. But travel presents us with an invitation to seek, to search, and to find that which can appear in a flash but holds the potential, depending on how we think of it, to mean everything.

In Vincent's Footsteps

*What else except pain and suffering can we
expect if we are not well, you and I?*

—Vincent van Gogh, in a letter to
Theo van Gogh, February 1889

⌒

WHAT IF ALL YOU CAN DO is all you can do? Curl up. Breathe.
Exist. Breathe, exist. In. Out.

This was not what was meant to happen here.

During the two years Vincent van Gogh lived in Arles, 1888-1889,
the *mistral*—the keening, tree-leaning, untamed wind of the south
of France—pummeled him and gave his mind what he called *a queer
turn.* He fixed his easel in the ground with iron pegs, tied everything
down with ropes, and let the mistral gust the colors through his
body, out of his hand to the brush, and onto the wobbling canvas.
Sometimes, *a very spiteful and whining wind* forced him to lay the can-
vas flat on the ground, crouch over it, and work on his knees.

Image: Espace van Gogh, Place du Docteur Félix Rey, Arles

The wind rattled the shutters in my hotel room in Hôtel d'Arlatan, each tat-tat-tat a nail into my head. I curled tighter into the fetal position.

The train brought Vincent to this Provençal town. He was full of high hopes of creating an artist's colony. He had fresh plans. A house! Creative inspiration! Friends! He found a house near the train station and called it the Yellow House. Vincent painted a picture of it with supplies his brother Theo had sent from Paris. He would decorate the house with bright paintings and invite specially chosen artist friends to join him. They would all create together in this Artist's Colony of the South.

The air, Vincent wrote to Theo, did him good. *One of its effects on me is quite amusing, a single small glass of cognac here goes to my head.* His blood was circulating.

The train had spat me out in the underground station with my two suitcases and a bulky carry-on bag. Each seemed to bulge with additional books and boots, every second growing heavier and heavier. I shivered in the cold at the bottom of three flights of stairs, looked up toward the sunlight, hoisted my bags in aching arms, and clomped up, feeling as if a magnet were pulling me from behind.

At the top of the stairs, *Bienvenue à Arles.* As the seconds ticked by, what I knew about Vincent's life here simultaneously unfolded.

Each day, Vincent emerged from the Yellow House loaded up like a porcupine with sticks, an easel, canvases. He puttered around from site to site, happily painting the different aspects of Arles. *I even work right in the middle of the day, in full sun, with no shade at all, out in the wheat fields, and lo and behold, I am as happy as a cicada,* he wrote.

He made friends with the postman, Joseph Roulin and his family, and other artists and townspeople. He painted Roulin in his blue uniform with gold trim, thinking the postman looked a bit like Socrates.

Vincent did a self-portrait of himself jauntily setting out, his portable studio on his back, a whimsical likeness in which even his shadow seemed perky.

He painted the Langlois drawbridge; the women gathered on the banks of the river washing clothes appeared to move in rhythm, cheerily chatting away.

He painted people on leisurely promenades and clean still life works of bright pitchers and lemons.

I saw no taxis at the summit of the stairs. It was Sunday. I'd have to drag my burden through the town to my hotel. My map was buried, and I scanned for signs, hauled the carry-on upon my back and rolled/dragged/stopped every few feet. The joints in my fingers hurt, my energy twisted strangely.

There were signs everywhere for The van Gogh Walk: Over there was the park he'd painted so prettily, up ahead was the Arena, a small Roman coliseum, and around that corner was Place du Forum where Vincent had painted the café at night in festive yellow and blue. All the sites were labeled with poster-sized prints of the paintings and little vignettes of Vincent's activities in each spot.

Clusters of van Gogh lovers huddled together reading the placards, ran their hands along the backs of benches, railings, and chairs where Vincent had once existed, and scurried here and there, maps in hand.

I reached the top of a hill near the Arena and the colors of the coliseum, the sky, the trees, and people's clothes ran together in dizzying swaths.

Much later, the youth of the town threw cabbages at Vincent. The people of Arles turned against him and called him "Fouroux" (redheaded madman). In the end, Vincent was smacked from all sides.

I checked into my hotel and, still oddly achy, went to a hammam where I was slabbed face down on a table. Hands pummeled my shoulders, squeezed my neck. This was supposed to feel good, but my muscles shrieked, my joints gnashed together. The grip felt as if the huge hands of Vincent's washerwomen were kneading me to a pulp. I returned to the hotel and crawled into bed.

If you are coming down with something, it turns out that a massage can call the illness forth in a rush.

Inside the Yellow House, Vincent covered the whitewashed walls with paintings of sunflowers, six in all. He carefully decorated the bedroom for his friend Paul Gauguin, who had agreed to come, even putting up a painting he'd finished of the bedroom itself, an asymmetrical picture done from a skewed perspective. He wrote to Gauguin that he hoped the delightful garden near the house would stimulate his imagination.

> *My bony carcass is so full of energy. . . . However clumsy this attempt may be, it may show you perhaps that I have been thinking of you with great emotion as I have prepared your studio.*

Vincent prepared and prepared. He put flowers in vases, purchased bread and cheese, made the bed carefully.

I'd filled the map of Arles with my own notes ahead of time: *Find the Yellow House. Have a glass of wine and live inside the painting*, Café Terrace on the Place du Forum at Night. *Stand on the banks overlooking the river, near where he painted* Starry Night Over the Rhone. *Visit Espace van Gogh.*

I had prepared and prepared. Hopes were high.

On Day #1, I'd planned to place my feet, clad in black ballet slippers, directly on the path Vincent had taken through the park, to sit on a bench and contemplate the life of the artist. I would visit Espace van Gogh, the hospital where he'd stayed later, when things went bad, a tall building that I knew had a courtyard in

the middle (which Vincent had painted) with another bench on which to ponder. Later that evening I would linger outside on the terrace of the café Vincent had made appear so inviting and cozy, and gaze at the stars in rapt admiration.

That morning, I swung my feet over the side of the bed, and the walls of my hotel room tilted into a trapezoid.

Vertigo. Nausea rose and fell in swells.

Chills, heat rising, teeth chattering, hot, cold, thrashing, still.

My hip joint seeped poison into my side, into my legs, into my back.

All I'd wanted to do this day was to meander through the park and sit quietly in the courtyard at Espace van Gogh, which was right around the corner from my hotel.

I went nowhere. Instead, I was visited with lurid visions in hideous reds and greens, scenes inside the other café Vincent painted, the place he'd lived before moving into the Yellow House, *Café de Nuit*.[8] A pool table with one harsh light over it, sad, slumped, depressing figures, the painting Vincent had said was the ugliest he'd ever done.

People on The Walk that day were enjoying the café on Place du Forum, but I was in the grip of the other painting, about which Vincent had written, *the café is a place where one can ruin oneself, go mad, or commit a crime.* This place where *"Night Owls" can take refuge if they haven't enough money to pay for lodgings or are too drunk to be taken in anywhere* was not featured on The Walk.

Café de Nuit filled my fever-dreams.

My system had failed me in the most unpredictable, devastating way. Even if I could move, my intestines insisted on my staying. On top of it all, lugging my suitcase had carved a strip of agony from my arm up my shoulder up the side of my neck to my ear.

I was trapped.

[8] My poem, *Café de Nuit*, is included in the anthology, *Burning the Midnight Oil*, by Phil Cousineau, Viva Editions, 2013.

Vincent came to Arles convinced that two things were his destiny: to paint and to bring artists together. He had not yet sold a painting, but here he felt as if he sailed on the cusp of his creative powers. He painted an Arlesienne, a woman with delicate, angled features, her chin resting on a slender hand, and a Zoave, an Algerian soldier, who he rendered in vibrant oranges and blues, *a young man with a small face, a bull neck, and the eyes of a tiger.*

Gauguin was the first of the artists to arrive. It was happening, Vincent's destiny was opening. He poured happiness and hope into his work, and kept up a brisk pace, spending hours out in the blazing sun and wind.

Vincent and Paul painted together and often enjoyed vigorous discussions that lasted late into the night. *Sometimes when we finish,* Vincent wrote to Theo, *our minds are as drained as an electric battery after discharge . . . We have been right in the midst of magic . . .*

I had gradually begun to suspect that two things were my own destiny. I had won this trip by writing the winning essay at a conference I attended annually. I'd been first to Rome, of which Arles was a miniature replica. Next I'd gone to Geneva, then to the writing seminar in the Jura, where rich friendship and creative collaboration had increased my certainty that I was destined to travel and to write. This pilgrimage to walk in Vincent's footsteps fulfilled both, and was a dream I'd had since I was a little girl and had first seen an image of van Gogh's *Bedroom.*

 All I wished to do on Day #2 was stroll over to Place Lamartine to finally see the Yellow House, but crunched up in bed squinting at my guidebook through a searing headache, I read, to my own stupidity-laced surprise, that it had been destroyed in the World War II bombings

Image: The Yellow House, which was located at 2 Place Lamartine

of 1944. How had I missed that? That night I'd hoped to gaze at the starry sky from the quai and feel what Vincent had felt as he painted *Starry Night Over the Rhone*, wishing *to express hope by some star.*

Inside this tiny space, seconds crawled to hours, day to starless night. I was alone with no hope of salvaging my time in Arles.

It turns out, Vincent learned, that sawing your ear off with a razor brings madness forth in a rush.

He began having bouts of melancholy and soon he teetered on the edge of psychosis. One evening, Gauguin was strolling through the gardens near the house and Vincent pounced on him, threatening him with a razor. Paul met Vincent's eye and calmed him down, but left to spend the night in a hotel. Vincent hacked off part of his ear and carried it to a nearby brothel, where he plopped it, gloppy and bloody, into the hand of an unsuspecting woman named Rachel.

"Take good care of this," he said, and returned home and crawled into bed. It must have been an excruciating night, for he had severed an artery. His ear burning as if on fire and gushing red onto the pillow, his mind spinning and screeching, his heart broken, Vincent must have willed himself to take each breath, his thin chest puffing out, then caving in. The police found him unconscious there, but there is no picture of bloodstained sheets, of Vincent's pale, tortured expression, or of his hands unable to hold a paintbrush, his immobile feet. He was taken to the hospital, wracked with fear and heartache.

I awoke on Day #3 still feverish, dizzy, and now beginning to feel stabs of anxiety. I gaped at the tropical scene on the curtains. How would I get to my next destination, Aix? (Considering Paul Cézanne's miserable temperament, what the hell was in store for me there?) I had planned to take the train, but could barely shuffle to the window. I picked up my three-inch cloth makeup

bag and my finger joints weakly released it to clump to the floor. Equilibrium was almost within reach, I could feel it, but there was no way I could take the train. I phoned a driver.

Vincent, trapped in the hospital, was miserable, wretched. He later wrote to Gauguin, *In my mental or nervous fever or madness—I am not too sure how to put it or what to call it—my thoughts sailed over many seas.*

When he returned home from the hospital, his equilibrium fluctuated. He experienced moments when he was *twisted with enthusiasm or madness or prophecy,* but he knew he had lost Gauguin, and his dreams of the artist's collective and his life's work were at risk of crashing down upon him. Everything Vincent loved was in turmoil.

Vincent tried to start afresh, but his presence caused uneasiness all over Arles. The people filed a joint petition, and the mayor ordered him locked in an isolation cell in the hospital for a month while police searched the Yellow House.

By the time he was released, Vincent had come to think of his madness as a disease and had made plans to stay in an asylum in nearby Saint-Rémy, but he would not be allowed to paint outside at first. He'd be imprisoned there, too.

Vincent packed up his things inside the Yellow House, his studio, *now come to grief.* He had painted and sketched 300 works here in Arles. He wondered whether it was all a losing battle, this weakness of character. Had it been the drink that had gone to his head, the sun, the *mistral?* The artistic and intellectual stimulation of having Gauguin near? How had he missed the signs?

He wrote to Theo that everything was vague and strange. He pondered the condition of an artist in nearby Marseilles who had committed suicide: Vincent didn't think it had been too much absinthe that caused the man to kill himself, but who knew?

As he left Arles, Vincent was filled with a limb-numbing remorse. He had failed himself.

A large, solidly built man in shades with a short, trimmed beard easily tossed my baggage into the trunk of his car.

"*Vous etes mal? Je suis desolee,*" he crooned, then gestured to the big car and pointed around the corner up ahead. "*Les rues est très petites.*" The streets were too narrow for the car. We'd have to take the long way out of town.

I slumped in the back seat as the car rolled up the street. On my left was Espace van Gogh, the place Vincent had suffered so.

We passed the hammam where my condition had been unknowingly aggravated.

A thought tugged at me.

We turned the corner and there was a group of people, noses to a placard.

We drove over Pont van Gogh, across the Rhone where I'd missed the starry night because I'd been incapacitated.

A couple stood holding up their map, then the man pointed ahead and they walked in Vincent's footsteps.

It was all I'd wanted to do.

Then I knew.

What if all you can do
is
all
you can do?
Curl up.
Breathe.
Exist.
Breathe, exist.
In.
Out.
This was exactly what was meant to happen here.

⌒

Signs

Since such as they have fortune in a string,
Who, for her pleasure, can her fools advance,
And toss them topmost on the wheel of chance.

—Juvenal, Roman poet and satirist (55–127 A.D.)

IT IS A SIGN.

A spot above my right eyebrow tingles as I stare at the iron sign that dangles at the end of the alley. Its black outline, stark against the stone arch that leads to leafy, green Boulevard Saint-Germain, is of a whip-wielding groomsman driving a carriage atop seven little spirals. *Relais Odeon Brasserie*, it says innocently, sticking out from the ecru building high on the right side of the narrow passage. As I contemplate it one June morning from a sun-drenched table on my last day after two weeks in Paris, it seems to stare back at me. *I'm just a sign.*

The previous November, one morning on my last day after a month in Paris, the snarling leopard of regret rose out of my

ribcage and lunged at the top of my throat every few moments. As on each day-before-departure, my brain battled with my heart: stop/go, linger/hurry, stay forever/say goodbye.

My routine was to pack the night before I left, but that morning I had followed some unexpected urge and placed my boots in the bottom of my suitcase, stacked skirts, bagged up toiletries, and swept my apartment for loose papers. Ready/not—I numbed myself against this contrast and set off.

Across Pont Saint Louis, the flying buttresses of Notre Dame reached out, begging me to stay, but I ignored them. I was headed toward Shakespeare and Company, then to lunch with my friends Edouard and Michèle, and would spend the rest of the day purchasing last minute gifts.

With a scratch of the leopard's claw, I realized that I hadn't gone to the Louvre or walked down my favorite hallway under the wrought iron signs at Musée Carnavalet in the Marais. I longed to be inside a medieval building under Gothic arches.

At the bookshop, two weeks previously, I had taught a workshop in the library upstairs, where the dust motes smell of stardust and the literary gods reside. A bell tinkled as I walked in and waved to Sylvia Whitman at the cash register.

The man in front of me cleared his voice and spoke to her.

"I feel so lucky," he said, with undisguised awe. "I can't believe I'm standing here at Shakespeare and Company in Paris. I've been waiting my whole life for this moment: 60 years. What a pleasure it is to meet you. Do you live upstairs like your father did?"

Sylvia laughed and visited with him for a few minutes, and then she and I arranged to communicate about travel books I had recommended. I said goodbye, walked out and turned up rue Saint-Jacques.

This street, once the main road of medieval Paris, is home of the Sorbonne, with Lycée Louis-le-Grand across from it. I loved the story—whether legend or wild rumor—of how, in 1775,

Robespierre, at age 17, had been chosen to read a speech to the king at this school.

A deluge began as the royal carriage rolled in with Louis XVI and Marie Antoinette lounging in the back. Robespierre welcomed the royal couple, who did not emerge, began his comments on the glories of France and . . . the king waved his arm, the carriage splashed over the cobblestones and was gone.

I wondered if, years later as he watched the blade of the guillotine rushing toward him, the king had remembered this, and wondered about interconnected events.

My nose was stung by the antiseptic smell of oysters, and I realized that, once again, I stood in a pool of melting ice chips on the corner of rue Saint-Jacques and rue Danton. At the outdoor seafood stand, a man in an apron shucked oysters like a magician shuffling cards. I *always* ended up in this spot, no matter what route I mapped out to avoid it, gagging at this seasick smell I detested, and wondering if there were some kind of magnet in the slimy, pearly-gray globs that drew me here against my will.

At this eastern end of Boulevard Saint-Germain, young people in black coats and scarves swarmed in the dusty-bookish Latin Quarter. On my left was Musée du Moyen Age, the Cluny, with its golden turrets and reddish trim. Inside a high-ceilinged room stood a group of headless statues that had been hacked off of the façade of Notre Dame during the Revolution, their heads arranged on a nearby platform.

Oh, to stand in a slanted November sunbeam inside the Cluny drinking imaginary cocktails with The Kings of Judah.

That day, I tossed wishes out like confetti. I was not careful what I wished for.

The Cluny borders Saint-Germain's posh section, and up ahead *voitures* zipped and heels nipped in pursuit of fashion's rushing edge. I waited to cross the street correctly, the green stick-man lit up on the sign, all cars stopped, for one does not jaywalk in Paris. Ever.

I dashed down Boulevard Saint-Michel to Café Saint-André, the favorite haunt of Sabrina, my tiny, black-haired snip of a friend. Might Sabrina be there huddling over a café crème? No time; I ran the gauntlet of tourists and restaurateurs on rue Saint-André-des-Arts.

It came to me: the man in the bookstore had been waiting his whole life. To be able to teach even a few times a year at Shakespeare and Company, to be co-editor of a book of writings from there: It was I who was lucky.

Luck in French is *la chance*, or *la fortune*. Was my own luck by chance or fortune? In English they differ. Chance is unpredictable, without cause, while fortune points to a force that moves events in our favor. In this lucid moment, my luck felt as if it clung to me like a shimmering aura.

In the window of a print shop on rue de Seine, a medieval engraving of rowboats on the Seine snagged my attention, but I hurried on, not wishing to be reminded of the many 14th century engravings I would miss viewing this visit.

As cars zoomed past, I thought of my dark-eyed driver, Eyal, who, the previous week, had driven me all over the suburbs to sites for my research. I adored this quiet, interested man; he'd become a friend. I knew he'd pick me up in the morning to take me to the airport, but we hadn't had enough time for him to tell me what his three-year-old son was up to.

I met Edouard and Michèle at Le Petit Zinc, a landmark Parisian brasserie with tall, cone-shaped lamps of blues and yellows and oranges, and Art Nouveau arabesques reflected in

mirrors. After two hours of the pleasures of the palate, although it felt counter-intuitive, I declined dessert and said goodbye with a pang.

Showers began: umbrella up/down.

Seeking special notebooks, I decided to go to an exquisite *papeterie* in the tiny alley of Cour du Commerce Saint-André, the passage behind Le Procope, the first café in Paris, where Robespierre and his cadre transformed the wildest Revolutionary dreams into plans.

In Cour du Commerce Saint-André, during the Revolution, sheep could be heard bleating until the whistle of a blade silenced them forever, for here was where Dr. Guillotin proved that heads could "topple in a flash and you will feel but a light breeze on your necks." Later, the doctor himself was spared the breeze of the blade only by Robespierre's bloody head thumping into the basket first.

Raindrops plunked upon the A-framed, glass-covered entrance. The cobblestones along the passageway were arched, and people walked as if on a giant log. They lurched this way and that, arms out for balance, looking up, down and around. At the other end, beyond an arch, rain slashed bare branches on Boulevard Saint-Germain.

On my left was Grim'Art, the *papeterie*, named for *grimoire*, a book of magic spells. I admired the window display of red-feathered fountain pens arranged in a fan shape, with the word *Calligraphie* written on cream-colored paper of the finest linen.

Here. Here was where I wanted to stay, in this alley with rain hammering above and cold curling under my collar. I felt embraced by history, thrilled by its violence and strides. Light filtered down through the glass, footsteps and

voices echoed through the narrow space, keeping my feet rooted to this spot, my rhythm paused inside this stanza of time, my soul riveted to this place.

No—I had to hurry. I'd go to the paper store on Île Saint Louis, where the balding man behind the counter would smile, and meticulously wrap my notebooks. (Alas, I had no great story to write in them after an uneventful month.) Then I could dash across the street to the *pharmacie* for my traditional last purchase of each visit to Paris.

As I passed Le Procope, a portrait of Robespierre loomed, and his beady stare sent my pulse skittering. I thought of another revolutionary, Marat's apartment just around the corner, where he had reclined in his bath, head wrapped in a towel, and a young girl had stuck a knife into him, sending blood spurting all over the porcelain tub.

Gingerly maneuvering the cobblestones, I teetered toward Boulevard Saint-Germain, glancing up at a black iron sign of a horse and coach.

Then it happened. Clip-clop of hooves, shopkeepers calls. The feeble cry of a sheep, the slam of a blade. Shouts from upstairs at Le Procope. Cold, gray, dismal, dripping. 1792.

A boy in a red cap and short pants skipped past, his wooden clogs tapping the stones, chasing a girl whose honey-colored ringlets bounced. A cat yowled and arched its back. Rattling carriage wheels, the crack of a whip.

In front of me, a woman's skirts, thick silk of the deepest crimson, rustled as she raised the hem to reveal silk stockings embroidered with gold thread. Her right shoe came clearly into focus, covered in butter-yellow satin with a one-inch heel, and a squared toe with a satin-covered buckle on top. The toe wedged into a crack between stones, stuck. The heel jerked upward, black lace petticoats and crimson silk flying. She fell.

Boulevard Saint-German's traffic roared. I rushed down the boulevard past the Cluny, out of the corner of my eye was a window display of a bird's skeleton. I was struck by how fragile its skull was. Again, a faint feeling of fear.

As I walked, I scolded myself for having too vivid an imagination, for I often had strange scenes play out in my mind. Many times I'd had forebodings that felt as if I were alone in a desert before real crises had occurred, hunches about popular people who eventually showed more sinister sides, and inklings of harm-to-come before injuries. I expended great effort to hide this, to appear "normal" on the outside. I had spent years trying to out-distance the *weird* inside me, and preferred to keep moving.

I mentally checked my list: I'd already packed, so after my trip to the *papeterie* I'd pop into the *pharmacie* to buy band-aids, a French item I thought superior and always stocked up on. I imagined the round, blond woman at the *pharmacie* handing me a white paper bag. Then and only then would I be ready to leave Paris.

The longings I'd carried with me throughout the day came in flashes. In the past, I'd rolled up such wishes and crammed them between my fuchsia ankle boots and my black skirt, as do travelers everywhere, for the leopard stalks all. At home these regrets would stare at me as I unpacked, snag my memory with times-that-could-have-been, and tamper with my sense of a-trip-well-traveled. But not this time.

This time they all came true.

Back on Île Saint Louis, I bought my notebooks and dashed out, rain bouncing upon the sidewalk. In my rush to get across to the neon green cross of the *pharmacie*, I glanced to my left at cars waiting at the light a block away. With both hands elbow-deep in my bag, rummaging for my wallet, I took a chance, and I could hear my heels smacking the pavement as I jaywalked.

Gray sky spinning, twirling, gray pavement. Whomp-crack. Head, head, head, hurt. Stun, shock. Car wheels rolling past, too close.

"Madame? Madame? Can you hear me?"

Hands stinging, knee screaming, head, head, head. Wet. Red, red, red.

"Madame, come with me, take my hand, get up, Madame, I have your bag." Lifted, an arm. "We must go here, to the *pharmacie.*"

The blond pharmacist: "Madame, sit here, please, hold this to your head." She handed me a white, gauze bandage. "You must go to the hospital now, Madame."

Shaking, shaking, I dialed Eyal's number.

He arrived, dark eyebrows slanted with worry. "What happened? *Allons-y.* I'll take you to Hôtel Dieu, it's nearby on Île de Cité. It's the Emergency."

Even through the pain, I knew that Hôtel Dieu de Paris was the most gigantic bulk of a medieval building I had ever seen. Eyal held my arm as we walked down a wide hallway which overlooked a courtyard bordered by arches. Through one eye, I took in cavernous vaulted ceilings and wrought-iron chandeliers, which shed a surprisingly bright glow over walls covered with framed medieval engravings: nuns in black habits carrying soup bowls, the Hôtel Dieu itself looming behind rowboats on the Seine.

In spite of the clean, antiseptic hospital smell, I felt I was being escorted through this castle by the grandest of chivalrous knights.

Eyal squired me through X-rays, examinations, stitches, and sat close during long waits, showing me photos of his son, telling me stories of Paris. I was diagnosed with a concussion but the

doctors conceded that I could leave the next day as planned. My head began to throb. Sabrina, whom I had called, came rushing in, her long black hair windblown, took me back to my apartment, assured me she'd check on me every few hours, and settled in to spend the night on the couch.

I stumbled into the bedroom and tripped over my suitcases, knowing I could not possibly have gathered my wits enough to pack.

I was drawn into dizzy, disturbed sleep.

Hours later, I sat up, eyes wide in the darkened room. The yellow shoe. She'd fallen. I'd fallen. I sank back into sleep.

I returned home to Seattle, my right forehead swathed in white gauze, sporting a black eye, my face covered in bruises. Vision was disturbed; shapes had an odd, candle-lit aura around them. Hearing was accentuated, as if the volume had been cranked up. Thoughts came slowly and were often incoherent.

Recovering from the concussion is a travelogue I'd rather not re-open. Gradually, painstakingly slowly, I could see without the shimmering glow, hear without the loudness, attend to speakers, participate in conversations, drive, gather thoughts and write, my head throbbing and tingling all the while. By spring I still could not finish an entire book, and music was still far too distracting to listen to.

In Cour du Commerce Saint-André on this sunny day in June, I dine outdoors at Pub Saint-Germain. I have been waiting months to recover from the concussion, and I can't believe I'm here. I read the last chapter of the book *Paris*, by Edward Rutherfurd, a sweeping saga of this place. It is the first book I will finish since my fall.

On the very day I had been struck so strongly by my incredible luck, it had turned as if upon a wheel.

If I had heeded the signs, would I have fallen? Was there significance in the Heads of Judah, the miniature skull, the etchings of rowboats, the shoe? Had the spirit of Robespierre somehow claimed me as a victim? Why had I packed early, why had I jaywalked? If I'd fallen one moment earlier, would I have been crushed under the wheel of a car? If I hadn't longed so desperately to be in a medieval building, would I have been spared the trip to Hôtel Dieu? If I'd let myself stay outside Grim'Art, would the day have unfolded on its own or been shaped by a magic hand in the same way? Are our regrets always transformed into wishes at the wave of some wand?

Who can know?

I feel pulled toward Boulevard Saint-Germain: leaves shaken by wind, cars being driven, people seeking fortunes. I rise to my feet and move below the sign, approaching the arch. There is only one thing I do know.

I've been waiting my whole life for this moment.

⌒

Duende in the Louvre

*The muse and the angel come from outside us: the angel gives lights
and the muse gives forms . . . but one must awaken the duende in
the remotest mansions of the blood.*

—Federico García Lorca, *In Search of Duende*

⌒

NEVER IN MY LIFE HAD I FELT MORE LURED INTO A TRAP.

I stared at the grimace of a dead sheep. Nearby, slabs of
his body, glistening with rust-colored blood: raw meat, hacked
in half by an unseen, dripping cleaver, showed shockingly white
ribs and bone. An eerily elongated Christ writhed on the cross
underneath a black sky that squeezed clouds in a vise grip.

I did not, in that moment, recall that I had asked, even
begged, for this sinister sight that steamrolled into me.

I was in Paris for two weeks before leading a writing trip in
Morocco and had planned to teach a workshop there first, a sort
of practice session of one I planned to roll out in Morocco,
"Evoking *Duende* in Your Prose."

Duende is a murky concept that Spanish poet Federico García Lorca harnessed—in the 1920s and '30s—and used in his writing. He defined it as *an intimate and anonymous cry of pain and longing* which Lorca noticed inside Adalusian music called *cante jondo* (deep song), flamenco, the bullfight, and the art and literature of Spain. This quality, according to Lorca, included irrationality, earthiness, a heightened awareness of death and a dash of the diabolical, and could help artists create.

I had sought this in my own writing, had tried to evoke *the precious stone of the sob* in the way Lorca described. I planned to share numerous quotes from Lorca's short book, *In Search of Duende*[9], with the writers, which I knew they would toss back and forth to see what meaning they could extract.

> *Deep song shoots its arrows of gold right into our heart. In the dark it is a terrifying blue archer whose quiver is never empty.*
>
> *The* duende, *then, is a power, not a work. It is a struggle, not a thought . . . it climbs up inside you, from the soles of the feet . . . the same* duende *that scorched the heart of Nietzsche.*
>
> *. . . the dark, shuddering descendant of the happy marble-and-salt demon of Socrates, whom he angrily scratched on the day Socrates swallowed the hemlock, and of that melancholy demon of Descartes.*
>
> *Every man and every artist, whether he is Nietzsche or Cézanne, climbs each step in the tower of his perfection by fighting his* duende, *not his angel, as has been said, nor his muse.*
>
> *The true fight is with the* duende.

This is what people love to do in Paris, hold ideas up to the light, examine all sides, discuss them for hours, and integrate

[9] *In Search of Duende* is a collection of Lorca's writings about the concept.

them into their lives. I looked forward to facilitating this workshop here, as I knew my writers would run with it.

But the workshop was later in the week, and I knew if I was open in the meantime, I'd be presented with some new insights into *duende*. This was my first day here and before any of my friends knew I'd arrived, I planned a solo visit to the Louvre to visit with my muse, mentor and best girlfriend, Winged Victory of Samothrace. I had an odd connection with this ancient statue. She was a kind of barometer for my own personal growth, and we had a lot of catching up to do.

I glided on my usual route down into the museum through Pei's glass pyramid, dashed across the crowded foyer, up the escalator to the Denton wing, wove through statues and carved doors in Gallerie Donatello, nodding as I passed the enameled terra cotta *Madonna* by Della Robbia, turned left up the curved staircase to breeze past Michelangelo's *Captives*: angels emerging from raw marble in all their masculine glory.

At the end of this long Gallerie Michelangelo, I paused to admire a pure white Psyche arching her back to receive Cupid's kiss. A few footsteps later I knew I'd glimpse Winged Victory, my compass-rose in the universe, at the top of the Daru staircase, waiting for me, as always. After a nice, long chat with her, I'd go to the café at the end of the Italian painting hall and write some notes for the workshop, for I knew there was *beaucoup duende* in the Louvre.

It had been a rough few months, with the death of my father-in-law and the health of my mother going from crisis to crisis. Although it was a brilliant group of writers and I knew it would be a fantastic trip, I had little enthusiasm for this upcoming teaching stint in Morocco, of smoothing out arrangements, finding no privacy, showing constant leadership. I needed the reassuring

presence of my soul-sister-in-a-statue, her earth-toned solidity, her counsel. She would restore my energy.

I envisioned her wings, thickly carved yet delicate, with cracks that accentuated the light and always reminded me of Leonard Cohen's song about how the light gets in, her breasts rounded and high, the sheer folds of her gown clinging to her stomach like a wet tee-shirt; her bold, sexy stance, legs braced, rising to take off.

Of course I wouldn't be able to reach out and touch her ancient, fragile stone, but she was my touchstone, permanent and eternal. I reached the bottom of the staircase and placed myself on the left side so I could, as always, hold the railing and gaze up at her as I ascended.

At the top of the stairs loomed a gunmetal gray partition, dark, stark, like a metal bar across the top of my stomach.

She was gone.

A sign informed me that she was in another room of the Louvre undergoing restoration.

I reeled around the corner to the right and flopped down on a bench in an alcove in the little hallway leading to the Italian painting galleries. In front of me was the delicate pastel beauty of Botticelli's *Venus and Her Three Graces*. This frescoed fragility was not solid like my statue, not real, like her.

But, I realized, she wasn't solid or real. Winged Victory was transitory.

When we are weakened or brought low, we often do not know it until we have been, like a baby swinging in a blanket from a stork's beak, dropped into a dark forest.

Then, as if out of the blue, comes the one thing that tips our balance, the straw that cracks the camel's back, that seemingly mundane occurrence that annihilates us. When it happens, our

senses are sharpened, sensations sting, sounds smack our ear-drums, colors clash and shadows loom. We are exposed in all our fearful vulnerability, human beings susceptible to forces outside of our control.

The flimsy lace of our careful design unravels.

Coffee, *tarte tatin*, equilibrium. This was all I sought now.

I swam in an international school of fish down the Italian painting hall, blond Madonnas and cherubic Christs lining the walls, with the occasional scene of mythological violence gorgeously rendered in hues of blues and crimsons. Leonardo da Vinci's Saint John the Baptist grinned as he pointed to heaven.

I peered ahead, looking for the familiar foyer outside the café at the end of the hall. I'd been in the Louvre dozens of times and frequently got turned around, lost in the labyrinth. I didn't see the café but maybe it was around a corner, I was almost positive it was on this floor. God, I was exhausted.

I reached the last gallery, stood in the middle of the room and sighed, trying to calculate where the hell that café was. Was it too much to ask, I thought, to sit down and have one cup of coffee and just think? To gather my wits, to re-group?

I felt the hair on my arms rise: the sensation that someone was watching me crept up from behind my lungs and began swinging on my veins as if they were vines. I slowly turned my head and met the stare of a heavily lidded eye. A severed sheep's head in globs of blood lounged among the butchered sections of its body, fixing me in its dead gaze.

Dead.

Dead.

Dead.

My pulse skittered, burning my chest.

I jerked my head away, dizzy and nauseated.

My eyes were drawn to an eerily elongated body, pale with gray shadows, writhing on a cross. Ugly. Black clouds, rimmed in shocking white, lunged out of a dark indigo sky. The contrast exploded inside of me, turning my insides to cold pudding. All around me were paintings so stark and aggressive in their clashing colors that I was stabbed by arrows of fear, visceral sensations that stung to the tips of my fingers. I sensed my own shell cracking, the edges of my skin exposed. The paintings emitted a fizziness that sizzled as it pierced me.

Menacing.

I staggered out of the Louvre and hastily crossed Pont des Arts, skittering away from the monstrosity that had swallowed my friend Victory and unleashed these waves of horror. I spent the rest of the day in the Luxembourg Garden seeking light, and having coffee at Le Rostand. I phoned several friends and made plans to meet for lunch, for an exhibit.

I distracted myself from the dark.

Later that week, the writers squeezed the concept of *duende* as I'd known they would, refused to take a break, continued to hash it all over and share their own thoughts.

"It's like a laugh," said Jean-Bernard.

The group gaped, tilted heads, puzzled brows.

"It just comes up and you can't stop it."

A nod, two, three. Murmurs of agreement.

I was struck by the memory of the swirling, dark agony that Goya and El Greco had injected into me that day in the Louvre, for I had ended up in the Spanish painting gallery, eye-to-eye with Francisco de Goya's *Still Life with a Sheep's Head*. El Greco had tossed the last straw with his *Christ on the Cross*. The paintings had

loosened a black ribbon which had unraveled out of me, leaving only an awareness of emptiness inside.

Perhaps, I thought, that empty place is where you find it: your own inadequacy, your true condition as a human being on this earth. You strive to fill the space with light any way you can—fleeing to a garden, catching Cupid's arrows, finding friends, slaving away at what you love, and soothing your grief—knowing the dark is in there too, and you will face it again.

The true fight is with the *duende*.

Belonging

*You take delight not in a city's seven or seventy wonders,
but in the answer it gives to a question of yours.*

—ITALO CALVINO, *INVISIBLE CITIES*

Image: Bastide du Jas de Bouffan, 17 Route de Galice, Aix

As TRAVELERS, EACH OF US HAS our strings strummed by different hands: one delights in the spontaneous dancing that begins at the sound of a guitar in Yelapa, Mexico, another as violins sigh and soar in an outdoor amphitheatre in Milan, and yet another as the muezzin's call to prayer echoes off the walls in the old city of Jerusalem. One who has dedicated his life to unraveling myths feels a shudder when he leans against a pillar in Greece, and someone else may enter Saint Petersburg with a surge of power as if he were a long-deceased czar.

We are attracted to people in different ways as well. One woman's instant connection with a young man in Fez, Morocco is uncanny until they discover they both have twin siblings, and a traveler in Kyoto meets an old scholar who shares his birthday, December 9. While in Bolivia, you strike up a conversation with an old woman and your friend gabs with a little boy.

There are places where our own personal gifts are needed: a photographer is lowered into a cave mine in Ghana and chronicles slavery there in photos that reverberate with urgency; a writer exposes the slaughter of sea turtles on a beach in Mexico. Your cousin plays his flute for a gathering of cancer patients in a city a half hour's drive away, and you discover, to your own surprise, that the skills you picked up while serving the homeless on the streets of Calcutta come in handy at the food bank in your town.

There are places we feel we fit that make little sense to us: an heiress who has never wanted for anything feels oddly at home squatting in a favela in Brazil, a college boy feels as if he is one of the gang while having a beer with a group of old men in Madrid, or a poor villager enters a villa in Tuscany with a sense that he could recline on the couch, snap his fingers, and have every wish granted.

We travel for all these reasons, but Italo Calvino suggests our real quest is for answers.

Indeed, it turns out the woman visiting Yelapa needed to loosen her limbs and dance, the Bolivian boy showed your friend how to overcome loneliness, and the old men urged the college boy to follow his heart and pursue the girl who he eventually married. The photographer spearheaded efforts to get to the root of modern slavery, and the writer, in discovering the cause of their deaths, saved the lives of thousands of sea turtles.

When first I traveled to France, it was the art and architecture that curlicued its way into my consciousness. The Millau suspension bridge in southern France seemed to link the present to the past, as did the cowbells ringing among French and Swiss style chalets in the Jura Mountains.

In Paris, I felt I fit: Monet's *Waterlilies* curved around me in l'Orangerie, and the view from the Louvre's Arc de Triomphe du Carrousel to the Arc de Triomphe to the Grande Arch de la Défense felt as if it began with me and ended at the edge of the world. This place worshiped writers and I felt cherished. The music resonated, the history fascinated, and the people beckoned me over the threshold, welcoming me as family.

I became addicted to traveling to France, to feeding my lust to wander. People would ask when I would next escape to France and I began to wonder. We often venture far and wide before we realize that what we are trying to escape is ourselves. Paul Cézanne spent his life darting between his home in Aix-en-Provence and Paris, or Aix and L'Estaque, or Aix and Pontoise. "Cézanne's Salon des Refusés" is a story of an artist who pushed beyond the edges of color, form, and beauty as a way, perhaps, of seeking that which he most deeply desired.

What I found in France was question after question: Was I acting my authentic self? How did the unconscious mingle with the mind? What was the divine right of kings, of emperors, of regular people? "Reconnaissance: Seeking Sainte-Geneviève" is

an essay addressing what the Patron Saint of Paris taught me about seeking at a time when I was restless for answers.

The beauty of perpetual motion, the wonder of wanderlust, like wine, gets into our blood and teaches us how to respond to what pilgrims refer to as "the call." A friend wrote me recently that she has resisted the temptation of Italy for too long and is going. Speaking Italian, she said, makes her feel totally herself, only more so, *a blown-up version instead of a shrunken-down one.*

Of such logic are longings realized. "Now, Fly" is a story written from the perspective of the surprised eye. As my friend and mentor Tim Cahill said recently, "Trust your subconscious. Why is it in there? The story is the little lens through which we see life."

Somewhere out there, Henri Cartier-Bresson nods.

Cézanne's Salon des Refusés

Be gentle with the young.

—Juvenal, Roman poet and satirist (55–127 A.D.)

*Light-hearted and carefree in his youth, he later
becomes suspicious and withdrawn.*

—John Rewald, Preface to the *Letters of Paul Cézanne*

⌐

"Cuppa nakes!" said three-year-old Brendan with a grin, years ago, as he brought forth, from behind his back, a hand bearing two writhing creatures.

"Ohhhhh," I crooned, walking backwards and reaching for the terrarium I always kept handy. "You found a couple snakes!"

Brendan and his two pals, Kyle and Corbin, spent every spare second outdoors. Over the years, the three of them built a spectacular tree fort that incorporated the bark, branches, and design of the tree; created streams, rivulets and dams in a gigantic mud hole; rode their bikes on trails, through gardens, and up trees;

hacked out a camp in blackberry bushes they called "the stickly fort"; and collected all species of wildlife from lizards to frogs to—snakes.

One year, Brendan's science fair project was entitled "Sticklies," and on his posterboard display he taped, glued, and tied every branch, bush, stem, and stinging nettle he could find within the radius of our neighborhood. The board was so plastered with treasures of the forest that it had to be propped up with more sticks.

This is true passion. Brendan had a knack for understanding nature.

Kellan, my older son, had come into his own as soon as he began to wield the word "no." Unlike most other two-year-olds, there *was* reasoning with him.

"Okay, Kellan," I'd say. "You just sit there in the corner and yell until you're ready to put on your coat, and then we'll go."

Several sessions of screaming at the wall and he figured it was faster and easier to put on his coat and get going.

At the grocery store, he never needed to be bought off with a candy bar; if he demanded one, I would explain that we had exactly $33.00 and the steak, potatoes, milk, and paper towels totaled up to that, so sorry, there was no extra money. Kellan would nod, loftily look down from the shopping cart seat at a toddler having a tantrum on the floor, and continue to question prices so he could grasp grocery store logic.

Kellan was a rule-follower as long as the rules made sense to him, and during his school years was always captain of whatever sports team he was on, smoothing out disagreements and explaining the Little League rule about a fly ball on third or calming the guys on the bench after a bad call by a basketball referee.

I presented plenty of opportunities for debate over curfews, bedtimes, and my own illogical mom-behavior, and he rose to the

challenge. One day I looked at him and said, "You're going to be a judge."

Now, Brendan is a senior in college seeking a career in Natural Resources and Kellan has completed his last year of law school. I don't know if he will become a judge, but I do know that as they grew, both boys wanted me, their mom, to recognize their unique gifts.

So it was with Paul Cézanne growing up in Aix-en-Provence, only for him it was his father and it was not so easy.

Paul was born in 1839, and his childhood was spent racing around the fields and thickets of Aix with his two best pals, Émile Zola and Baptiste Baille. The three "inseparables," as they called themselves, climbed pine trees in the sun and bathed in the River Arc with the zeal and zest that propels young boys.

When Paul was sixteen, he began drawing lessons.

Paul's father, Louis-Auguste, opened a bank, accumulated a fortune and, when Paul was twenty years old, moved the family to a thirty-five-acre estate called Jas de Bouffan. Louis-Auguste decided that Paul would go to law school and take over the bank, following in his footsteps. Upon this his allowance would hinge. Paul began law school at University of Aix, but continued his drawing lessons.

The stand-off started when Paul wanted to go to Paris. Louis-Auguste was appalled that his son preferred wielding a pencil upon drawing paper as opposed to a ledger, and made the trip contingent upon his finishing law school.

About that time, Paul wrote this poem,

Cézanne the banker can't see without a quake
The birth of a future painter at the back of his bank.

Having been denied acceptance to École des Beaux-Arts in Paris, Paul returned to Aix desperate to prove his passion. He

had an idea, which Zola encouraged, having seen some paintings upon a café wall *like the ones you want to paint at your house.*

Paul painted directly upon the walls of the large, oval-shaped salon in Jas de Bouffan, between the tall windows, allegories of the four seasons, landscapes of Aix. The room, which was mostly unused at the time, became his gallery. Perhaps his father allowed this as a concession, or hoped his son would get this artistic urge out of his system.

Paul began what would be a lifelong pattern of bouncing between other places, usually Paris, and Aix. In Paris at this time he cut a dapper figure, was a dreamer, a visionary. He would return to Aix to paint out of doors, but then would conclude that his family were *the most disgusting beings in the world, crappier than anybody,* and depart again.

In 1863 in Paris, those rejected by the official jury of the Paris Salon—Manet, Pissarro, Cézanne and others—were included in a new exhibit created by Napoleon III, called *Salon des Refusés,* Salon of the Refused. The critics were not amused.

Louis-Auguste's displeasure in his son grew and he suspiciously tore open his mail. Paul and his friends were petrified that one of their letters would end up being scrutinized and used as an excuse to cut the paternal purse strings.

He painted a portrait of his father reading not the newspaper he habitually read, but *L'Évenement,* in which Zola, who was now a renowned writer in Paris, had published a series of articles defending the experimental work of the future Impressionists. Zola wrote of the painting, *the father looks like a pope on his throne.*

In 1873, when Paul was in Auvers-sur-Oise, Dr. Gachet, friend and confidant to many of the artists there and an acquaintance of Louis-Auguste's, wrote a letter praising the son, to which the father replied, *You wrote that Paul has behaved very well towards you. He has only done his duty.* Gachet interceded and obtained a higher

allowance for Paul, but the stingy banker remained on the prowl for any excuse to decry his son.

In a draft of an unsent letter to his parents next to a sketch of Jas de Bouffan, Paul wrote, *Once in Aix, I am no longer free . . . I am very much troubled by the resistance I feel on your part.*

Paul continued to paint, his brushstrokes becoming sharper, his colors leaping from the canvas or the salon wall.

He had an encounter with the director of the Musée d'Aix, who *wished to see for himself how far the menace to painting went* after what he called Paul's *attempts on its life.* The director closed his eyes and turned his back.

In 1872 when he was thirty-three years old, Paul's lover in Paris, Hortense Fiquet, about whom only his mother knew, bore him a son named Paul, an event to be kept from Louis-Auguste at all costs, for surely the money would dry up if this were discovered. Paul continued to paint, traveling between Paris and Aix, writing to Zola that he was constantly aware of being *under the paternal eye,* and of *traps laid for me.*

Zola was Paul's rock, his closest confidant, consistently encouraging him and even sending money to Hortense when the child became ill with typhoid.

Paul painted Mont Sainte-Victoire and scenes of nature with trees of greens and blues. He painted the rectangular stone basin of the Jas de Bouffan and the house in winter, with tree branches at sharp angles and yellows, oranges and blues in patches.

In 1882, the painting of his father reading the newspaper was chosen for the official Paris salon. It would be the only painting Paul ever did that was accepted there, but the success was fleeting, unheralded in Aix.

By then Zola was a powerful presence in Paris, and perhaps his success went to his head. He released a book called *L'Oeuvre*, in which the main character was a painter whose failure as an artist caused him to kill himself in front of a painting he had been unable to finish. All of Paris society saw the similarity. The friendship which had been the centerpiece of Paul's life was over, and he became increasingly embittered.

A letter from Hortense's father addressed to her in Paris as Mme. Cézanne was accidentally forwarded to Jas de Bouffan. In spite of Paul *taking all precautions to prevent my father from gaining absolute proof,* the ruse was discovered. Much to everyone's surprise, Père Cézanne, then 80, was busy chasing a charming young maid and actually increased his support. The weapon he'd wielded so viciously had become meaningless to him. Finally Paul and Hortense were married in April of 1886 in Aix.

His father died the following October, leaving Paul a fortune, but by this time, the artist seemed incapable of celebration or cheer. The money was his but never the recognition: In his father's will, Paul had been listed as "without a profession."

Paul's style of painting became more pronounced, with light falling in planes, in cubes, in geometric shapes.

Paul gradually had less and less contact with Hortense, and when he was in Aix stayed with his mother. Renoir visited him there, but left quickly because of what he called *the black avarice that reigns in the household.*

He painted a series of Jas de Bouffan's laborers and gardeners playing cards, and a series of bathers, which may have reminded him of the early days when the "inseparables," in Zola's words, *bathed under the trees which stretched their branches over the river. The last rays of the sun slid between the leaves, dotting the dark shadows with spots of light, and sometimes laid large patches of gold on the river. We saw nothing but water and leaves and little edges of sky, a distant mountain peak, or the grapevines in a nearby field. We floated there in the cool silence. Sitting on the fine grass of the*

bank with our legs dangling and our feet skimming the water we exulted in our youth and our friendship.

Paul Cézanne no longer exulted in anything except perhaps his work. In his *Still Life with Cherub* the apples were astonishingly skewed and seemed almost rounder than reality. Still, the people of Aix pronounced his brushstrokes erratic. He was on drugs, they guessed, dabbling in hashish, out of his mind.

Jas de Bouffan was sold in 1899 but the paintings remained on the walls of the salon.

In a 1902 article, *Love for the Ugly*, Henri Rochefort wrote of spectators having fits of laughter upon seeing the paintings of "Ultra-Impressionist" Paul Cézanne. People openly mocked him and left nasty notes on his doorstep ordering him to leave Aix, the place he had so dishonored.

In 1906, while painting outside in the playground of his childhood, Paul was caught in a storm, taken ill, and died at the age of sixty-seven. Upon his death certificate, instead of artist, he was listed as a *rentier*, a person of independent means.

When I visited Aix on a warm autumn day, the first place I went to was Jas de Bouffan. The water in the basin was strangely still, as if posing for someone to paint it. The house stood as in Paul's paintings of it, yellow and tall, with windows reflecting the blue sky in rectangles.

Inside, chairs were set up in the salon, with the white walls blank and the high windows covered. A crowd gathered and settled in and the lights were switched off. It was explained that upon the walls would be projected a series of slides of the paintings the young Cézanne had done there.

Image: Atelier Cézanne, 9 avenue Paul Cézanne, Aix

I remembered the first time I'd seen the paintings of Cézanne in Museé d'Orsay in Paris. *The Card Players* had seemed to vibrate with passion and such a variety of color my eyes had widened automatically. Every time I'd seen it, the work of this artist had seemed, more than any other artist, furthest from reproductions, more alive and moving, like a tree or river. I wondered if this *son et lumière* would be more like the images in books or the real paintings.

Spring, a woman with flowing blond hair in a cherry red dress with a garland held over her head and draped across her body. It looked familiar but I couldn't place where I'd seen it. *Autumn*, a bright yellow and blue background and a woman in a yellow skirt balancing a basket of fruit upon her head. Ah: I had seen these four seasons panels in the Petit Palais in Paris, and though they were much brighter and more vivid than any of his other works, I had thought them done by the artist Jean-Auguste-Dominique Ingres, for they were signed so. I hadn't read the descriptions or I would have learned then that Cézanne signed them "Ingres" because he wished to be thought of as an artist of his day, as Ingres was.

The paintings had been painstakingly removed after the death of the artist and sold to museums and galleries.

As slides flashed upon the walls—a painting of Mary Magdalene, one of his father reading in profile, scenes of nature, a bather—something of the desperation Paul must have felt while he painted them seemed to pervade the room. The slide show ended but the lights remained off; the crowd departed.

Sitting in the dark salon, the white walls eerily empty, I thought of Paul's consistent dedication to the attempt to touch his father. What it had cost him, I thought, had been revealed in an anecdote that was told by his fellow artist Émile Bernard, who once tried to help Paul up when he stumbled on some rocks. Paul had snarled, "I allow no one to touch me."

I remembered a self-portrait I'd seen of Cézanne, his eyebrows a lightning bolt, his eyes challenging. He had done it about the time the museum director in Aix had turned his back, yet Paul had written he saw in this portrait *a painter yet to come.*

He had died un-named as the artist he was. After his death, fifty-seven works of his were shown at the Salon d'Automne in 1907. Rainer Maria Rilke wrote about Paul's last years, *the time when he was shabbily dressed, and when children ran after him as he walked to his studio and pelted him with stones as if he were some stray dog* . . .

Which may have been what he felt like, a stray, after spending so many years taking the risk of presenting himself here at his home.

For it is a risk to try to be seen.

As a former teacher and a mom, I knew how essential it was for a child to have his gifts acknowledged by his parent, that when a child sought approval of a parent who denied it, the word that imprinted itself upon the soul of that child was "Failure." One tried a task—a test of logic, a science project, a painting—already hearing the word, "Failure." One attempted everything dreaming of the warm embrace of parental acceptance but instead received the sensation of being ripped in half, of frayed fibers, of something torn inside. Although the embrace eluded the child, the attempt to deserve it could become addictive. This effort would lead to that; hopes would rise with the next try. It could go on and on. One season would become two, become three, become four. Wishes became the food which fed the efforts.

I remembered that in the painting of his papa reading the newspaper, Paul had added, behind the chair, a still life of his own upon the wall. If only one of his paintings had been framed and hung on the wall in that house, if only his father had turned around. But he wasn't looking.

I knew also that when what a parent sought in a child was not the shape of the child's own unique self, but flaws and

imperfections, and no validation came, the child acquired an odd sense of guilt for falling so short of expectations.

When a sense of belonging was absent at home it was always sought elsewhere, but Paul did not seem to find it in all those decades of traveling away from and back to Aix.

When he was alive, Aix had never wanted its genius-son, precursor to Picasso, would-be muse to Matisse, palette-preparer to Kandinsky. But later that week I would walk past hundreds of bronze "Cs" embedded in its sidewalks, visit Musée Granet, which has borrowed most of the few paintings by Paul they exhibit, and tour his atelier, preserved just as he left it.

That afternoon as I took one last look at the walls of the salon at Jas de Bouffan that he painted with the eagerness of youth, I saw how it had become Paul Cézanne's own private Salon des Refusés. His sharp angles had said, "make room for me," his own intense colors had whispered, "value me," and with bold brushstrokes he had begged, "see me." In this way, he had painted his home, "I belong here," and his father, "you love me."

As I left the place where he had been refused, I wondered what would have become of the man Picasso would later call "the father of us all" if the world had been just a little more gentle with him.

~

Reconnaissance:
Seeking Sainte Geneviève

So. You have a wonderful view
but no way into the prospect.
I have no wings, you mutter, depressed,
but your looking outside the senses
is a fire that kindles the body.

—Jelaluddin Rumi, *Sticks Full of Light*

I STOOD IN THE ALCOVE knowing she'd called me here, but I still had no idea why. What did she want with me? Hadn't I come here every day for the past week, waiting for her to speak? She'd reclined in her jewel-encrusted bed, silent.

The fact that she had been dead for more than 1,500 years was no excuse.

A church is normally the last place I would look for answers, but on a recent trip to Paris, I had entered the white sculpted stone cathedral of Saint Étienne du Mont, walked down the right

side admiring the stenciled intricacy, like cut-out snowflakes, of identical spiral staircases which met in a high bridge across the middle of the church. I stopped to light a candle for my mother who was ill and my father-in-law who had recently died, and kept walking to once again end up in front of this stone reli-quary under a latticed ironwork design in the Chapel of Sainte-Geneviève, the Patron Saint of Paris.

I had repeated this scenario every day for the past week.

The previous week I had made the horrid discovery that my grounding force in Paris, Winged Victory, was away at every ancient-girl-statue's version of a spa vacation, having her cracks highlighted, her marble massaged and, as she had no arms, prob-ably just a pedicure. I shuddered at the memory of the gunmetal gray partition that had denied me access to her just when I was desperate for her counsel. During my last few visits to Paris, I had also had the utterly absurd feeling that she had been trying to shoo me away, to toss me from the nest, and now that she was gone, I was stung by rejection.

I had tried everything to comfort myself, but the sneaking suspicion that Winged Victory was just a statue had slid into the realization that Paris, my elegant refuge, was in many ways a city like any other. I had noticed tents pitched by the side of the freeway on the way in from Charles de Gaulle airport, pickpock-ets appeared to lurk everywhere, and the city seemed seeped in smog. Sabrina, my closest American friend in Paris, who always appeared in front of me whenever I thought of her, was out of town, and my other friends were either gone or busy.

I was plagued by the conviction that I needed a mystical con-nection with some sort of sisterly figure. Over the past few years,

Image: Saint Étienne du Mont, 1 Place Sainte Geneviève

I had come to take such illogical hunches seriously, as signs that needed attention, so there I was, right where my sixth sense of intuition had led me.

But Sainte-Geneviève couldn't be for me. I was not religious, had only recently become comfortable wandering into cathedrals, and knew nothing about her.

I left the church and, glancing at the Pantheon's dome catching the sun on its curve, went the opposite way, down the hill toward the bookstore to find a book about her.

Geneviève was born in 420 A.D. in Nanterre, in northern France, the daughter of a simple shepherd. As a girl, she often attended her father's flock on Mount Valerien. When Geneviève was eight years old, two bishops visited Nanterre and happened to inquire whether she might want to become a nun someday. As soon as she said yes, her mother said no. In what was surely every thwarted eight-year-old's guilt-laced fantasy, Geneviève's mother was struck blind on the spot.

Geneviève had many visions and dreams of saints and angels, and, like Jeanne d'Arc would nearly a thousand years later, this peasant girl followed her inner signals. All she had to do was bide her time until she could enter the church. After both parents died, at age fifteen, she went to live with her godmother Lutetia in Paris and became a nun.

In 451, when Attila the Hun approached to conquer Paris, Geneviève (in a young woman's wildest imaginings) upbraided the cowardly men who wanted to leave town, "Wait. Hold still. Don't move. Just stay inside your homes," I imagined her saying. The barbarians abandoned their quest and went off to conquer Orléans instead.

Geneviève also performed exorcisms and other political and garden variety miracles, led prayer marathons and was an intermediary with kings. Her enemies conspired to drown her in a lake of fire (always the aim of zealots through the ages) but she had fans as well:

Saint Symeon the Stylite, a 5th century celebrity, saw Geneviève in a vision and wrote her a letter, which must have thrilled her.

Sainte-Geneviève seemed like a rock star of a saint.

 On my repeated trips to her home in Saint Étienne du Mont, Chapel de Sainte-Geneviève, I had noticed the stained glass windows with scenes of Geneviève curing her mother's blindness like a good girl, enduring a nightmare about Hell in preparation for her mission, distributing bread to Parisians, and patiently relighting a candle blown out by a devil. There was also a statue of her holding the keys to the city, and of course her coffin/crypt/reliquary that housed what remained of her remains.

Geneviève was buried, at the request of France's very first king, Clovis, next to his wife and him. Her shrine was venerated and visited so often that a series of churches were built to accommodate the crowds. She became increasingly popular when miracles began to be attributed to her. In one case, in 1129, an epidemic, *mal des ardents*, a blazing, pestilent fever with "a violent inward heat," had killed off 14,000 victims in Paris. This burning sickness was halted when the shrine containing Geneviève's relics was carried to Notre Dame cathedral. The little structure next to Notre Dame, now the treasury, was named after Sainte-Geneviève. The following year, the pope declared a feast day for her, and eventually her shrine was moved to the New Church of Sainte-Geneviève.

Then those philosophizing free-thinkers of the Revolution secularized the church and renamed it The Pantheon, and in 1793, melted down Geneviève's shrine. They hauled up her remains and held a public trial of her bones, the pile of which were found guilty of "participation in the propagation of error" and were burned, like a pile of sticks, on Place de Grève, now Place d'Hôtel de Ville. Her ashes were tossed into the Seine.

What was left of Geneviève's body
was ultimately collected and these relics
were placed in a sarcophagus tombstone
that was covered in a lacy ironwork design
and placed in Saint-Étienne du Mont, this
gorgeous church with the delicately carved
interior, a perfect home for her to finally rest after all her ordeals.

It was this humiliation of her very remains, her bones, that
most struck me. Geneviève had been through the ringer, even
after her death, and seemed capable of becoming my advisor.
Compared to her, Winged Victory had had it easy, just sailed over
from the Greek island of Samothrace missing only her head and
arms. Geneviève, although in pieces, was one tough gal.

I'd likely remain intact, but felt sure she could offer me a
pointer or two. I noticed copper plaques papering the wall of her
chapel. *Reconnaissance,* they said. *Reconnaissance, Sainte-Geneviève.*

Reconnaissance, I thought, like a reconnaissance mission, must
translate to mean seeking. All the people who commissioned the
plaques had been seeking, just as I was. But what was I seeking?
And why did I need Sainte-Geneviève? I tried every combination
of reasons.

Perhaps some strength for the trip to Morocco. I'd spent the
winter grieving—and helping my family grieve—the death of
my father-in-law, working with my frantic father trying to find
medical care for my ailing mother, and missing deadline after
deadline for writing publications. I was in no mood to even be in
Morocco, which is an ancient place that sizzles with spectacular
intensity and zaps every sense in the body.

Maybe as a dream amnesiac I needed this Patroness's ability
to remember her dreams, or her quick hand at curing her mother's
ailments, or what if I accidentally caused a car accident and had
to go to trial and needed the endurance of her bones under ques-
tioning? None of my guesses seemed accurate.

Geneviève's story bolstered me during the week in Morocco—every time my spirits flagged or a snag arose, I thought of her squeezing her eyes shut and ordering the devil out of a writhing figure, or bolting upright in her nightshirt, hair disheveled, from a nightmare of burning-hot Hell, or of her bones igniting like kindling. I saw how small my troubles were by comparison.

Her bones, her bones, her bones, I thought. My bones were strong, I could feel them. Not one had ever been broken, and I imagined them, white and marrow-filled. This gave me energy, but it wasn't enough; I was an automatic marionette moving as if someone else were jerking the strings.

I returned to Sausalito with plans to go between Seattle and the Bay Area throughout the summer and finish my book by July. I would make this deadline, I vowed, and do a few other things as well. In May I planned to write two chapters of the book, resume work on a novel I hadn't looked at in months and finish a chapter of that to take to a literary conference I'd been invited to attend. I'd spend four days in Calistoga at the conference. I also planned to begin accepting submissions for an anthology about Morocco I was editing, and write an entire screenplay for a short film. It was a lot but I knew I could do it if I kept my pace.

The puppet danced faster and forgot about her saint-sister.

At the Napa conference, a well-known author worked with me on my chapter. I outlined all my projects and she gawked at me.

"Girl," she drawled, "you got too much goin' on."

I inwardly flared. I could do it, I knew I could, if I just accelerated everything.

The conference was invigorating and exhausting, but I returned ready to roll. I skyped with my screenwriting mentor, James, twice a day, plowed through page after page, dotting i-s, crossing t-s, met with my editor to complete a chapter each week, and sent out calls for submission for the anthology.

One morning toward the end of May I woke up to an email from my friend Neal, with whom I exchanged frequent communications with a kind of mind-reading regularity; we always seemed to know when something was up with the other.

How are you? Thinking of you.

I shut my computer, then headed out the door for my daily walk. Neal was probably picking up on my busy pace. I couldn't wait to return and send him the list of my many accomplishments of the past month. On the way out I glanced back at a postcard of Sainte-Geneviève I kept on my desk: a statue in an outdoor alcove, her braids spilling over the folds of her robe, a sheep snuggling her feet. *Her bones,* I thought with a sigh.

I never had figured out why she was my new guide; she'd helped me in Morocco but I knew there was more. I remembered the sensation of rightness I'd had standing in front of her elaborate coffin. My brain picked up the puzzle as I clipped up and down the hills of Sausalito. The church? No, I hadn't found religion. Invaders? No, hadn't been burglarized. Nightmares, devils, fires, no, no, no.

It seemed as if by now I should know the reason for this strange affinity I had with this saint. I had so many burning questions that persisted, like an un-erasable chalkboard filled with equations, with permutations of meanings. $x = yz + m^2$. As sand shushed through the hourglass, I pondered: what was the value of x, the meaning of y combined with z, the significance of m^2? My reasoning was paralyzed.

I walked faster, as if I were chasing answers.

A month later, the questions intensified, became crows pecking at my eyes, puncturing my brain. Why, why, why?

For four weeks, I had been strapped in a thick, padded contraption that pinned my arm to my chest. A branding-iron of pain sizzled from my shoulder down my arm, from my shoulder

up through my head, from my shoulder into my body. I burned with fever, and had no sense of whether I was asleep or awake, dreaming or existing.

I had fallen while power-walking down a hill that day in Sausalito, found myself sprawled in the middle of the street with such agony screaming from my shoulder that I could not move. Horrified, I saw something bulging in the middle of my arm, shoved my shoulder back into its socket and crawled to the side of the road. Ambulance, morphine, hospital, morphine, airplane, Seattle.

I had broken my shoulder in a crescent shape in the exact spot where all of the nerves, tendons, everything connected. It shrieked in white-hot pain every second, and the pain doubled whenever I moved because I had bruised some ribs as well. I developed a high fever, an infection.

Wait, came a voice from the back of my memory. *Hold still. Don't move.*

The doctor told me that the pain would be excruciating for two months, that all I could do was keep my arm still and wait for my bone to miraculously heal itself.

I drew on Sainte Geneviève's reserves of patience, of endurance, of composure while being licked by flames. She reminded me that the rift in my bone would sew itself together on its own and there was nothing I could do except do nothing.

Gradually I began to move. Unable to type with both hands on a computer, I started to write by hand. I found my notes from Paris, from Saint Étienne du Mont.

Her bones.

Reconnaissance.

So many seeking, like I had been, seeking Sainte-Geneviève. I remembered this had only been a guess at the meaning, so I clumsily reached across my strapped chest and grabbed my yellow and blue French dictionary.

Reconnaissance: recognition, acknowledgment, gratefulness, gratitude.

All those plaques thanking her for her life, her intercession, her healing power. All those different people who had found what they had sought right there in Saint Étienne du Mont in her chapel in front of her iron-laced crypt, who had stopped there and felt peace.

My equation became clearer. The value of a steady pace. The meaning of pain combined with patience. The significance of going to her without understanding why. So often, we do not find the answers we seek at the time we search for them, and we must wait—and sometimes seek outside the senses and slow down long enough to grasp what is offered.

Sainte-Geneviève, I saw now, had been innocent of the Revolution's charge. She had, for me, participated in the propagation of truth.

The fire of gratitude kindled my body.

⌒

Now, Fly

Then comes a moment of feeling the wings you have grown,
lifting.

—Jelaluddin Rumi, *Unfold Your Own Myth*

⌒

SHE WAS BACK.

The last time I was in Paris, one blustery March afternoon, Kellan and I crossed the Cour Carée, the eastern courtyard leading to the Louvre. Wind whipped a tangled mass of hair across my face, and I couldn't wait to be inside the climate-controlled palace, where the windows were shut tight and the wind would never get in.

On the cusp of his graduation from law school, Kellan was on a mission to find Hammurabi's Code of Laws from ancient Mesopotamia. Written in script on basalt in the 18th century BC, the Code illustrated the legal precedents and judicial powers of Babylon, and was essentially the first extensive list of those precise things that make Kellan's world go round: rules. I sensed in him

the same allure I'd experienced on approaching the Louvre—his step was quick, his eyes alight. He was on a mission.

On the way to the Eastern Antiquities wing, I wanted to show him the Spanish painting gallery, as he'd majored in Spanish and had studied in Madrid. But first . . .

He trailed me as I dashed past Della Robbia, skipped up the stairs and kept moving, flinging my arm out to indicate Michelangelo's *Slaves* despite the hundreds of times I'd wished Kellan were here with me so I could fill him in on the sculptor's woes. I could hear his footsteps behind me as I pointed to *Cupid and Psyche* without turning around, and veered toward the left side of the Daru Staircase, which rippled up in smooth waves.

She was absolutely altered.

Her marble was white, pristine. She captured the dazzle out of all the light in the arched area and held it: in the air, the light vibrated; within her, it was still. Gone was her platform; her feet stood directly upon her sharp-angled ship.

As I approached, I saw that crevices in the design of her wings that had been shadows on her former golden form were delicate tracings on this lighter hue. A curl of hair around her neck had been released from its layer of plaster and her fragments were integrated seamlessly.

In her snowy splendor, it was easy to envision her on the island of Samothrace, surrounded by the cobalt-azure-turquoise Aegean Sea. She seemed closer to her origins, the blues and whites of Greece.

In a split-second, silence. A surreal state of reverie. She and I were alone in the vacant museum. Gone was *The Lacemaker, The Venus de Milo*, El Greco's *Christ*. The people, as well, had disappeared.

It was daunting to be given wings as a gift. I held them in my arms—a heavy cloud of fluffy, white layers of feathers—unsure what to do. I knew I had to make them a part of me before I

could use them. I stood at the statue's feet and strained to hear her voice, which rang clear as a cut-crystal wind chime.

"Attach these wings to yourself. Reach around and feel where they can connect to you."

An armful of wings is cumbersome if one is caged inside a tunnel or narrow space. They stiffen and refuse to bend if constrained. In order to fasten wings to a self, one must leave one's comfort zone, as has every work of art inside Musée du Louvre, from different lands and time periods, from Bronze Age Cyprus to Late Antiquity Algeria, Renaissance Italy to Revolutionary Lyon.

One must twist and turn to find sensitive spots, empty spaces that are hooks for clasps, button hole openings—yearnings such as I'd found in France.

Travel's acquisitions, I'd learned upon returning home again and again, must be nurtured with care. I'd have to remove embedded objects, smooth unruly edges, and breathe life into these wings from within.

To unfold my mythological wings—now a wispy blanket curling around my shoulders, weighty and warm, their scalloped edges overlapping as if glued together—I rustled them. The feathers fanned out as if encouraged by a breeze. It felt like the way I'd been pried open here in France, whether unclenching or blossoming.

I considered the risks of ascent. Traveling sometimes requires our all, and often tricks us into believing we are weak and unready. In France I'd journeyed most often alone and had sometimes been lonely or afraid, my attempts at the language were frequently laughable, and I embarrassed myself regularly. At times I had staggered like a baby bird on the edge of her nest, or been sucked whirling into a vortex, or been tumbled by turbulence.

I had found that the only way to move beyond this was to act: to inch toward the edge of whatever precipice presented itself, to accept invitations, to share whatever gifts I could offer, and in

turn I'd received inspiration, friendship, a sense of being nour-
ished and of old wounds being healed.

I had made so many discoveries here, now viewed from a
perspective of hindsight, with a sense of farewell. I resisted this:
I fit here, felt such resonance with the people, the traditions, the
language, the cuisine and culture. My writing flock was here, my
many muses, my touchstones.

But I sensed I was being pulled to a new place. I'd recently
read, at a literary event, a story I'd written about a bullfight in
Madrid. My screenplay, *Siesta*, was in pre-production in Andalusia.
I had been invited several times to go on the Camino de Santiago
de Compostela pilgrimage. I was tempted to delve into *duende*, see
the influence of Cézanne on the work of Picasso, let Goya and el
Greco take me for a ride, and perhaps even encounter the ghost
of Dalí. But I didn't speak Spanish, was afraid of *duende*, and had
no sister-in-a-statue there to show me the way.

Winged Victory's voice again echoed in the empty Louvre.

"*Go to Spain.*"

Spain? I was jarred out of my fantasy. This was totally weird,
I thought. I'd failed here? Some victory, to be kicked out of
France. She's just a statue, I reminded myself.

But, as I turned away, a gust seemed to stir the air, and the
curl on her neck fluttered.

Perhaps it is true that the soul does encompass the body
and not the other way around, because as I walked toward Kellan
who was waiting among the milling crowd near *Venus and Her
Three Graces*, I could hear with my ears my boots clicking along
the floor, but her voice I continued to hear with a different,
revivified sense, and it rose above the noisy bustle, resonant as an
angel's singing.

"*Go where you next may belong. You will never lose me. I go with you, as
does everything you have been given in France, for when human beings respond*

to the call of any place on this earth, near or far, gifts open inside them that are theirs to keep. To be transformed is victory. Now, fly."

I felt my wings lifting, their lightness, their sweeping curvature, each individual feather carefully sculpted, precious and powerful, propelled by my own power mingling with the wind.

Postcript: Out into Paris

NOVEMBER, 2015

Et maintenant, on fait quoi?
And now, what do we do?

—COVER OF *LE PARISIEN*, 20 NOVEMBER

"Now walk. Kick leaves. Continue," said Rogier in the Luxembourg Gardens one day in early November. "Cut. It's good."

"*C'est bon,*" I said, and we laughed.

Late afternoon light lent a spotlightesque glint to raindrops as if to preserve them. Nearby, a woman in plaid wool sat serenely upon a bench, a girl and her mother huddled under a pink polka-dot umbrella, and students sauntered past, gesturing. A statue of Pan rose above a ring of violet pansies on a green scattered with leaves of rust, amber, and scarlet.

We strolled around the central pond, the Grand Bassin, noting different languages spoken in muted tones, children leaning in to push sailboats with sticks, and dabs of drippy color: Everything that made this exact spot the X on my soul's map.

We were filming a book trailer, and had shot in the Louvre, scenes of Winged Victory, who, in these pages, rustles her wings and teaches me how to catch air in mine. I envisioned workmen, prior to the German occupation, wheeling her down ramps to be whisked off for safekeeping. Just as quickly, I imagined Victory resuming her rightful pose after the Liberation. I remembered that recently, again she was moved, restored, and set back in place.

We shot scenes in Cour du Commerce Saint-André, the alley behind Le Procope, the café where Robespierre dreamed up the Terror, where Dr. Guillotin practiced his invention on sheep. Arched cobblestones, hanging iron signs, and latched shutters evoked those days when Parisians were petrified.

We filmed in Saint Étienne du Mont, where the remains of Sainte Genneviève, patron saint of Paris, lie. In 451, Genneviève ordered Parisians to stay in their homes as Attila the Hun approached. His hordes left, but the next day when people flocked to the common well to draw water, their sense of safety was shaken.

The week of filming celebrated all I love about Paris. People welcomed us graciously, showed interest, and eagerly offered ideas—a book signing here, a party there, anything at all. In cafés, connections sparked, continual electrical currents. At sunset, the Seine flickered as people wandered along the quais, or stopped to listen to jazz trios jamming on bridges. The city invited all to be enthralled, charmed, romanced.

As usual, I taught a writing workshop at Shakespeare and Company, read in a crowded underground cavern at Spoken Word Paris, and planned to host a salon. At my previous salon in March, friends Jane and David had presented the topic of their

upcoming book, Charlie Hebdo, and we'd had hours of discussion, searching for consensus in considering terrorists who acted outside the parameters of our own cherished values.

Friday evening, eighteen of us gathered in my apartment on Île Saint Louis. We drank champagne, tasted *fromage*, and shared storytelling secrets. Later, people drifted out the door until only a few of us lingered. Gonzague, late, walked in and said, "Something's happening."

He opened the window.

A cacophony of sirens wailed.

My phone rang; it was Martin, who'd left a half hour earlier. "It's a terrorist attack," he said. "Shootings everywhere. Don't go out."

Later that week we would learn of personal connections—Hannah's partner worked with the manager of Bataclan, who died; Ann's friend had been shot in the arm; and Christophe's sister, who lived around the corner from Petit Cambodge, had phoned him as people fell. But that night all we knew was that we couldn't go out into Paris.

We awoke to warnings, but this city is known for her unceasing enticement to join in, to engage. I heard her urgent invitation and, feeling oddly driven to attempt to save Paris as if I were some sort of expatriate Geneviève, I crept to the café on the corner, Le Flore en L'Île, and later the bistro across from it, the St. Regis, then returned home.

Sunday, I crossed the river and looked through the fence into sun-dappled Jardin des Plantes: closed, as vacant as in Anthony Doerr's scenes during the occupation in *All the Light We Cannot See*. Still, I felt an affinity with others who were not quite sure what to do, but had dared to come out.

Each day, Paris beckoned me. I thought of all the times people had been driven inside by violence and terror, and had ventured out again. Medieval wars with England had seen many doors

padlocked, then opened. The Parisians of *Les Misérables* had hidden behind barricades, but just decades later came Haussmann's era, when everyone flocked to balconies and boulevards. It seemed to me that throughout history, in heeding her call to return, Parisians had reclaimed their city.

Monday, I peered through the Luxembourg gates, locked, as the palace was home to the Senate. Here, in spring, bands performed polkas; in summer, Chopin resonated from a sunlit piano; in autumn, children chased through puddles; and now, chess players should be contemplating, their chins buried in scarves.

Peace felt out of reach.

Sirens blasted, nonstop. Raids occurred all over Paris, in Saint Denis, in Belgium. People lit candles in République, laid flowers at Belle Équipe, set up a piano outside Bataclan. To mark a week since the attacks, Parisians went out onto terraces, for as human beings, the only way we can overcome terror is to return to our rightful places.

In an odd twist of timing, Jane and David's book came out, *De Charlie Hebdo: À# Charlie: Enjeux, Histoire, Perspectives*. Rogier sent footage of our last scene, shot that Friday afternoon: a panorama from the Pompidou of a tumultuous, slate sky churning with roiling clouds—a storm approaching Paris. I went to sparsely populated bookstores, bistros, museums, and concerts, always contriving to be near the Luxembourg, still closed, with armed gendarmes everywhere.

On this last day before returning to the U.S., I wind my way through the Left Bank and dine near Saint Sulpice at Chez Fernand, usually packed on a Sunday, but today there are many empty chairs. I sit at a red-checkered tableclothed table and savor *boeuf bourguignon* and Côtes du Rhône.

Afterward, I head toward the Luxembourg. I need it to be open; I need to see how Parisians are, there in that place. I need to walk that loop in order to recalibrate my compass.

The gates are open. Few people drifting around. No band playing this November day. Still, there is something essential here. Sky, clear and blue. Voices muted, calm.

A breeze rustles leaves; lifts my own hopes.

Paris continues in concentric circles.

She will be restored.

C'est bon.

Publications and Awards

Chapter I—Les Deux Garçons

"Day Dreamer"
The Best Women's Travel Writing Volume 10, Travelers' Tales
Publications, October, 2014
New Millennium Writings Honorable Mention, Nonfiction, 2014
Silver Solas Award, Family Travel, 2014
Points North Atlanta Magazine, November 2013

"Coasting Beyond Boyhood"
WanderlustandLipstick.com, May 2011

Chapter 2—Characters

"The Rarest of Editions"
Vignettes & Postcards fom Paris, 3rd Edition, Reputation Books, 2014
New Millennium Writings Honorable Mention, Nonfiction, 2011
Besttravelwriting.com, Editors' Choice, 2010
Gold Solas Award, Culture and Ideas, 2010

"Dear Madame Renaud"
Wild Horses—The Women on Fire Series, ELJ Publications, March 2015
Winningwriters.com, September, 2012
Tom Howard Short Story Most Highly Commended Award, 2012
Besttravelwriting.com, Editors' Choice, August 20, 2012
Bronze Solas Award, Doing Good or the Kindness of
 Strangers, 2012

Chapter 3—Tastes of Place

"The Taste of This Place"
Gold Solas Award, Travel and Food, 2011

"A Rare Blend"
New Millennium Writings Awards, Semi-Finalist, Nonfiction,
 2013
Wanderlust and Lipstick.com, May 12, 2011
WritersWorkshopReview.com, July 2008

"Jurassic Cheese"
Erin is interviewed about her experience in the Jura Mountains
in the book, *100 Places in France Every Woman Should Go* by Marcia
DeSanctis, Travelers' Tales Publications, October, 2014

Chapter 4—Connections

"French Connections"
American Association of Pen Women's Keats Soul-Making
 Award, First Place, Memoir, 2013
New Millennium Writings Awards, Honorable Mention,
 Nonfiction 2013

"Vignettes & Postcards from Paris"
Introduction to anthology, *Vignettes & Postcards From Paris*,
 edited by Erin Byrne and Anna Pook, 3rd Edition,
 Reputation Books.
Vignettes & Postcards is the winner of ten international awards,
 including Foreword Book of the Year Finalist., the Next
 Generation Indie Book Award, and Readers' Favorite
 Silver Award.

"Vincent's Vision"
Crab Creek Review literary journal, 2011 volume 2

Chapter 5—The Mystique of Art

"À Propos de Paris"
Silver Solas Award, Most Unforgettable Character, 2015

"Winged Victory"
The Best Travel Writing 2011 anthology, Travelers' Tales
 Publications
Besttravelwriting.com Editor's Choice, October 2011
WorldHum.com (under the title, "Winged Victory's Energy")
 August 2010
Gold Solas Award, Travel and Transformation, 2010
Whidbey Island Writers' Association Benefactor's Award, First
 Place in Essay, 2010

Chapter 6—Storykeepers

"Storykeepers"
The Best Travel Writing Volume 10, Travelers' Tales Publications,
 January 2015
winningwriters.com, September, 2013
Tom Howard/ John H. Reid Short Story Award, Second
 Prize, 2013
Besttravelwriting.com Editors' Choice, April, 2013
Bronze Solas Award for Best Travel Story of the Year, 2013

"The Boy and His Shield"
Wild Horses—The Women on Fire Series, ELJ Publications,
 March 2015

The Storykeeper documentary film was shown at film festivals
worldwide in 2013 and is the winner of an Accolade Award, Best
Documentary Short at the Geneva Film Festival and the Universe
Multi-Cultural Film Festival. For a list of selections, nomina-
tions and awards and to watch a trailer of the film, go to www.
thestorykeeperthefilm.com.

Chapter 7—Transformations
"Bastille Day on the Palouse"
Tales to Go, Issue #17

"Avé Métro"
Silver Solas Award, Travel and Healing, 2015
Midlife Mixtape, Still in Rotation, February, 2015—excerpted

"Deep Travel Notre Dame"
Bronze Solas Award for Travel Story of the Year, 2015
Besttravelwriting.com March 2015

Chapter 8—Secrets
"The Secret of It"
Wild Horses—The Women on Fire Series, ELJ Publications,
 March 2015
Bronze Solas Award, Travel and Transformation, 2011

"In Vincent's Footsteps"
A poem from this story, "Café de Nuit", is published in *Burning
 the Midnight Oil* by Phil Cousineau, Viva Editions, 2013

Chapter 9—Signs
"Signs"
Bronze Solas Award, Destination, 2014

"*Duende* in the Louvre"
Silver Solas Award, Women's Travel, 2015

**For current publications of new stories in this book, go to
www.e-byrne.com.**

Acknowledgments

Reconnaissance, gratitude, to my precious guides:

Larry Habegger, James O'Reilly, and Sean O'Reilly at Travelers' Tales for giving wings to my words for so many years, culminating in this book. Anna Elkins, graceful *artiste,* whose images adorn these stories so delightfully, and Kimberley Cameron, literary agent extraordinaire, for sweet inspiration over glasses of rosé in Paris and Sausalito.

My travel-writing-tribe-guides at Book Passage Travel Writers and Photographer's Conference: Elaine, Bill, and Kathryn Petrocelli for *bienvenues;* Don George for showing me how to freefall and travel this world with open arms; Phil Cousineau for synchronistic insights and reverence for France and for life; Grande Dame Georgia Hesse, who shared pointers with her usual panache; Linda Watanabe McFerrin, word-goddess; Larry Habegger again, because no one can ever thank Larry too many times; Jim Benning who helped me balance craft and craziness; Tim Cahill, my brilliant guru, for the idea of this book; Janis Cooke-Newman for generous wisdom; and Jeff Greenwald, Coach Taylor for many of these stories with his "clear eyes, full heart."

Christina Ammon, *ma bonne amie,* for listening to a constant string of medieval tales and Revolutionary tidbits, and adding such sparkle to salons, soirées, and *flâneuring.* The trio of literary *femmes:* Marcia DeSanctis, whose book, *100 Places in France Every Woman Should Go,* is the perfect companion to this one; Lavinia

Spalding for *beaucoup* advice; and Kimberley Lovato, my red-headed sidekick: *France, Nous t'aimons*. Lone Mørch, my Danish sister in creativity, litcamp writers Naomi Goldner, Frances Stroh, and Amy Marcott, and Candace Rose Rardon, fellow day-dreamer. Nick O'Connell, who introduced me to *garagistes* and *Grand Cru*, and Kelli Russell Agodon, whose editing expertise shaped earlier stories.

Many *mercis* to my friends in France: Christophe, Liliane and all at Guest Apartment Services, who create lovely living spaces; Eyal Iloni for squiring me around the *banlieue* for research and through the majestic halls of Hôtel Dieu; Adrian Leeds, who enlightened me about *la vie en France* at Café Charlot; Michèle and Edouard Duval for deep and lasting friendship; Sabrina Crawford for popping up on the streets of Paris every time I think of her; Rolf Potts for asking why; and Ben Sutherland and Gonzague Pichelin for pure *joie de vivre*.

Sylvia Whitman, thank you for always welcoming me to teach at Shakespeare and Company, Anna Pook for dreaming this book with me years ago, and to the fabulously gifted flock of writers with whom I've gathered so many times in the mystical upstairs library—Martin Raim, Laura Orsal, Claire Fallou, Ann Dufaux, Jean-Bernard Ponthus, Fiona Robertson, Karen Isère, Estefania Santacreu-Vasut, Catalina Girón, Maria Bitarello, Patricia Rareg, Emily Seftel, Nancy Szczepanski, Jennifer Flueckiger, Jane Weston, Manilee Sayada, Philip Murray-Lawson (and Nadine!), and so many others—to me, you are the ruby-red-pulsing-heart of Paris.

René and Ann Psarolis, who trusted me enough to venture to Paris for *The Storykeeper*, and Rogier Van Beeck Calkoen for making such a moving film and the trailer for this book . . . soon, *Siesta* in Spain! James and Diane Bonnet, *mes parents d'esprit*, for delving into the sources of these stories with me.

My very best reader, *ma belle mère*, Kathryn Cooney, and my parents Bill and Vonnie Cowan for showering me with books, music and art throughout my childhood.

Loving thanks to John Byrne for first taking me to France and for many thousands of miles, holding down the fort while I traveled, and unwavering support of my writing. Kellan and Brendan Byrne, for enduring, during your growing-up years, my frequent forays to France; for embracing me, the mom who sat in the basketball bleachers bent over her notebook like *The Hunchback of Notre Dame*, and stood out in the baseball stands wearing a beret and bright red Chanel lipstick; and for sampling sauces over lingering dinners which lasted hours longer than any of the other kids'. Brendan for your moments with Corbin in Bistrot d'Henri, Musée d'Orsay, and the beaches of Normandy, and Kellan for sauntering through Père Lachaise and escorting me to Hammurabi's Code in the Louvre.

Finally, a *frisson*-filled embrace to my magical guides—Henri Cartier-Bresson, Claude Monet, Madame Simone Renaud, Vincent van Gogh, George Whitman, Sainte-Geneviève, Winged Victory, and all the rest—for leading me on my own true adventures in France, and for offering yourself to readers of this book. All they need do is move their chairs a few steps and you will appear and take them, as you did me, straight into the sunset, right from noon.

About the Author

Erin Byrne writes travel essays, poetry, fiction, and screenplays. Her work has won numerous awards including Grand Prize Solas Awards for Travel Story of the Year, the Reader's Favorite Award, Foreword Reviews Book of the Year Finalist, and an Accolade Award for film.

Erin's writing appears in publications including *Vestoj, Burning the Midnight Oil, Adventures of a Lifetime,* and The Best Travel Writing anthologies. She is editor of *Vignettes & Postcards from Paris* and *Vignettes & Postcards from Morocco* (Reputation Books, 2016), and writer of *The Storykeeper,* an award-winning film about occupied Paris, made with Dutch filmmaker Rogier Van Beeck Calkoen. Erin teaches at Shakespeare and Company Bookstore and on Deep Travel trips, and hosts literary salons in Paris and Sausalito.

Erin's screenplay, *Siesta,* is in pre-production in Spain, and she is currently working on a novel series, *The Storykeeper of Paris.* She reads and performs her work in many places around the world including exotic cafés in Marrakech, underground caverns in Paris, and bookstores on the dock of the bay in San Francisco. She lives in both the Bay Area and Seattle, and travels around the globe, but is drawn most magnetically to Paris. For details, please visit her website: www.e-byrne.com.